Fashion: concept to catwalk

A FIREFLY BOOK

Published by Firefly Books Ltd. 2010

First printing

First published in France in 2007 by Groupe Eyrolles as *Studio et Produits*
English language edition first published in Great Britain 2008 by A&C Black Publishers

Published in the United States by
Firefly Books (U.S.) Inc.
P.O. Box 1338, Ellicott Station
Buffalo, New York 14205

Published in Canada by
Firefly Books Ltd.
66 Leek Crescent
Richmond Hill, Ontario L4B 1H1

Translation by Sasha Wardell
Cover design by Sutchinda Thompson

Printed in China

Publisher Cataloging-in-Publication Data (U.S.)

Gerval, Olivier.
 Fashion: concept to catwalk / Olivier Gerval.
[216] p. : ill., photos. (some col.) ; cm. Studies in Fashion series
Includes bibliographical references.
Summary: Covers the creation of fashion from design and choice of material to the manufacturing process, catwalks, publicity and marketing. The book is filled with photographs and sketchbook drawings that clearly illuminate the processes involved.

ISBN-13: 978-1-55407-664-2 (pbk.)
ISBN-10: 1-55407-664-1 (pbk.)
1. Fashion design. 2. Fashion merchandising. I. Title.
II. Studies in Fashion series.
746.92 dc22 TT515.G478 2010

Library and Archives Canada Cataloguing in Publication

Gerval, Olivier
 Fashion : concept to catwalk / Olivier Gerval
(Studies in fashion)
Includes bibliographical references.

ISBN-13: 978-1-55407-664-2 (pbk.)
ISBN-10: 1-55407-664-1 (pbk.)
1. Fashion. 2. Fashion design. 3. Fashion merchandising.
I. Title. II. Series: Studies in fashion
TT507.G475 2010 746.9'2 C2010-900606-2

studies in fashion

Fashion: concept to catwalk

Olivier Gerval

FIREFLY BOOKS

Contents

Preface

For more than 30 years fashion has been my life: not just its history and anecdotes but also the genius and high craftsmanship of French haute couture. *To fully understand it in its truest sense, one must love it. Its vast universe, at times falsely criticized as artificial and futile, is, in truth, simply a work of research, devotion and humility.*

Which is most important? The garment, from conception to finish? The fashion designer's inspiration and the work of the studio? The fashion show and its team of models, makeup artists and hairstylists who are supposed to present it in its best light? The space where it can be bought? Or the visual props that do their best to promote it in the shops?

From the dream to the drawings, or these "little engravings" (as Mr. Dior called his sketches), to the choice of fabric, detail of the cloth and even to the manufacturing of this much-desired object, how much tension, anguish, application and labor, but also great pleasure, goes into its execution! From the solitude of the designer to the hub of activity and skills of the production studio, or the arrival of the suppliers, this flowing ballet for a fleeting creation is illustrated in this first book of the Studies in Fashion *series.*

But the garment itself, which is rejected from the outset by the fashion designer as he or she concentrates on the next collection, is bound to be out of fashion and quickly forgotten. Is it just a soulless piece of material to be thrown away? Saying that would be to ignore all the passion that comes with its creation, and the care taken to give it identifiable and palpable qualities.

No! This book aims to place the garment firmly in context. Proving that it endures as well as being admired and cherished by the aficionados of style, elegance, art and beauty. The passing years give it an unrivaled patina and a sense of mystery is linked to all the lives it touches. Like an exceptional wine vintage, with time it acquires a certain smoothness, giving it its own identity. As you will have understood, vintage fashion is my passion, giving me a favorable perspective on what is happening today in the fashion industry.

I defend the authenticity and charisma of vintage fashion, finding it quite wonderful. Imagine all the emotion when discovering Madame Grès' dress, where the designer had inscribed "not for sale"; or the unparalleled structure of a Balenciaga coat having belonged to Mona Bismarck: the affinity of two beings on the quest for perfection.

Timelessness is a dress from Schiaparelli's "Circus" collection, a photo that Christian Dior dedicated to one of his French models, a piece of Bristol board with some words in blue ink by Cristóbal Balenciaga, some phrases from Chanel with her unforgettable voice, the youthful radiance of Jacques Fath ... And then, among all these unique and authentic wonders is the ultimate symbol of Parisian style and feminine elegance — the "little black dress." You will find several famous examples in the following pages. Omnipresent in the fashion scene for more than 80 years, ever since Chanel's "Ford," they are an almost obligatory "rite of passage" for any aspiring designer which punctuates our memories now and then.

Balenciaga has used the little black dress in each of his collections: discreet, almost modest, yet unforgettable as a trademark or signature of his fashion shows.

One of the great merits of the Studies in Fashion *books is the ability to pay homage to these talented craftspeople of taste, luxury and style. This book does just that, by logically integrating all the necessary aspects and processes required in the production of a garment.*

This is why I am delighted to accept Olivier Gerval's invitation to participate in his first book, because the intrinsic nature of my profession is to share and impart knowledge.

Didier Ludot

Foreword

The 21st century sees a new chapter in the history of fashion. France loses its monopoly on this activity which is inextricably linked with its history. The advent of new markets, delocalization of manufacturing sites and the birth of a more demanding consumer define new parameters for the designer.

The 1950s were synonymous with a particularly French expertise, that of *haute couture*. Its originators were designers such as Christian Dior, Jacques Fath and Pierre Balmain, to name but a few.

By the time the "space race" was in full flight these big names had started to wane as already designers and street fashion had become symbiotic of which Pierre Cardin was the self-made ambassador.

The American dream had died in Vietnam, with the younger generation and the hippie movement strongly contesting consumerism; Michelangelo Antonioni's film *Blowup*, supermodel Veruschka and iconic designer Mary Quant coincided with the first oil crisis; design was no longer in fashion. Flower power epitomized the return to one's roots and the importance of the craft industry.

At the end of the 1970s, music dictated fashion. *Saturday Night Fever* prevailed over good taste. For designers such as Malcolm McLaren and Vivienne Westwood, who together founded the punk movement, the world was their oyster. Japanese fashion designers also began to come to the fore at this time – people such as Kenzo Takada, Issey Miyake, Rei Kawakubo (Comme des Garçons), and Yohji Yamamoto, who collaborated with the film director Wim Wenders. These designers established a trend by introducing specific concepts into their collections. At the beginning of the 1980s a new start took place, with the birth of the fashion designer.

The consumer craze for designer labels, coupled with the media impact of fashion designers on the public, led financial groups to consider more closely the *prêt-a-porter* or "ready-to-wear" sector of the fashion industry. LVMH (Louis Vuitton, Moët Hennessy), Richemont and PPR (Pinault-Printemps-Redoute) took over certain market sectors by establishing artistic directors in order to personalize their company image. This extended into other consumer areas as well as clothing, most notably accessories and cosmetics. The brand image and the personality of the artistic director had a notable effect on a garment's success. For example, Tom Ford was synonymous with the Gucci label in the 1990s, while Marc Jacobs with Louis Vuitton and Alber Elbaz with Lanvin illustrate this type of collaboration today.

So many transformations require a new approach toward the fashion industry, while specialist knowledge and a global understanding of the textile industry are fast becoming indispensable. The designer can no longer ignore the balance that exists between creativity, image control and commercialization; it is the belief that fashion is a "product," coupled with continuing creative research, that allows designers to be successful today. It is also necessary to have a work ethic that can adapt to market demands.

The *Studies in Fashion* books originated from a desire to share my diverse professional experiences in France and the United States and Asia, notably Japan. I have done this by echoing a schools' teaching program I perfected for secondary education. The aim is to give young designers a global vision of the fashion world, in order to familiarize them with the professional sector.

The complete series aims to thoroughly and comprehensively present fashion and its related trades. Each book independently, offering an analysis of techniques, knowledge and working methods from the great masters of the trade, including a glimps into their studios and ateliers. The series describes all the skills and trades connected with our industry, taking into account their transformations and relocations.

Fashion: Concept to Catwalk presents two types of creative areas. One is practiced by the fashion designer and is simply termed "products." The other, the conceptual side, belongs to the designer. Advice is given regarding the visual organization of the "material" at the research stage — storyboards, silhouettes, illustrations, finishing details, etc., all of which assist the apprentice designer in presenting his or her work to its best advantage. The production stage in the atelier, ranging from the technical drawing to the making up of the garment, must be perfectly mastered. This is thoroughly illustrated by means of an example that is described in the preceding chapters concerned with the concept of the idea. Eventually, the product becomes a finished outfit, including accessories, as the book follows its journey, which culminates in promotion and marketing.

Fashion: Concept to Catwalk is the result of many exchanges between professionals such as Didier Ludot, Lutz, Stéphane Marais, Odile Gilbert, Rebecca Leach, Stephan Schopferer, Martine Adrien, Antoine Kruk, and so on. Like the other books in the series, it describes the knowledge and techniques that are part of French heritage and that have been so fittingly represented by Jeanne Lanvin, Sonia Rykiel, Christian Louboutin, Loulou de la Falaise and Louis Vuitton. We have access, here, to the creative starting points of these prestigious labels, right through to their commercial strategies.

The label Lutz, which has been chosen to present the fashion show, clearly demonstrates this evolution. With an average-sized company such as this, it is just as important to satisfy its clientele as it is to respond to the demands of the boutiques. In our opinion, this case history seems more informative than that of a large company with the media impact that ensues.

If the *Studies in Fashion* books have been conceived primarily to appeal to young designers wishing to work for large brand names within the international textile industry, then, hopefully, they will equally attract a larger audience curious to discover what goes on behind the scenes of this trade. Fully illustrated and constructed in the same vein as fashion and design magazines, these books aim to appeal to all of those interested in fashion — a passion that is part of my daily life and that I fervently wish to share.

What we understand by the word "products" are clothes which are normally destined for a wide audience, and known as *prêt-à-porter* or ready-to-wear (top end of the market). However, the creation of such a line of commercial products does not at all suggest a lack of originality.

The term *prêt-à-porter* appeared in the 1960s with designers such as Pierre Cardin, Emmanuelle Khanh and Christiane Bailly and their desire to democratize "couture" by making it accessible to the person in the street. Today, we observe the opposite of this phenomenon as collections actually adopt the influence of the street. This shows that if the product is commercialized, it becomes inextricably linked to a certain historical and sociological context.

From the huge range of existing products, we have chosen to concentrate on women's prêt-à-porter. A number of these products will be presented to the reader, accompanied by detailed descriptions. We will also explain how to conduct the preliminary research necessary for developing coherent product lines, as well as how to define the theme of a collection.

Louise Brooks, Marlene Dietrich, Greta Garbo, Jackie Kennedy Onassis, Grace Kelly and Audrey Hepburn are all personalities from the past who, through their photographs, have contributed to the glamorization of our dreams. They incarnate the fashion of their time and have defined past styles for posterity. Moder design muses tend to be actresses, rock

stars and top models such as Nicole Kidman, Sarah Jessica Parker, Madonna, Beyoncé, Jennifer Lopez, Kate Moss and Naomi Campbell, and of course veritable fashion phenomenon Paris Hilton. This has the effect of making them seem more accessible.

With reference to these past icons, you will discover Didier Ludot's private collection of vintage fashion – his "little black dresses" being the glamorous items of a woman's wardrobe. Then, to introduce the world of the young designer to the reader, Lutz, ex-assistant to Martin Margiela, will explain his approach to clothing and the notion of the "remake" – timeless clothing reinterpreted for contemporary trends.

The premise of a good collection is finding the right "silhouette" – this is essential for a designer. We will demonstrate how to develop successful silhouettes that contain all the wealth and originality of a collection, as well as clearly expressing a brand identity.

We will then demonstrate the construction phase of the collection by defining the color ranges and harmonies relating to the seasons, plus print and embroidery patterns.

Finally, we will explain how all this work culminates in a collection plan and how it is ultimately made ready for merchandising and marketing.

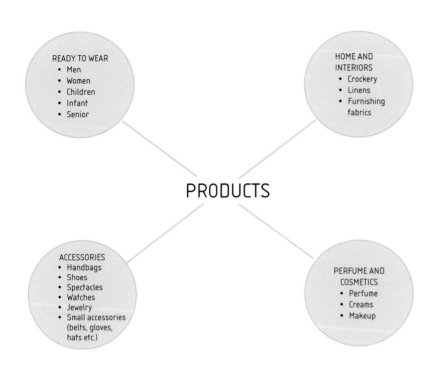

PRODUCTS

READY TO WEAR
• Men
• Women
• Children
• Infant
• Senior

HOME AND INTERIORS
• Crockery
• Linens
• Furnishing fabrics

ACCESSORIES
• Handbags
• Shoes
• Spectacles
• Watches
• Jewelry
• Small accessories (belts, gloves, hats etc.)

PERFUME AND COSMETICS
• Perfume
• Creams
• Makeup

Sectors and industries

Fashion products are sold through boutiques, department stores (Macy's, Saks Fifth Avenue), large chain stores (H&M, Zara, Urban Outfitters) and supermarkets as well as by mail order, through catalogs and online. They are divided into sectors: clothing, or ready-to-wear; accessories; perfumes and cosmetics; and home and interiors.

Nowadays, the industry concerns itself with products that are directly linked to a policy of brand exploitation, with larger conglomerates absorbing increasingly specialized distributors. For example, the group LVMH uses retail chain Sephora to entice customers to a

feast of cosmetics and perfumes, with the help of attentive assistants who replace the original perfumers.

The designer has to remain alert to consumers' ever-changing fashion trends. Too large a specialization, for example with print or jewelry, could result in a "dead-end" if fashion reverts back to a minimalist trend, and could also be detrimental to other products. It is infinitely better to be versatile and adopt a global view of fashion and its diverse sectors.

Manufacturing costs are too high in developed countries for the majority of products, in comparison to developing

countries such as China and India where wages are low and the industries are heavily subsidized. This delocalization, coupled with global trading, requires new strengths. Therefore, above and beyond possessing a sound knowledge of the product, the designer must have a good understanding of geopolitics, international law, economics and sociology. It is also an advantage to be multilingual in order to communicate with foreign production sites and representatives.

The textile industry makes products for men, women and children – from babies to teenagers – and even the family pet. As it is impossible to include all of this in one book, we have chosen to concentrate on ready-to-wear womens-wear.

This branch of prêt-à-porter is divided into several sectors: knitwear (jerseys and sweaters), sportswear, casual wear and underwear. It is worth noting that, within these sectors, there are also products that are under license: for example, a specialist jersey manufacturer can make an assurance to produce and distribute a product for a brand that in turn will receive royalties.

Women's prêt-à-porter can also include more elite sectors. In fact, if Paris manages to maintain its privileged position as the capital of the fashion world, it is thanks to its specialist knowledge of *haute couture*. This is understood by many large organizations, which, to stem the competition from developing countries, will buy up specialist artisans' studios that are on the point of disappearing. A particular example of this was the buyout of the embroiderer François Lesage by Chanel in 2002, thus saving it from near bankruptcy.

An essential principle: lengths

In the history of costume and fashion the length of women's clothing varied depending on the economic and social context. This in turn became a determining factor of fashion.

For example, at the beginning of the 20th century, women wore long hemlines. Then, with the advent of the First World War, which was a decisive period in the emancipation of women, they wore more practical clothing as they were obliged to work in factories and fields while the men went to the front. In the 1920s this trend was affirmed by the introduction of knee-length fashion, illustrated by Chanel's "tomboy" look.

In response to the 1929 Wall Street crash and the ensuing Depression of the 1930s, a more austere fashion emerged that saw women returning to reassuring traditional values and longer hemlines. The shortage of material in the 1940s resulted in a return to shorter fashions for women, with the provocative style of the jazz swingers' long jackets and zoot suits. After the Second World War, Paris became once more the capital of elegance, with the emergence of couturiers such as Jacques Fath, Hubert de Givenchy and Christian Dior, whose New Look collection in 1947 spawned the calf-length fashion.

The space race of the 1960s inspired futuristic visionaries: fashions became radically shorter with the geometric forms of André Courrèges, Pierre Cardin and Paco Rabanne. In the 1970s they lengthened again with *djellabas* and the peasant skirts adopted by the hippie movement, only to shorten once again in the 1980s with tailored suits designed for the career woman.

From the 1990s onward, designers became interested in the notion of

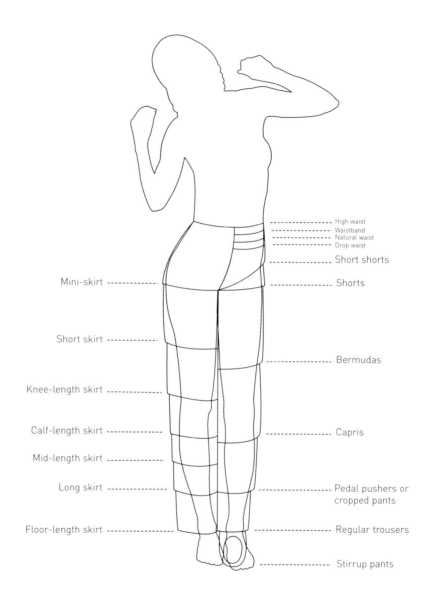

"concept" (see Chapter 3). In an effort to create a strong personal identity, each impose their own length and style. Today, in an attempt to impress the media and public alike, they aim to be the "best of the season," with the concept being more important than the length. Trends define the "indispensables," such as the trench coat or the safari jacket, which each

designer includes in his or her own style. The designer is then free to modify the shape and length within the body of the same collection. We advise apprentice designers to concentrate on one or two shapes at most, which in turn will naturally determine the lengths of their collections.

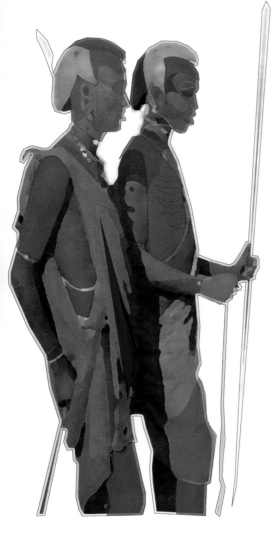

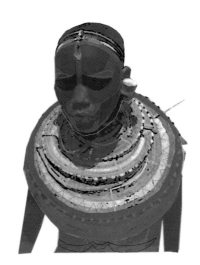

others communicate to an already established following by means of a code. In this case, it is very important that the designer becomes a visionary who is able to produce an element of surprise and originality.

Women have always been a major source of inspiration for designers, with many drawing on the feelings of adoration that women evoke. This then becomes their muse and, in turn, a theme. Contemporary fashion icons are inextricably linked to the impact of images that depict symbiotic collaboration between the designer, the model, and the photographer who ultimately captures it all on film.

The muse

The muse can embody a style and remains a continual source of inspiration for the designer. Each season's collection is made up of different themes inspired by, or for, the muse. A good example of this was Thierry Mugler with Dauphine de Jerphanion — the style never varied, whether she was represented as a Hollywood "vamp" or was wearing motorcyclist leathers. In cases like this, it is often difficult to seperate the label's image from the muse's style. Although special relationships still exist between designers and particular models, exclusivity is less frequent today. The following associations are perhaps some of the most famous: Jacques Fath and Bettina Graziani, Hubert de Givenchy and Audrey Hepburn, Mary Quant and Twiggy, Yves Saint Laurent and Loulou de la Falaise or Catherine Deneuve, Karl Lagerfeld and Inès de la Fressange for Chanel, Azzedine Alaïa and Naomi Campbell, Pierre Cardin and Hiroko Matsumoto.

The subject of a collection is known as the theme, and it is this which determines the shapes, colors and materials used. A collection can also have a principal theme that is developed through a series of subthemes (see Chapter 3, pp. 86–89). The artistic director decides on the theme in consultation with the design team. It is here where the ideas are debated in a language particular to the fashion world; its technical vocabulary, codes and references must be mastered by the designer so that he or she can communicate it to the rest of the team.

Thorough research is necessary to define a theme. This is done by looking at a number of sources including historical, ethnological and sociological as well as art and the natural world. The archives of the fashion house with whom the designer is working should also be explored.

The designer, who is in fact the trendsetter, must also be aware of what is happening in the arts, fashion, music and cinema, architecture and design, and up to date with important current affairs and new technologies. In order to increase his or her inspiration, regular visits to museums, exhibitions and art galleries are indispensable.

Certain labels choose themes that follow trends for their clientele, whereas

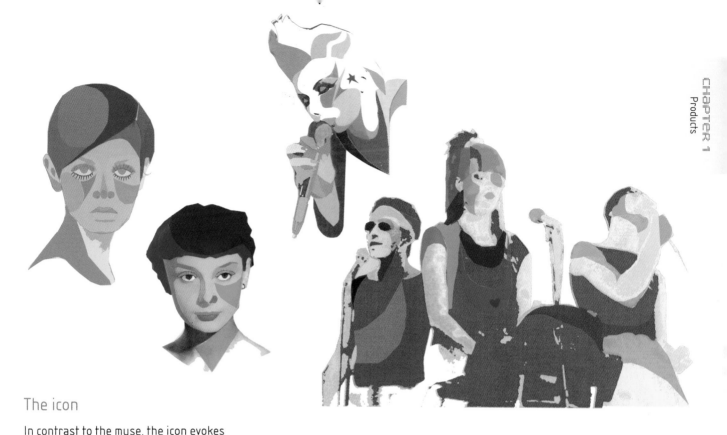

The icon

In contrast to the muse, the icon evokes a collective dream or idea. Her charisma is often more famous than the label she promotes. She is an ambassador for the fashion world and doesn't identify with any one designer, even if she has a preference for one or another. She corresponds more to a style, or an era, and will lend her name to a product that has been specially made for her. Examples include the Kelly handbag from Hermès, named for Grace Kelly, and Dior's Lady Dior handbag, named for Lady Diana Spencer.

Nowadays, icons such as Louise Brooks, Marlene Dietrich, Grace Kelly, Veruschka and Jackie Kennedy Onassis illustrate the classical themes associated with their own "couture" styles.

Designers and celebrities

In the 1990s, top models such as Kate Moss and Naomi Campbell, and actresses and singers such as Madonna, Beyoncé, Jennifer Lopez, Paris Hilton (to name but a few), as well as women in general, became great sources of inspiration, as diverse as women themselves. Madonna's sexy stage bodices and exaggerated corsets by Jean Paul Gaultier became a strong element of this particular designer's collection. However, this media-oriented approach sometimes projects a simplified vision of fashion, which can develop unnervingly quickly and can at times be difficult to follow.

Collaborations with artists

Some themes originate from famous artistic collaborations such as those between Paul Poiret and Raoul Dufy, Coco Chanel and Sonia Delaunay, Yves Saint Laurent and Piet Mondrian, and, more recently, Marc Jacobs with Louis Vuitton and Takashi Murakami, where the artist's paintings are used as the theme for a line of bags.

Ethnic sources

These are also rich sources of inspiration. For example, John Galliano incorporated Masaï designs into one of his collections and Jean Paul Gaultier fascinated us with his theme of African masks. Oriental influences, in particular that of Japan, were important at the beginning of the last century not only in fashion but in art in general.

Classic items and new looks

The garment itself can be a theme, with true classics being reinvented – the trench coat is a good example. Work clothes such as overalls and military uniforms are often used as inspiration for shape, fabrics and details – for example, safari jackets, reefer jackets and sailor sweaters. Here the reference point is historical as well as ethnological; where past and present meet.

History itself provides a rich variety of sources that can be used as research material. By giving us common cultural references, which are always interesting to work with for a collection, it is everywhere, from our studies at school to interpretations in cinema, literature and the fine arts. Nothing escapes history, not even our personal or collective memories. Places are imprinted by their history and we, in turn, belong to them.

Fashion itself has its own history – that which we perceive to be "out of fashion."

For the designer, the first task is to build up his or her own historical reference bank and immerse him- or herself in fashion culture, thus acquiring a better understanding of clothing and its evolution.

Historical research is carried out by visiting museums and libraries. It is important to find the source of the information, rather than reinterpreting work which has itself been recycled and may therefore lack substance or integrity. Through historical document-ation you will learn how to interpret the facts themselves.

Interpretations

The farther back in history we go, the more fictional and mythical the collective imagination becomes. Perceptions of past events differ continually. We only have to look at historical films to see evidence of this, as interpretation of the same subject varies from one generation to another.

Moreover, historical periods, or interpretations of these, intermingle: for example, in the 19th century the historical novel influenced fashion, and even the habits of women of a particular era. The designer therefore needs to keep in mind that history is constantly being rewritten, and that he or she must draw on solid references to give designs true originality. A particularly good example of a designer who considers these factors is Yohji Yamamoto. His work draws on the clothing of tradesmen from the last century, such as carpenters, cobblers and millers.

Updating a historical theme

In the fashion world, research into the past can be very interesting when connected to the present. A good iconographic selection must be able to be updated. Good examples of this are the fitted coat and military uniforms, which are regularly revisited by designers.

The difficulty is avoiding falling into the trap of creating theatrical costumes. Nevertheless, some artistic directors opt for this genre of clothing, as with John Galliano for Dior, whose themes have been Egyptian, Victorian and Marie Antoinette-inspired. However, it is worth noting that these fashion shows are aimed more at the promotion of a particular label than at clothing for everyday consumers. The young designer must bear in mind that to ignore business imperatives would be commercial suicide.

Sources of inspiration need to be used subtly, with just a hint of their origins apparent, and adapted to a current lifestyle. One can always use a cliché if it is in good taste and humor. An example of this is Jean Paul Gaultier, who established his fashion identity by reinventing sailors' and market traders' clothing.

Our example

Research of historical themes allows the designer to borrow outline, cut, finish and details from the past and reinterpret them with excellence and originality.

The prototype we have chosen to develop throughout this book uses the the peplum and gladiatorial armor as its historical reference. The contrast between femininity and masculinity illustrated by these historical costumes seems to correspond perfectly to our current era. The draped dresses designed by Phoebe Philo for the Chloé Summer collection of 2005 bear witness to this.

We have used the pansy flower as inspiration for patterns and motifs, as this flower emphasizes the fragile nature of the design.

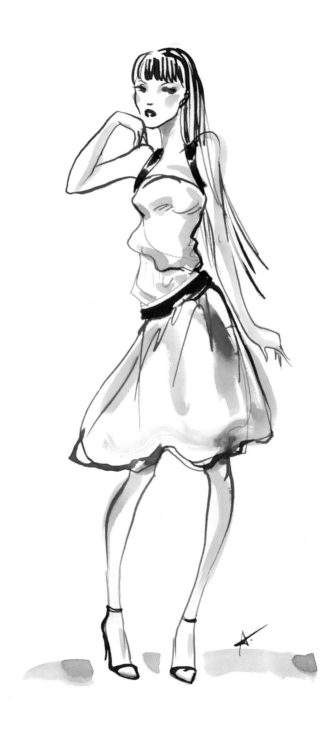

The designer will use the visuals found during his or her research to compose the storyboards – these will determine the collection's direction. Normally, one is made for the theme, one for the fabrics and one for the colorways. These visuals are an important part of the young designer's portfolio (see Chapter 4 pp. 116–19), as they assist

PANTONE® REFERENCES
PANTONE® PINK LAVENDER - 04-3207 TPX
PANTONE® PALE OLIVE GREEN - 15-0522 TPX
PANTONE® TAN - 16-1334 TPX
PANTONE® NAUTICAL BLUE - 19-4050 TPX
PANTONE® ELEPHANT SKIN - 17-0205 TPX
PANTONE® LET BLACK - 19-0303 TPX

with the coherence and possible directions of the project. In the studio, they will eventually be presented as boards so that the entire team can proceed in the same direction.

Storyboards illustrate the chosen theme in a balanced composition incorporating colorways, fabric textures and shape suggestions. They must also convey an immediate under-standing of the theme.

In the above example, the gladiator's armor, with its very masculine appearance, disappears into an abundance of flowers that instantly evoke femininity. The combination of pastel and somber colors contributes to the paradoxical aspect of the composition, while the flower textures inspire the use of fine fabrics such as silk and dupion.

The illustration on the left balances the page with reference to the color chart on the right. Together these visuals suggest a "look" that corresponds to a particular feeling or atmosphere (see Chapter 6, p. 173).

Defined by Didier Ludot

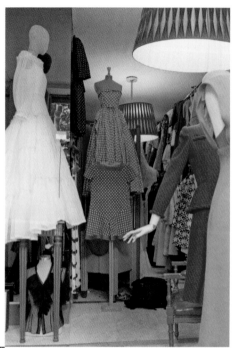

Vintage fashion is an elitist idea. The word itself, which is borrowed from the winemakers' vocabulary, implies a "great vintage." Applied to the fashion world it likens a garment to this metaphor, suggesting that it is a rare and authentic piece that represents the style of a particular couturier or era.

Yves Saint Laurent launched this trend with his "war" collection in 1970-71. The retro look entered the couture world and Didier Ludot created a new métier: vintage fashion. Being "antique" is not a prerequisite — provided the items are signed, the range can be very broad. Madeleine Vionnet's "riding dress" and John Galliano's "tramp" collection for Dior are good examples of this trend; however, "secondhand" clothes are not included.

Vintage fashion is synonymous with quality in every sense, using only the very best fabrics in order to evoke luxury. It is a direct reflection of the unparalleled knowledge of French craftsmen and women, which the couture industry's suppliers strongly defend so that it does not disappear.

It is very much linked to Paris, and to France's heritage of haute couture.

A tentative resurgence of the latter has contributed to a growing general interest in its history, and never have retrospective fashion exhibitions been so vibrant.

One of the effects of teaching vintage fashion to the new breed of young designers is that the once-forgotten, famous couturiers and fashion houses such as Martial and

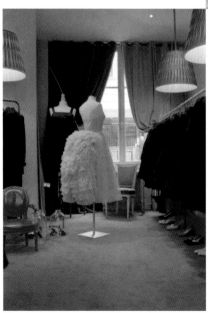

THE VINTAGE FASHION BOUTIQUE BY DIDIER LUDOT AT THE PALAIS ROYAL, MONTPENSIER GALLERY.
HERE ONE FEELS THE ATMOSPHERE OF THE BIG FASHION HOUSES WHERE THE CLOTHES ARE PRESENTED.

Armand, Louise Boulanger, Augusta Bernard, Agnès-Drecoll, Maggy Rouff, Jacques Griffe, Jean Dessès and Marc Vaughan are experiencing a revival, which in turn ensures the continuation of this trade.

If rarity is also one of the major factors of vintage fashion, it is because acquiring it requires not only a reserve of knowledge and patience, but also desire and longing. The woman who has found the dress of her dreams becomes very attached to it, considering it to be a valuable asset that deserves preservation. Vintage clothing allows her to be her own stylist, and by tapping into the playful spirit of the fashion world she will be able to dress it up with accessories from her own wardrobe. Those most passionate about this will be able to build up their own "museum" collection of vintage clothing, breathing life into the garments again by wearing them.

The interest in vintage fashion has for a long time gone further than the fashion world and its aficionados. It is not simply the designers and fashion houses determined to revive their archives, nor even the museums wishing to strengthen their collections, but more a sign of nostalgia for a quality of life considered lost by the younger generation. Vintage fashion is reassuring and comforting; a lasting and timeless addition to any woman's wardrobe, that reinforces safe values and allows its owner to affirm her personality and originality due to its rarity factor.

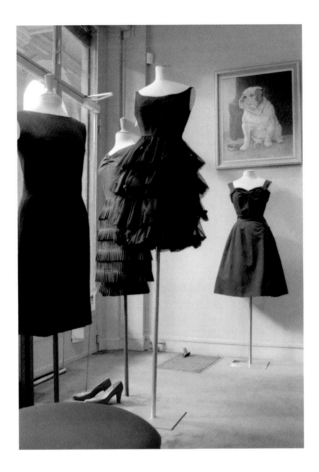

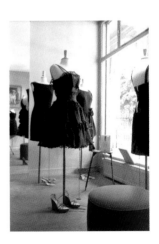

THE LITTLE BLACK DRESS BOUTIQUE IN THE VALOIS GALLERY AT THE PALAIS ROYAL.
A BOUTIQUE THAT EVOKES THE ATMOSPHERE OF A NIGHTCLUB THAT A BALLERINA MIGHT ATTEND.

Interview with Didier Ludot

1927

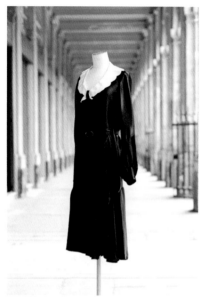

1936

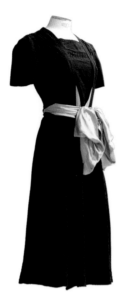

1942

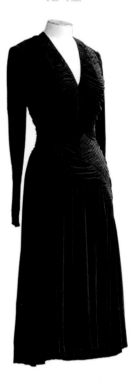

CHANEL. SILK-SATIN DRESS INSPIRED BY CHAMBERMAID AND SCHOOLGIRL UNIFORMS. CORNELY-EMBROIDERED COLLAR MOUNTED ON ORGANDY. BAKELITE-BUCKLED BELT. SAILOR DETAIL ON THE FRONT. FULL SLEEVES WITH STITCHED SEAMS ON THE ELBOW. GATHERED CUFFS. FLOUNCED.

AGNÈS-DRECOLL. BLACK CREPE DRESS WITH SMOCKED YOKE. SHORT PUFF SLEEVES. ABSINTHE-COLORED SILK-SATIN BELT WITH BOW.

MARCELLE ALIX (MADAME GRÈS). DRAPED JERSEY DRESS. ASYMMETRICAL BACK AND FRONT.

The little black dress is the epitome of Parisian style. It is also a combination of contrasts: originating from the clothing of widows and maids, it has become the symbol of the respectable woman who wants to seduce – a fantasy of men and women alike. In 1999, Didier Ludot* dedicated a boutique to it, and every season since has created a collection of 13 exclusive designs with the collaboration of the designer Felix Farrington:

Wearing a little black dress, the woman experiences the playful spirit of fashion: to be seen, to deceive and to confuse the issue! In 1926, Chanel made it the symbol of Parisian chic by incorporating modern elegance and the tomboy look. Slim with short hair, and wearing a knee-length dress with a pearl necklace are images redolent of Paul Poiret's Scheherazade.

His "Ford" dress is black and severe, similar to the cars of the famous puritan car manufacturer, but it is worth a small fortune and is only accessible to a rich and elegant elite.

The little black dress has, however, come onto the scene and has shown no sign of leaving. The 1930s saw it softened and lengthened, cut on the bias, accentuated by a white lining making it as romantic as those who wore it. Parisian haute couture was at the peak of its fame.

With the exception of Balenciaga, whose fashion house opened in 1937, this dress was an exclusive privilege, reserved for the following designers with their own particular characteristics: Vionnet – the bias; Chanel – style; Marcelle Alix (Madame Grès) – drapes; Nina Ricci – romanticism; and Schiaparelli – surrealism.

With the Second World War, the little black dress represented the Resistance in France. Shortened again for cycling, with long sleeves and only a slightly low neckline, in respect for those who were fighting, it was usually made from two or three old ones that had been dyed black and enhanced by a piece of tulle – this being the only fabric that could be found and that was not rationed!

*Didier Ludot is the author of The Little Black Dress, Paris, Assouline 2001.

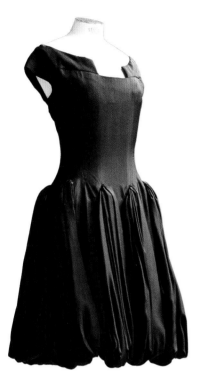

1955

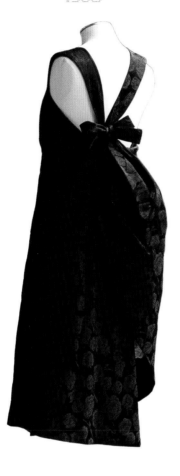

1960

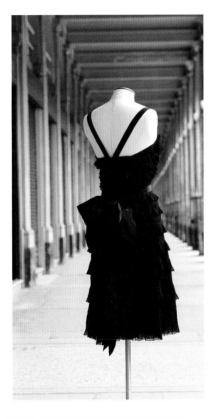

1961

CHRISTIAN DIOR. AFTERNOON DRESS IN SILK TWILL. SKIRT WITH PLEATED GODETS.

BALENCIAGA. EVENING DRESS IN DAMASK SILK. ASYMMETRICAL BACK ACCENTUATED BY A SHELL FABRIC FORM.

CHANEL. DRESS WORN BY DELPHINE SEYRIG IN ALAIN RESNAIS' *LAST YEAR AT MARIENBAD*. LAYERED BLACK SILK MUSLIN.

Once the war had finished, the dress became the symbol of existentialism for women. It was worn by France's Zazou-suited "swingers" before being submerged by the New Look. Reverting back to extreme femininity, the dress was worn fairly long at calf-length, with a bit of bust showing and with a flattering, wasplike tailored waist. Whether for cocktails or dinner, it became the apparel of the beautiful, idle rich such as Mona Bismarck and the Duchess of Windsor.

With the 1960s, the advent of the ready-to-wear market and the new wave of cinema, the little black dress became the uniform of the middle class – simple cuts, straight and democratic.

A string of pearls and a chignon in the nape of the neck, along with a boléro, were essential.

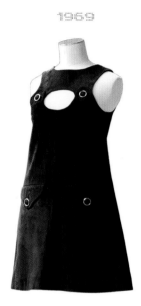

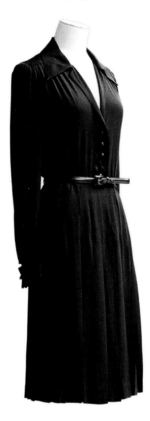

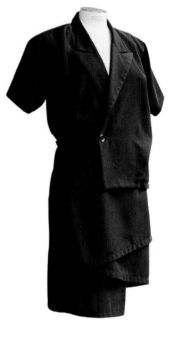

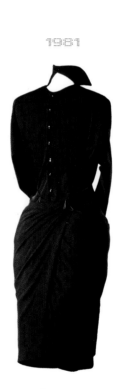

EMANUEL UNGARO. MINI DRESS IN BLACK SUEDE WITH CUTOUT KEYHOLE UNDER NECKLINE.

YVES SAINT LAURENT. CREPE DE CHINE SHIRTWAISTER DRESS. BOX PLEATED AT WAISTBAND. STYLE AND SIMPLICITY COMBINED.

AZZEDINE ALAÏA. JERSEY WOOL DRESS. GATHERED APRON HELD BY BLACK PATENT-LEATHER BELT FROM THE WARDROBE OF THE FAMOUS FRENCH MODEL BETTINA.

YOHJI YAMAMOTO. SHORT FROCK COAT CHARACTERISTIC OF HIS DECONSTRUCTED DESIGNS. TROMPE-L'OEIL JACKET WITH TAILORED COLLAR.

Later on, during the 1968 riots and the flower-power era, it was worn as a "mini" little black dress. Stylish women such as Edmonde Charles-Roux or Françoise Giroud could be seen dancing at Regine's or Castel in Paris, wearing Yves Saint Laurent's shirtwaister or Dior's clothing decorated with precious stones.

At the beginning of the 1980s, designers such as Alaïa, Mugler and Montana followed suit, using more figure-hugging fabrics with padded shoulders. With marked tailoring, and teetering above high heels, the Parisian black dress stood its ground as the wave of Japanese designers such as Issey Miyake, Rei Kawakubo and Yohji Yamamoto swept through the capital.

1992

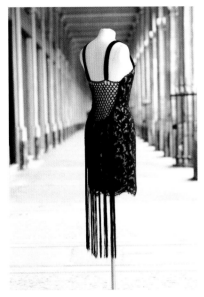

CHRISTIAN LACROIX. Cocktail dress in absinthe green duchess satin overlaid with black machine-embroidered lace. Macramé back with long fringes.

2003

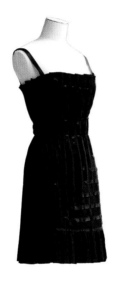

LANVIN BY ALBER ELBAZ. Pleated dress decorated at front with satin ribbons.

2006

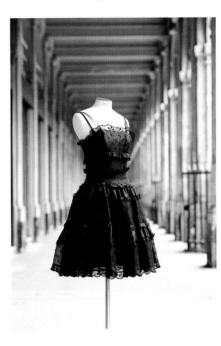

DIDIER LUDOT. Grand Alibi model from a collection designed as an homage to the elegance of Hitchcock's heroines. Embroidered organdy.

It also made a remarkable comeback on the haute couture scene following the advent of Karl Lagerfeld with Chanel, and of Christian Lacroix, whose fashion house was established in 1987.

The 1990s were black; however, the little black dress, made from nylon and worn with a Prada belt, held its own within what was essentially a somber wardrobe. Revered by new designers ranging from Martin Margiela to Helmut Lang, to the minimalist Antwerp group and its deconstructionist approach, it managed to maintain its position with the decadent, almost indecent, designs of Alexander McQueen and Galliano for Dior.

By the end of the 20th century and the beginning of the 21st, the dress was capable of turning heads again with the dramatic designs of Viktor & Rolf and Alber Elbaz for Lanvin. For the free spirit of this garment, which no couturier will ever be able to appropriate, still epitomizes eternal femininity.

Redolent of elegance and the French sociopolitical revolution for almost 80 years, the little black dress has become an obligatory exercise for every designer or couturier, as their clients pursue their quest for the symbol of elegance and Parisian style.

Defined by Lutz

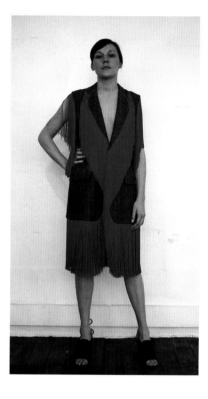

EXTRACT FROM LUTZ'S NOTEBOOK, PRESENTING DIFFERENT LOOKS FOR THE FALL-WINTER 2004 AND SPRING-SUMMER 2005 COLLECTIONS.

BOMBER JACKETS – FEMININE NEW LOOK. BOMBER JACKET REWORKED INTO A DRESS COAT WITH A SERIES OF COVERED BUTTONS USING LOOP FASTENINGS, A PARTICULARLY FEMININE FINISHING DETAIL.

DOUBLE-BREASTED JACKET – FLOWING NEW LOOK. MAN'S JACKET REWORKED INTO A DRESS WITH FRINGES. THE SLEEVES HAVE BEEN REMOVED TO FEMINIZE THE MODEL. THE CHOICE OF COLORFUL FRINGES GIVES A TOUCH OF FANTASY TO A SOMBER JACKET: THE SUIT IS TRANSFORMED INTO A FLUID PRODUCT.

To illustrate the notion of the new look, we have chosen the work of the young designer Lutz. His collections demonstrate the possibilities of changing around original clothing forms:

The new look works on ambiguity, it awakens a vague memory of something ... It is primarily a subtle reworking of a garment with the aim of keeping its identity.

The starting point of a new-look item requires some careful studying. For example, the question needs to be asked what makes a garment a basic item, otherwise known as a classic, timeless and forever-fashionable wardrobe item? It seems that it is essential because it has a reason for being there: the reefer jacket, the straight skirt and jeans, for example, have, generation after generation, remained indispensable items of clothing. The classic's useful characteristic constitutes the foundation of the work. To create a new-look product, it is a question of observing how our everyday lives evolve and making the original garment evolve accordingly.

Nowadays a well-conceived garment is in fact a hybrid of some-

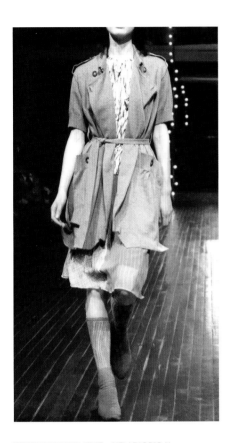

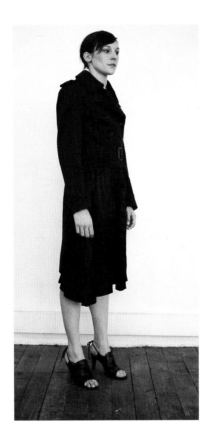

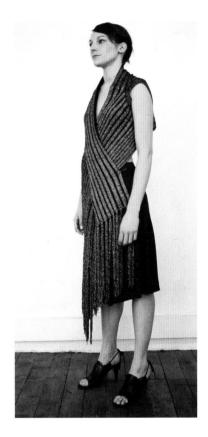

KNITTED TRENCH COAT – NEW FABRIC. USING A KNITTED FABRIC GIVES THIS TRENCH COAT A SOFT "CARDIGAN" FEEL.

TAILCOAT TRENCH COAT – FEMININE NEW LOOK. A TAILCOAT REDINGOTE OR RIDING JACKET REWORKED AS A TRENCH COAT, MAKING A HYBRID GARMENT.

FEMININE SCARF – NEW STYLING. VERY LONG LUREX KNITTED SCARF TRANSFORMED INTO A JACKET. CROSSED IN THE FRONT AND TIED AT THE BACK.

thing which follows our daily rhythms, suitable for every occasion and, above all, versatile. An example of this is Coco Chanel, who famously adapted a man's tweed jacket and tailored it for women.

I have worked with the tailcoat in this way, for the image it evokes is one of immediate ambivalence.

Another principle of the remake is the reversal of values. For example, it is possible to lose the masculine characteristics of a military uniform by adding very feminine details and modifying the proportions. It then becomes a completely new and different product,

just by adding a feminine aspect to a masculine base. The public is surprised, yet finds a point of reference by recognizing the garment's origins. It is the same thing with fabrics and emblems: a biker's leather jacket made in braided tweed can become a couture item, while a Yves Saint Laurent suit, made from denim with stitching and zip fastenings, can become a mass-market product.

The gesture, or the way in which a garment is worn, can also suggest an interesting type of "freeze-frame" interpretation – for example, when a shawl is fixed as a jacket.

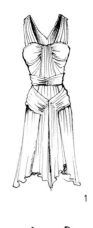

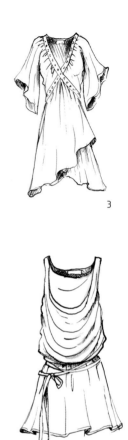

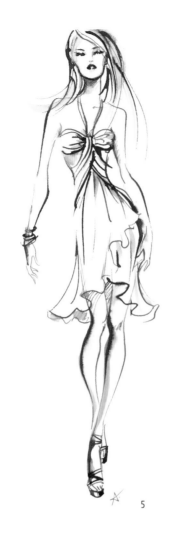

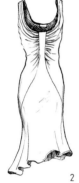

DRESS SHOPPING

1. Dress draped in front, with a rounded low neckline and asymmetrical flares.
2. Draped bustier dress in jersey silk.
3. Cross-heart dress with embroidered edging.
4. Short sleeveless tee-shirt dress with hipster belt.
5. Bustier dress cut away below bust with asymmetrical flares.

Shopping is the study of current fashion, enabling the designer to determine seasonal trends and their evolution in relation to previous seasons. It consists of finding a selection of the "best-of" silhouettes and themes that provides an overview of what is available to the public.

It is also a means of getting to know the distribution networks better. Every designer must fully understand the market, in order to successfully target their product and to be able to differentiate between luxury items and chain-store products. They must also be able to define the product's corresponding branch of fashion: for example, each socio-professional category as well as each person and their own definition of fashion in relation to their particular taste, place of origin and quality demands.

Shopping also introduces the merchandising aspect into the spectrum. This is an activity that consists of planning and adapting a collection in relation to its market (see pp. 58–59).

For the design professional, shopping is almost an automatic reflex. Some labels incorporate this into their forecasting studies. It must not, however, be seen as an excuse for imitation or plagiarism, as a lack of creativity can easily lead to the decline of a label.

This activity can also serve as a general observation of the catwalk's influence on the street. For example, sporting and cultural events could be portrayed in the selections made by the department-store buyers when a collection is presented.

Shopping can be organized by product – dresses, blouses or tops, jackets, accessories, etc. – as well as by subdivisions thereof. For example, in the case of the dress – shirtdress, fitted dress, dress coat, sundress – the research results are sorted by volume

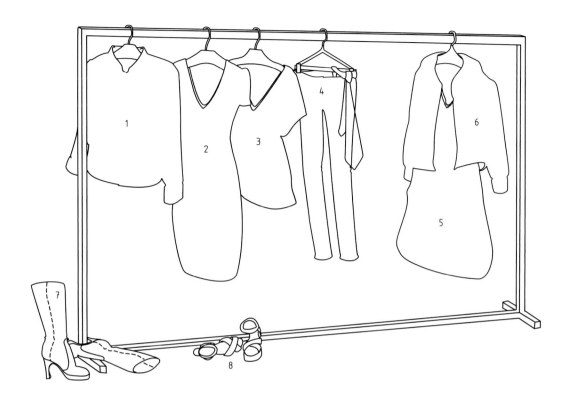

TREND SHOPPING: OFFSET THE FEMININE WITH MASCULINE CLOTHING BY WEARING A COUTURE OR VINTAGE ITEM WITH SEPARATES.

1. MAN'S SHIRT (DEPARTMENT STORE)
2. VINTAGE DRESS (VINTAGE COUTURE)
3. LOOSE-FITTING BLOUSE (DESIGNER)
4. A CLASSIC: FITTED JEANS (CLASSIC); ACCESSORIZE WITH A SCARF
5. SILK DRESS (LUXURY PRÊT-À-PORTER)
6. LEATHER FLYING JACKET (DESIGNER)
7. 1970S BOOTS (VINTAGE)
8. PLATFORM STRAP SANDALS (LUXURY)

(ball, wide, tight fitting), by color and by pattern (stripes, dots, squares). Shopping can also be presented under particular themes or looks, for example, sailor, military, tartan, sport, etc.

With the gathering of this information, seasonal details can be noted, such as types of shirt sleeves, i.e, puffed, ruched, pleated, and so on.

Shopping has also created a new occupation – that of the private stylist, or "personal shopper," as it is known in the United States. Large department stores offer this service to clients who are short on time or do not have the inclination to search through the aisles. This represents a new perception of luxury that the young designer must take on board.

In large department stores such as Macy's, for example, more and more personal shopping options have been created for those who require this type of personal and professional service. Helmut Lang is a good example of a designer who responded to this type of individual demand with his custom-made garments.

The personal shopper or private stylist's selection must meet the client's needs swiftly, making sure no time is lost or wasted. This profession requires a highly developed understanding of the fashion culture with all its labels and products, as well as an ability to coordinate products and create new looks.

The private stylist's job is similar to that of the photo stylist, who works in collaboration with fashion magazine editors and photographers, selecting the most interesting items of the season for the collection's presentation.*

*The work of the photo stylist is explained in more detail in an interview with Rebecca Leach (see Chapter 6, pp. 174–175).

Silhouettes correspond to the first stages of the collection's development. They can either set the trend or serve as inspiration.

The principal function of a silhouette is to illustrate the theme, and, along with the chosen volume and proportions, it is the first thing one notices in a collection and provides the initial impact of a garment. All of these factors result in the general look of the woman who is the target market. They respond to the lines (explained pp. 36–37) suggesting the fall of the fabric.

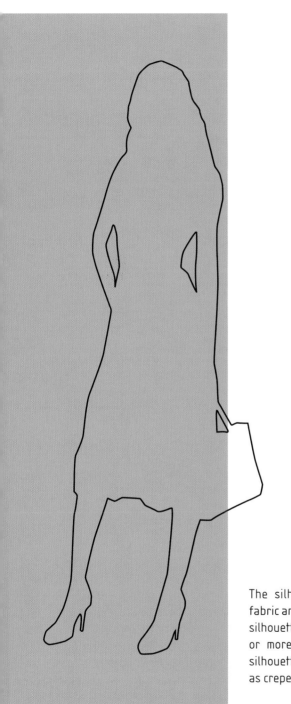

The silhouette governs the choice of fabric and how it will be used: a geometric silhouette, for example, demands stiffer or more rigid fabrics, whereas a soft silhouette requires softer fabrics such as crepes or muslins.

To summarize, the silhouette must portray a fragile yet fundamental balance of line, look, proportion and volume, as it dictates the general spirit of a collection right from the very beginning.

As with fashion illustrations, but even more so, the silhouette presents the look of a collection. These looks reflect the coordination of the products and, between them, harmonize and illustrate the collection's theme. The number of silhouettes required relates to the number of looks planned for the fashion show (see Chapter 6, pp. 172–173).

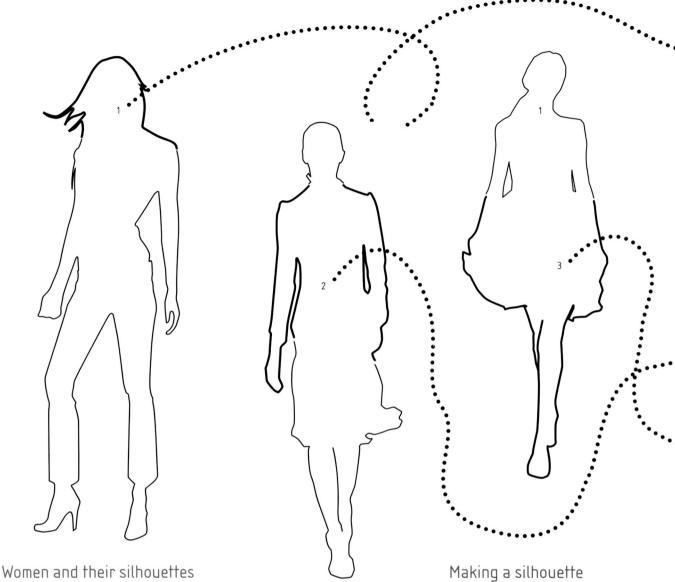

Women and their silhouettes

Each silhouette must represent a particular type of woman. The mythical silhouette of Coco Chanel with her hat and cigarette corresponds to the emancipated and independent woman from between the wars. That of Sonia Rykiel and her flamboyant red mane immediately evokes the bohemian artist of 1968. And that of Jean Seberg, who seduced the whole of France in Jean-Luc Goddard's *Breathless* (1959) with her short hair and plain clothes, symbolizes eternal adolescence. Here we have three silhouettes, and already three different types of women across several decades. A final example is when Yves Saint Laurent in 1966 dressed his models in smoking jackets, thus creating a new silhouette that corresponded to a type of woman perhaps best epitomized by Charlotte Rampling.

Making a silhouette

Silhouettes are made either by drawing with a pencil or felt pen, by cutting out and collage, or by tracing. It is a question of gradually building up, by eye, the contours that will constitute the style of the collection. A well-proportioned silhouette illustrates the precision and the correct balance needed for the form and volume of the garment. It also indicates how good the designer's eye is.

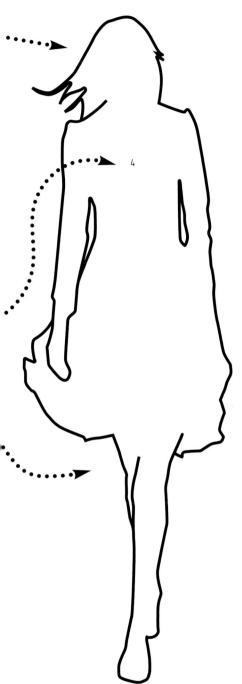

COLLAGE EXAMPLE

1. THE FIRST SILHOUETTE HAS A NATURAL FEEL DUE TO THE MOVE-MENT OF THE HAIR. THIS, ALONG WITH THE POSTURE, THE ACCES-SORIES AND THE LINE OF THE CLOTHES, GIVES THE EFFECT OF A MODERN "DISCO" STYLE.

2. THE SECOND SILHOUETTE IS QUITE CLASSIC. THE TAILORING SUG-GESTS AN AUSTERE FEEL.

3. THE THIRD SILHOUETTE SUGGESTS AN EXUBERANCE WITH ITS BILLOWING SKIRT. THE VOLUME OF THE SKIRT CREATES THE IMPRES-SION OF LIGHTNESS AND FEMININITY.

4. THIS SILHOUETTE ECHOES THE FIRST WITH ITS NATURAL HAIR-STYLE, THE STRUCTURE OF THE JACKET FROM THE SECOND, WHICH GIVES IT A CERTAIN STRENGTH, AND FINALLY THE VOLUMINOUS SKIRT FROM THE THIRD, WHICH BRINGS A LIGHTNESS AND FEMI-NINITY. THE COMBINATION OF THESE THREE GIVES THE OUTFIT A CONTEMPORARY, ORIGINAL FEEL.

Making a silhouette using collage

Collage allows you to fully understand the development or embellishment of a silhouette. Our example shows the work stemming from three different sources of inspiration.

In the case of historical theme, for example, it might be interesting to combine a top that represents a particular era with a contemporary bottom, and finish it with a hairstyle that defines the desired style of the target audience.

Equally, you can compose a sil-houette from abstract images borrowed from architecture, like Rei Kawakubo has in his collection Comme des Garçons. These would produce a new style of innovative volume and proportion. Or experiment with varying cutout shapes, using one or several sheets of paper and basic tools such as glue and scissors.

You can also digitally enhance your ideas using Photoshop, as we have done in our example.

Well-conceived silhouettes will aid the work of the designer, as the choice of fabric and product shapes has already been implied in the sketches. Under-standing the collection is then made easier for the designer's assistant as well as for clients and the press.

Research drawn from diverse sources of inspiration, such as historical, ethnological and even current fashion, will significantly assist in developing the silhouettes. The proportions of the initial visuals can then be exaggerated to express the designer's idea.

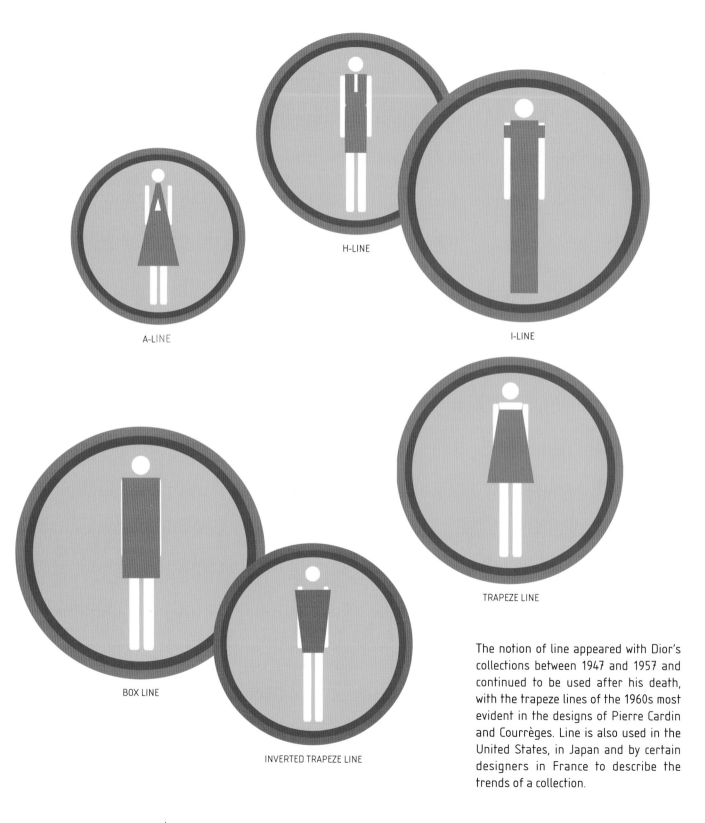

A-LINE

H-LINE

I-LINE

BOX LINE

INVERTED TRAPEZE LINE

TRAPEZE LINE

The notion of line appeared with Dior's collections between 1947 and 1957 and continued to be used after his death, with the trapeze lines of the 1960s most evident in the designs of Pierre Cardin and Courrèges. Line is also used in the United States, in Japan and by certain designers in France to describe the trends of a collection.

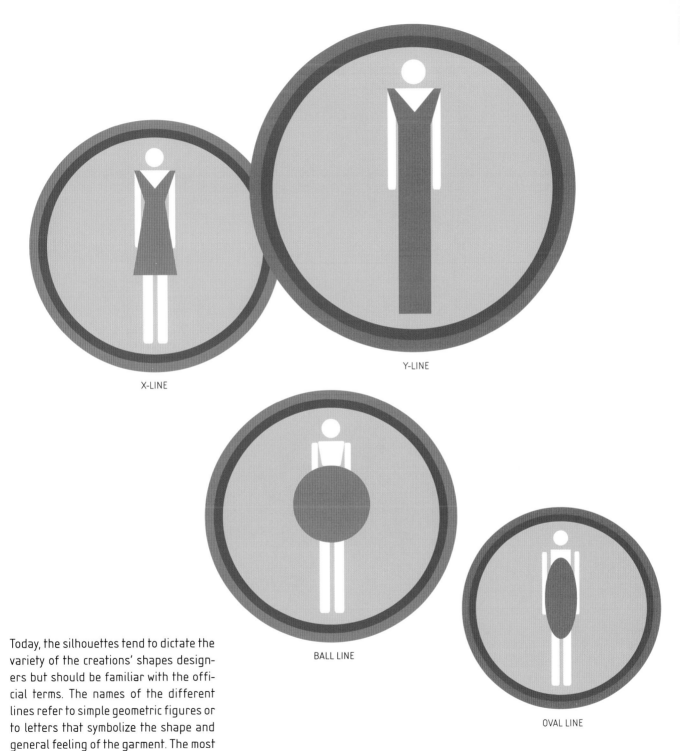

X-LINE

Y-LINE

BALL LINE

OVAL LINE

Today, the silhouettes tend to dictate the variety of the creations' shapes designers but should be familiar with the official terms. The names of the different lines refer to simple geometric figures or to letters that symbolize the shape and general feeling of the garment. The most common of these are shown above.

Classic garments are characterized by either their cut or their name. They are products that have survived fashion's ever-evolving trends and global variations. In relation to the general evolution of women's shapes, and varying sizes, age categories and differences in shapes around the world, they remain easily identifiable.

They fall into two groups:

- Lightweight, dressmaking fabrics. These include the bodice, the dress, the skirt, each with its cut variations (straight lines, flared, cut on the bias or draped).
- Tailored, heavier fabrics. These include the suit or sleeved item, originating from men's traditional separates or uniforms such as jackets and coats.

- Knitwear items are distinguished by the fact that they require techniques and specific machines that gives the garments their particular appearance.

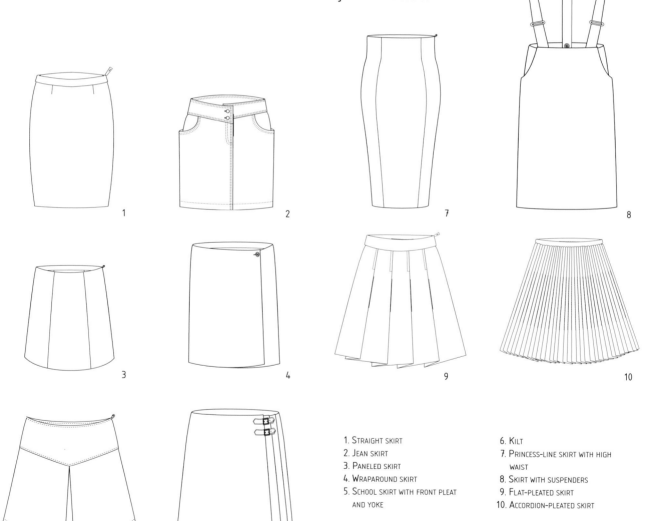

1. STRAIGHT SKIRT
2. JEAN SKIRT
3. PANELED SKIRT
4. WRAPAROUND SKIRT
5. SCHOOL SKIRT WITH FRONT PLEAT AND YOKE
6. KILT
7. PRINCESS-LINE SKIRT WITH HIGH WAIST
8. SKIRT WITH SUSPENDERS
9. FLAT-PLEATED SKIRT
10. ACCORDION-PLEATED SKIRT

Skirts

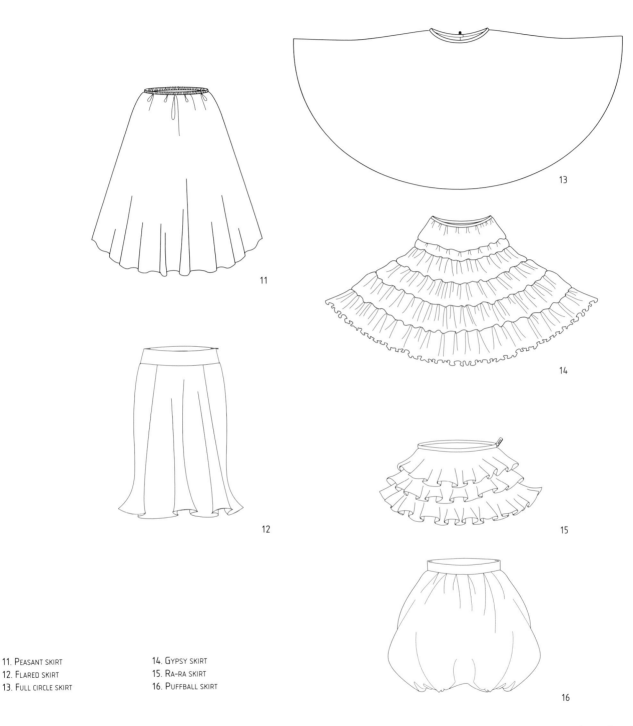

11. Peasant skirt
12. Flared skirt
13. Full circle skirt
14. Gypsy skirt
15. Ra-ra skirt
16. Puffball skirt

Straight, flared, bias, pleated, gathered, flounced and balloon skirts are all examples of classic separates. Our selection illustrates a number of timeless cuts that are used today. A classic can also be identified by the fabric, details and finishes used, such as overstitching, pockets and fly openings for denim skirts, and so on. It will always remain a simple product that is easy to wear.

Dresses

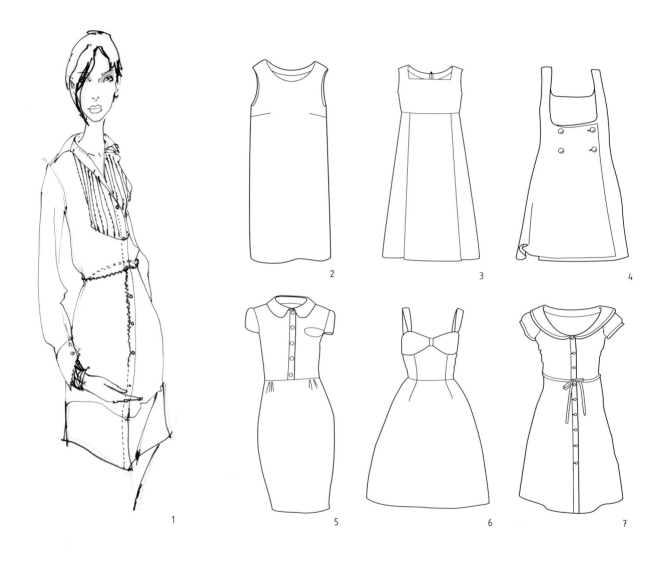

1. SHIRTDRESS WITH PIN-STITCHED BIB
2. SHIFT DRESS
3. A-LINE DRESS
4. PINAFORE DRESS
5. POLO DRESS
6. 1950S BUSTIER DRESS
7. 1940S SHIRTDRESS.

The dress is a one-piece garment with or without sleeves. It can be the result of a combination of a top and a skirt, as in the case of bustier dresses and sundresses (where the skirt is attached to a bodice). Our examples of the shirt dress and polo dress (nos. 1 and 5) are also tailored.

8

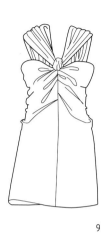

9

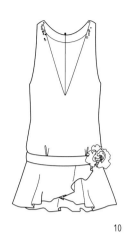

10

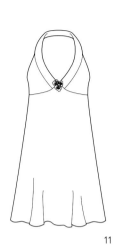

11

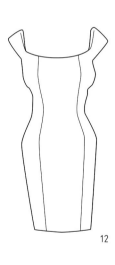

12

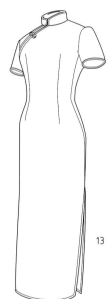

13

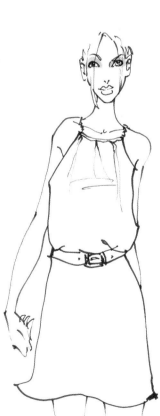

14

8. TUNIC DRESS
9. DRAPED DRESS
10. FLAPPER DRESS
11. SUNDRESS

12. SHEATH OR PRINCESS-LINE DRESS
13. CHINESE-INSPIRED DRESS
14. HALTER DRESS, BILLOWING AT THE WAIST

Trousers

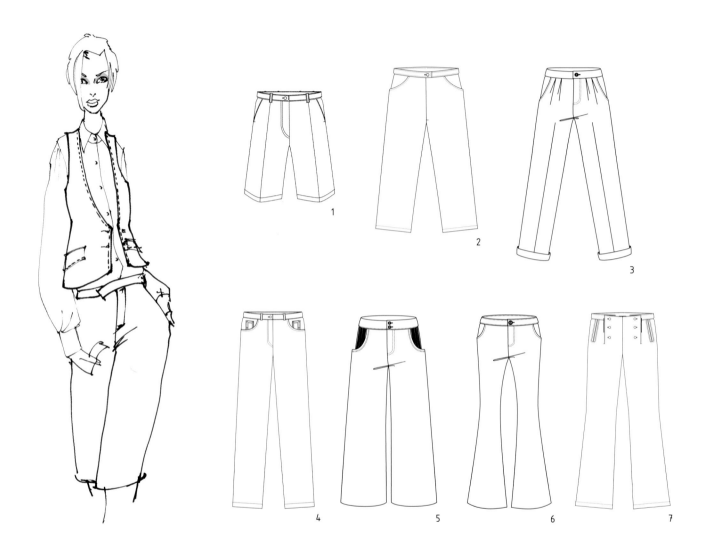

1
2
3
4
5
6
7

Originally trousers were a tight-fitting, knee-length masculine garment, worn with underwear by nobles, and without by peasants.

After the French Revolution, long trousers were adopted by all men, being made from fine fabrics, such as wool, for the middle class and from coarser, more hard-wearing fabrics for the working classes. Trousers became unisex in the 20th century.

Culturally diverse examples also exist such as the *saroual*, which was a traditional garment worn as a uniform by the Algerian light infantry corps, known as the Zouaves, in 1830.

These separates are defined by length, width, details (pleats, folds, gathers, drawstring belts, pockets, zippers and turned-up cuffs) and by the position of the belt (high, low, drop or fitted waist).

The shape of the trouser often corresponds to the original usage:
- military (combat pants, sailors' trousers)
- sportswear (jodhpurs, tracksuits)
- utilitarian (butchers' and mechanics' coveralls, jumpsuits)

1. BERMUDA SHORTS
2. CROPPED TROUSERS
3. CLASSIC TROUSERS WITH PLEATS AND TURNED-UP CUFFS
4. FIVE-POCKETED MEN'S JEANS
5. BELL-BOTTOM TROUSERS
6. FLARES
7. SAILORS' TROUSERS
8. JODHPURS
9. BLOOMERS
10. SAROUAL
11. OVERALLS
12. COVERALLS OR JUMPSUIT
13. BAGGY COMBAT PANTS
14. TRACKSUIT PANTS
15. SKI PANTS

8

9

10

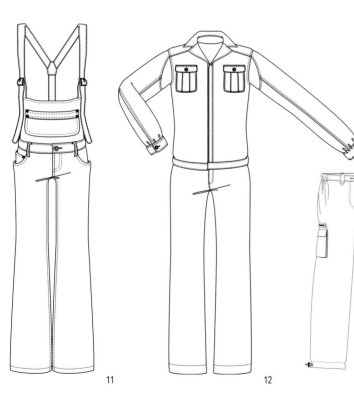
11

12

13

14

15

Jackets

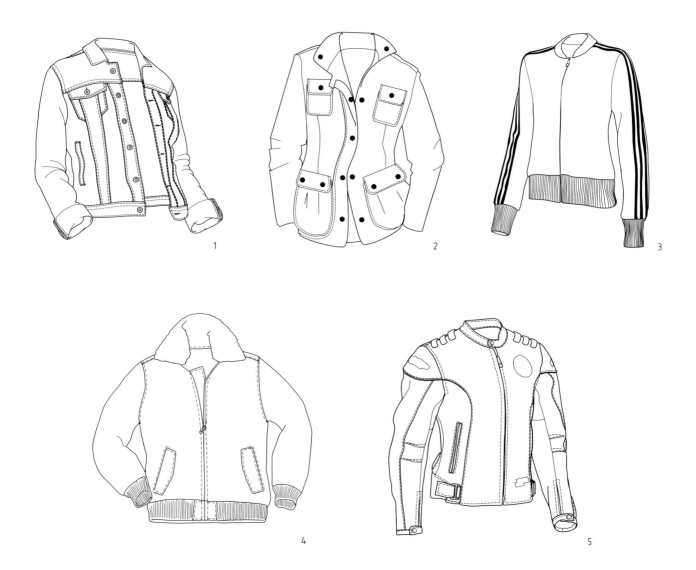

Jackets are items borrowed from the male wardrobe. The conception and manufacture of the sleeves, armholes and linings that form the structure of the garment (cloth, epaulets, shoulder padding and so on) require a particular type of care and precision.

Jackets usually originate from military or sports clothing; or ethnic clothing such as parkas. The choice of fabrics linked to each type of jacket is relatively fixed: leather for motorcycle jackets, jean or denim material for Levi's-style cuts, and so on.

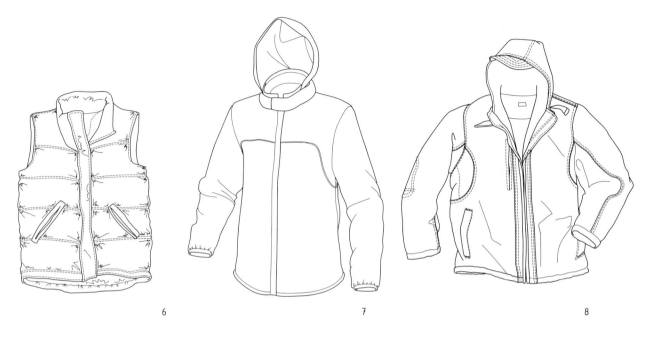

6

7

8

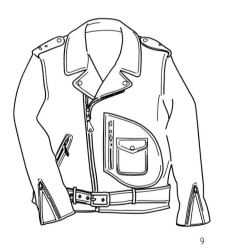

9

1. JEAN JACKET
2. HUNTING JACKET
3. TRACKSUIT TOP
4. BOMBER JACKET
5. MOTORCYCLE JACKET
6. PADDED VEST
7. PARKA
8. WINDBREAKER OR ANORAK
9. AVIATOR OR FLIGHT JACKET

Tailored jackets

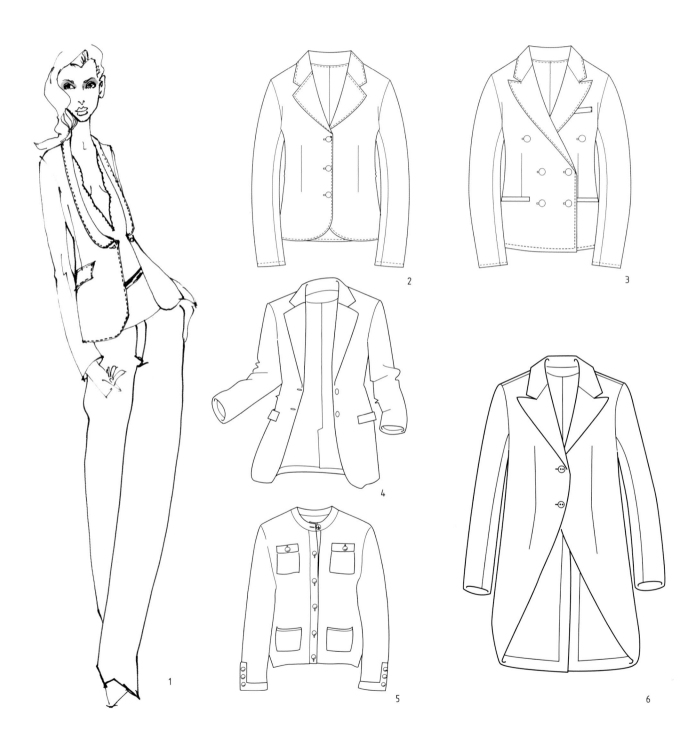

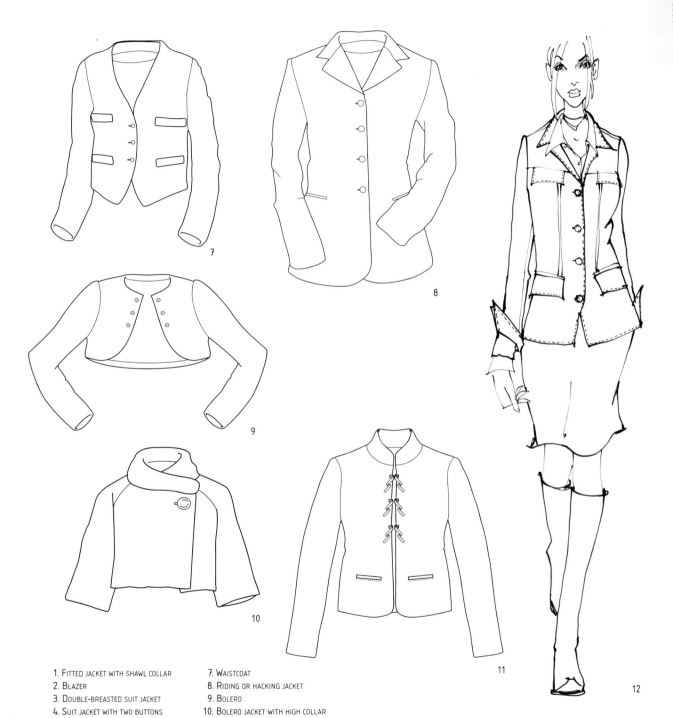

1. Fitted jacket with shawl collar
2. Blazer
3. Double-breasted suit jacket
4. Suit jacket with two buttons
5. Chanel suit jacket
6. Tailcoat
7. Waistcoat
8. Riding or hacking jacket
9. Bolero
10. Bolero jacket with high collar
11. Officer's jacket
12. Safari jacket

Coats

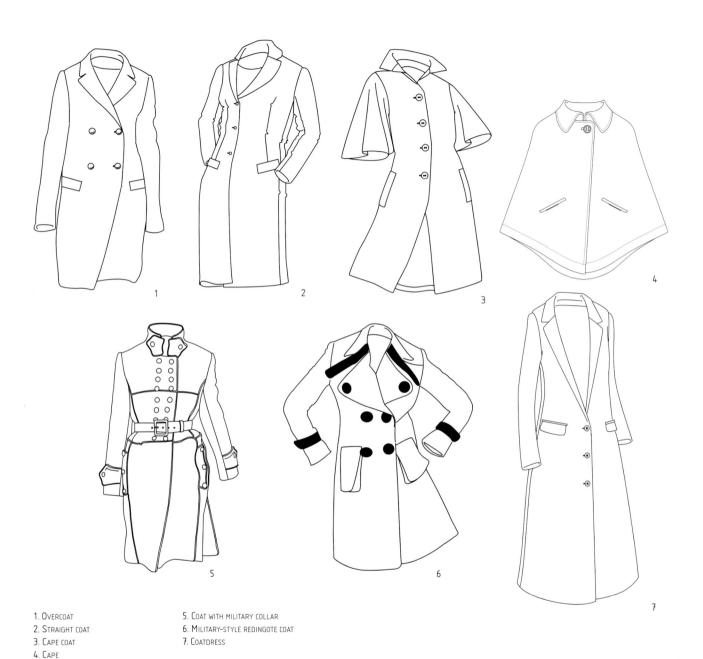

1. Overcoat
2. Straight coat
3. Cape coat
4. Cape
5. Coat with military collar
6. Military-style redingote coat
7. Coatdress

Coat shapes are also derived from the male wardrobe, and most often from the military wardrobe.

A coat's main function is to provide protection against the elements: the raincoat for rain, the woolen coat for the cold, the reefer jacket for the wind (it was used as a windbreaker by sailors). The fabric used was determined by its usage. Today, the shape of the coat is more a question of style, and coats are made in a variety of materials, for example, the knitted trench coat from the Lutz collection presented on p. 29.

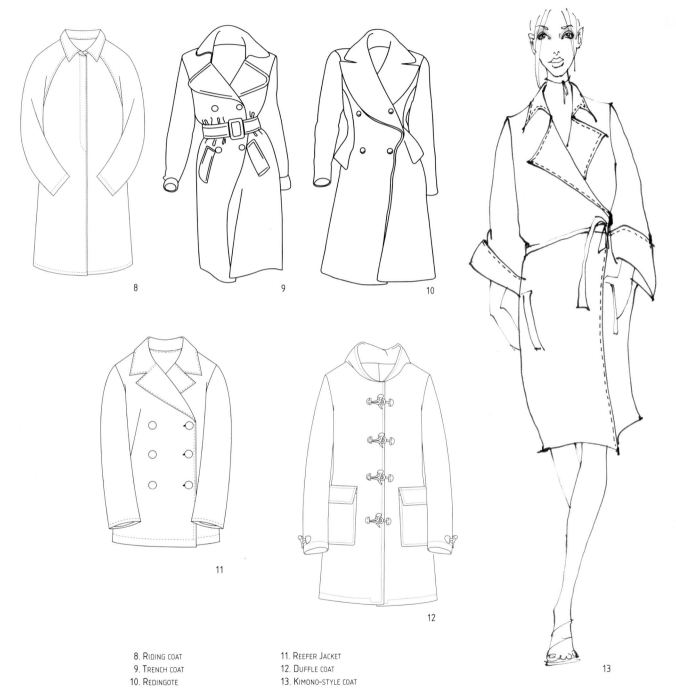

8. Riding coat
9. Trench coat
10. Redingote

11. Reefer Jacket
12. Duffle coat
13. Kimono-style coat

Knitwear

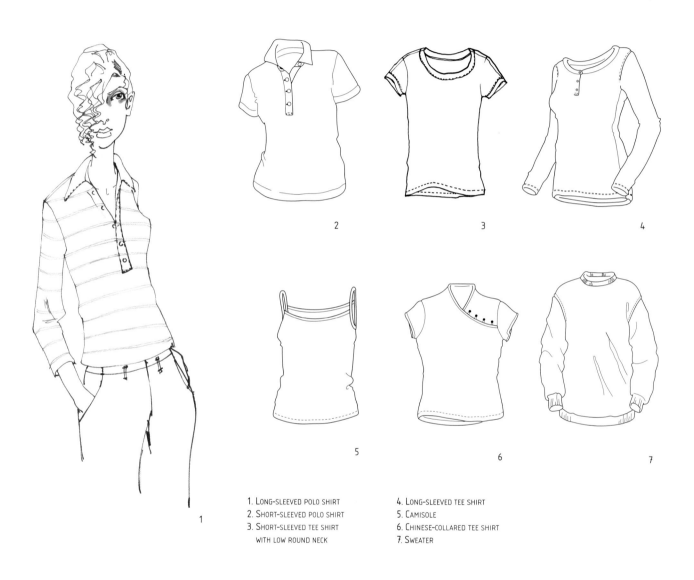

1. LONG-SLEEVED POLO SHIRT
2. SHORT-SLEEVED POLO SHIRT
3. SHORT-SLEEVED TEE SHIRT
 WITH LOW ROUND NECK

4. LONG-SLEEVED TEE SHIRT
5. CAMISOLE
6. CHINESE-COLLARED TEE SHIRT
7. SWEATER

It is important to distinguish between knitwear and the "cut-and-sew" tee-shirt material when it comes to sweaters. The latter is knitted industrially on large rolls, then cut, like fabric, with the aid of pattern cards (for example, jersey, which is worked with thinner or thicker thread, or yarn, for tee shirts and sweatshirts). In the case of knitwear, the fabric is knitted by machine or by hand, allowing direct production of garments such as sweaters, waistcoats and so on. The thickness of the garment depends as much on the gauge of the machine as on the type of thread used.

Knitwear requires specific technical knowledge regarding the variety of stitches and finishing that determine the look of the garment. This is why our examples include variations on collars and products included in this category of separates.

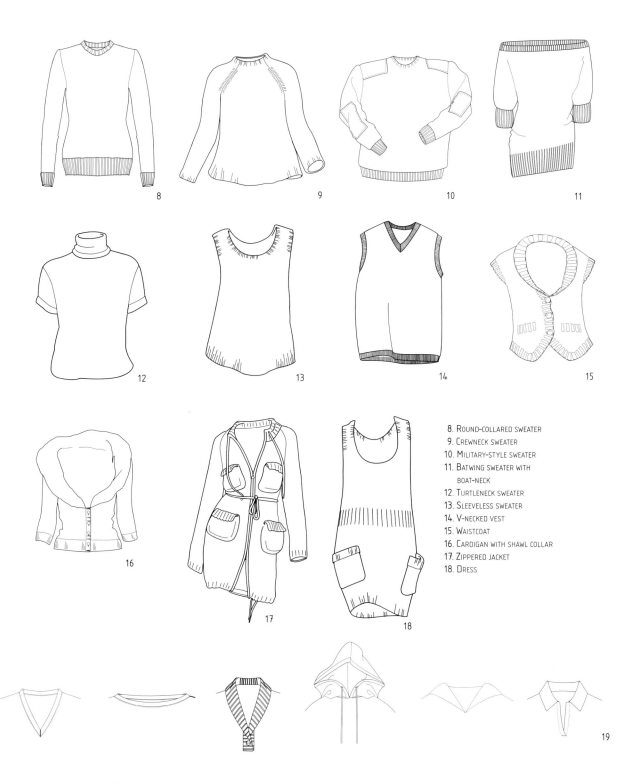

8. Round-collared sweater
9. Crewneck sweater
10. Military-style sweater
11. Batwing sweater with boat-neck
12. Turtleneck sweater
13. Sleeveless sweater
14. V-necked vest
15. Waistcoat
16. Cardigan with shawl collar
17. Zippered jacket
18. Dress

19. Collar variations. From left to right: V-neck, boatneck, shawl collar, hood, sailor collar, buttonless polo collar

Shirts and blouses

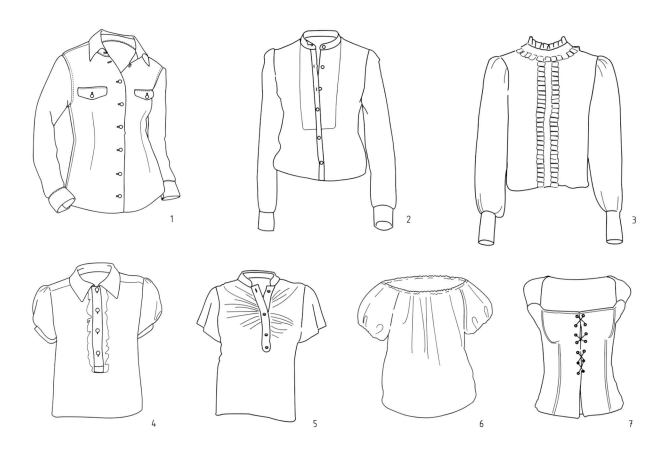

1. CLASSIC SHIRT
2. BLOUSE WITH MILITARY-STYLE COLLAR AND PLASTRON
3. BLOUSE BUTTONED UP THE BACK WITH FULL SLEEVES OVER THE CUFF
4. POLO BLOUSE
5. SHORT-SLEEVED BLOUSE WITH MANDARIN COLLAR
6. BOATNECK BLOUSE
7. BUSTIER BLOUSE

The shirt is one of the oldest items of clothing in the West. It first appeared in fifth-century BCE with the Greeks, and subsequently with the Romans (as the tunic).

For a long time it was worn as an undergarment, by women as well as men, and it only became part of men's clothing in the 15th century when it discreetly appeared above the vest. In the 19th century it was still worn with a jacket, and was fairly well worked with pleats and bib following the billowing lace of the 17th and 18th centuries. It can be seen in illustrations from that period, worn by women in sidesaddle riding habits.

The evolution of sleeve, cuff and collar details enable us to place them in history. For example, Louis XIV sleeves that have been shortened by three rows of billowing gathers and tied up by bows and ribbons, musketeer cuffs, Danton collars and so on.

The shirt took on a new identity with African and Hawaiian prints, America's flannel checked cowboy shirts, and Canada's heavy woollen ones. Shirts had, up until then, remained white like the undergarments they derived from. The introduction of the modern pockets came from British colonial troops.

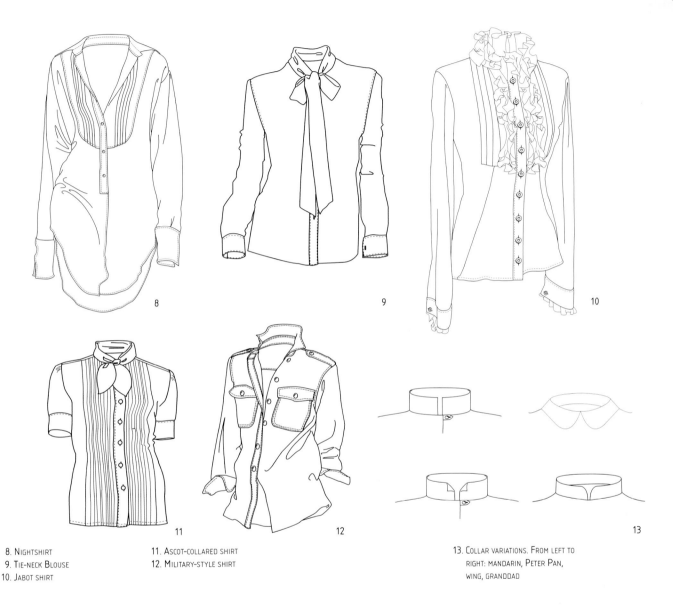

8. NIGHTSHIRT
9. TIE-NECK BLOUSE
10. JABOT SHIRT

11. ASCOT-COLLARED SHIRT
12. MILITARY-STYLE SHIRT

13. COLLAR VARIATIONS. FROM LEFT TO
RIGHT: MANDARIN, PETER PAN,
WING, GRANDDAD

The woman's blouse or bodice that buttoned up the front, and was inherited from the shirt worn under a corset, can be distinguished from the blouse that came from the working woman's shirt. The latter was fuller and often buttoned up the back (see illustration no. 3).

For this particular product, it is important to know the principles of the conception and manufacture of collars, sleeves, cuffs, and buttonholing.

The cuts and finishes are generally oversewn, but men's shirts can take on the appearance of American tailoring (reversible or oversewn as with jeans) to suggest a sports style.

DRESS FINISHES

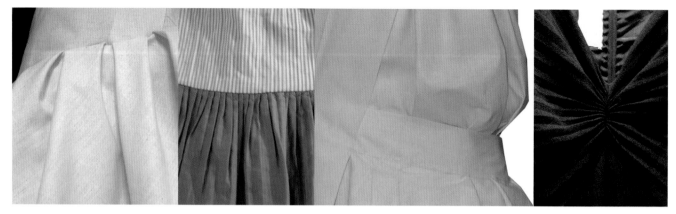

ROUND PLEATS — FLAT MINI-PLEAT — LARGE PLEATS IN A FITTED WAISTBAND — ACCORDION PLEATS

SEWN IN FLAT MINI-PLEATS

TULLE BOWS WITH PEARLS

The general line and balance of volume are the first things that we notice about a garment, then we look more closely at the details and finishes. These often become the deciding factor in whether we choose a particular item over another, as they determine its originality and quality.

With thorough research given to details and finishes, the stylist is able to give coherence to his or her collection (see Compilations of Ideas in the following pages). As with the theme, preliminary research for details and finishes comes from a variety of sources. In fact, they must be considered at the outset of the project and be completely integrated into the sketches at the beginning: being added as an afterthought can alter the general balance of a garment and upset the planning of the brand. This in turn will compromise the presentation dates, manufacture and delivery.

However, it is necessary during the fashion shows to identify the pieces that have been simplified in a way that responds to the commercial demands of standardizing a garment.

A stylist must have a good understanding of the different types of materials, the production tools and the manufacturing constraints for these details and finishes. Moreover, he or she must never lose sight of their functional aspect, particularly with openings and fastenings.

Warp and weft products, made from nonstretch materials, require openings so that they can be passed over the head and wrists for a shirt, and openings at the waist for a skirt or trousers. These details can be classic, or worked, using particular techniques for hidden buttoning, additions and so on.

The comfort of a garment must also be taken into consideration. This is done by creating pleats for ease, for example – by introducing them in the back, up to the shoulder, for men's shirts, and in the front, over the chest, for women. All types of pleats, tucks and fittings at the waist are equally indispensable. For even more comfort several materials now include spandex thread.

Originality in knitwear is most evident in the finishes. Techniques such as ribbing determine the stretchiness of the garment. The types of stitches and threads used will determine its volume, fall and look.

POCKETS

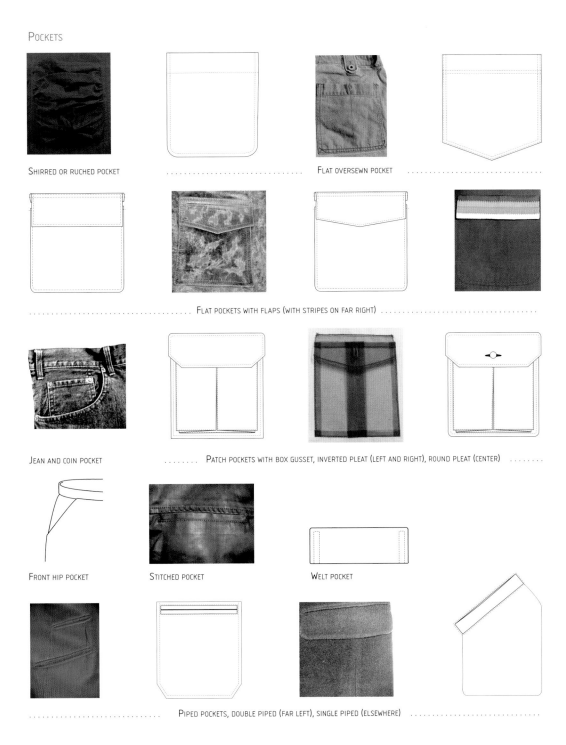

SHIRRED OR RUCHED POCKET · FLAT OVERSEWN POCKET ·

· FLAT POCKETS WITH FLAPS (WITH STRIPES ON FAR RIGHT) ·

JEAN AND COIN POCKET · · · · · · · · PATCH POCKETS WITH BOX GUSSET, INVERTED PLEAT (LEFT AND RIGHT), ROUND PLEAT (CENTER) · · · · · · · ·

FRONT HIP POCKET STITCHED POCKET WELT POCKET

· PIPED POCKETS, DOUBLE PIPED (FAR LEFT), SINGLE PIPED (ELSEWHERE) ·

It is important to bear in mind that a well-conceived garment adapts itself to different postures. Pockets that are too small or badly placed, for example, are impractical, are costly to make and do not necessarily give originality to a piece of clothing.

KNITWEAR VARIATIONS 1: COLLAR VARIATIONS 2: ROUND COLLAR VARIATIONS, WAISTCOATS WITH OR WITHOUT SLEEVES 3: LENGTH VARIATIONS AROUND MOTIF, BUTTONS AND UPTURNED COLLAR.

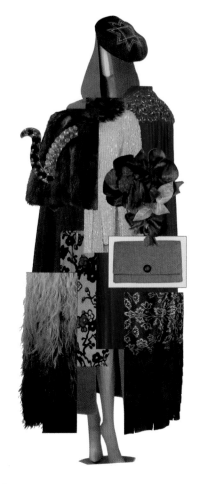

PRODUCTION ON A MANNEQUIN, DEMONSTRATING THE OVERALL FEEL OF THE FABRICS OF THE COLLECTION. THE SILHOUETTE, THE HARMONY AND PATTERN COLORS ARE IMMEDIATELY UNDERSTOOD.

SWEATER VARIATIONS AROUND A SQUARE NECKLINE WITH POLO TRIMMING AND DIFFERING SLEEVES.

LENGTH VARIATIONS AROUND A WAISTCOAT FASTENING, RIBBED FINISH USING STRAPS, ON A CARDIGAN WITH OR WITHOUT SLEEVES.

The compilation of ideas is essentially an exploration of developments of different pieces of the collection using different finishes and original details. And from this, only the best propositions will be kept.

This research can be developed by garment (i.e. skirt, dress, trousers, jacket), by fabric or by pattern. The same pattern, for example, can be diversely interpreted using different techniques such as embroidery, patchwork, hand painting or fabric printing.

The pattern research we have presented on pp. 74–79, which shows the development of a flower motif, offers an example of this type of investigation. We have chosen to illustrate this stage by pulling out a few pages from the sketchbook of the young designer Lutz (already mentioned on pp. 28–29).

The tools for this research can be very varied and don't only include sketches. On the opposite page you will see a presentation mannequin covered in fabric swatches and floral motifs, showing an original form of compilation.

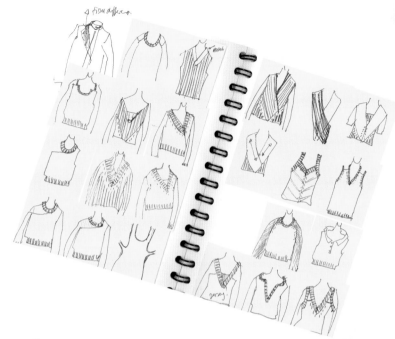

RESEARCH OF SWEATER SHAPES, NECKLINES AND SLEEVES WITH RIBBED FINISHES.

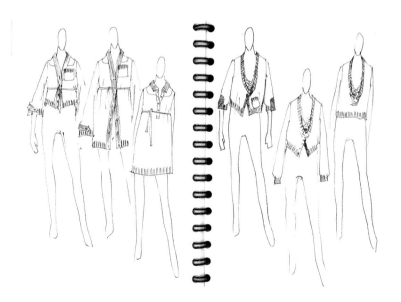

CARDIGAN, LONG WAISTCOAT AND DRESS WITH RIBBED FINISHES AND TIES UNDER THE BUST.

Lutz, Spring-Summer collection
Interview with Martine Adrien

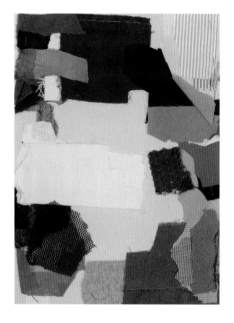

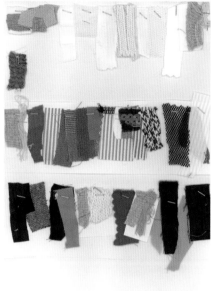

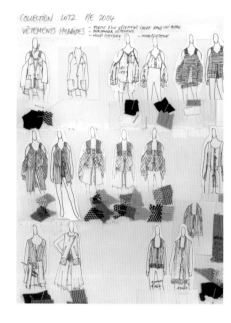

FABRIC CHOICES FOR THE SEASON.

FABRIC SELECTION FOR THE ITEMS IN THE COLLECTION, COORDINATED BY COLOR HARMONIES AND PRODUCTS.

COLLECTION PLAN OF "HYBRID" CLOTHING WITH STRAPS, SHOWING SEVERAL VARIATIONS WITH CORRESPONDING FABRICS.

The collection plan is a very detailed representation of the entire collection, categorized by garment. It must include:
• fashion show items, "look" and accessories
• trademark items destined for the press
• retail outlet items
• items destined for international clients, categorized by country and world region

The complexity of the above means the designer must establish a particularly rigorous plan for the collection.

Fashion show organization

The collection plan lists the items that have to be replicated for the fashion show by color and by fabric, and this in turn allows a work plan to be established prior to the manufacture of the pieces. It is a question of finding a balance between color and fabric in order to define the look presented by each theme (see Chapter 6, p. 173).

The collection plan is also indispensable for the organization of the appearances on the catwalk and it is normally pinned to the wall during the show. It is here that the items are coordinated with the accessories the model must wear during the presentation, and a photograph captures the desired look (see Chapter 6, p. 183).

Merchandising

The merchandiser plans the season in relation to the results of past seasons and boutique demands. In fact, an item can differ within the same brand, depending on the country or world region. For example, for a product such as a dress, clients from

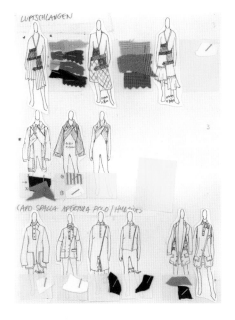

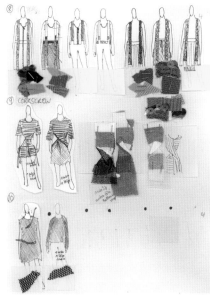

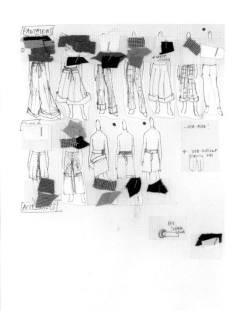

Line 1: Variations on a skirt.
Line 2: Variations on "trench" shirts.
Line 3: Variations on "hybrid" polos.

Line 1: Variations on a pinafore dress with a trompe l'oeil effect.
Line 2: Oversize tee shirt with ribbed effect.
Line 3: Variations on tee shirt with crisscross effect.

Collection plan for trousers and skirts, with fabrics.

Japan or the Asian Pacific region may prefer smaller, less fitted dresses, those from the United States may prefer more dressy ones, and European clients tend to choose printed ones.

It is the merchandiser who decides on the products that are essential for sales and coordinates them into the collection plan. Moreover, he or she dictates to the designers the important looks and accessories adapted to the target market.

Collection coordinator Martine Adrien recalls her experience with Robert Forrest, Ungaro's merchandiser from 1995 to 2000:

The merchandiser works with a team of designers. After reviewing the results of market research studies, varied and adapted products are required in order to maximize the company's profits. Therefore, a combination of diverse "mix and match" items is put forward. Different tops (blouses, sweaters, tank tops, etc.) will be matched with different bottoms (skirts, trousers) in coordinating fabrics; for example, Bermuda shorts, trousers and a skirt will be proposed for the same top.

Regarding different body shapes, the products' proportions will need to be reconsidered for certain markets, as with that of Japan, which can lead to a complete reinterpretation of the collection's initial plans.

Consumer habits also need to be taken into account. Japanese and American consumers are more keen on branding (designer clothing), whereas the English prefer vintage as well as branding.

In the textile world, it is hard to address color without taking into account whether the fabric is to be dyed or printed. The nature of the fabric and the yarn used play an all-important role in the production of the colors. The luminosity of the fiber, for example – shiny in the case of silk and matte in that of linen – will considerably alter the appearance of a given color, depending on the fabric used.

As with fabrics, colors are affected by trends, changing ways of life and technological progress within the textile industry.

Determining a color range and organizing the fabric swatches in correlation with the themes chosen for a collection involves using a selection of yarns and fabrics proposed by manufacturers. Today, advanced technology within the fabric indus-

try allows manufacturers to respond easily to the demands of fashion designers. However, this is not always without constraints, and the minimum quantities imposed for fabrics or original colors can pose high costs for many fashion companies.

Apart from knowing essential technical aspects of how a fabric is manufactured (such as understanding the nature of the fibers from which it is made, the type of thread torsion, or the differing techniques used for fabric making – i.e. woven or not, in the case of knitwear or felt), it is important to know manufacturing cycles and to present to the professionals the raw materials from which the product is made, in order to determine a modus operandi.

The yearly plan for a fashion designer is also governed by two very important periods, February–March and September,

when the large textile fairs such as Premiere Vision, Expofil, le Cuir in Paris and Texworld take place. This is where the fabrics intended for the collection or for the products in the diffusion lines are selected.

This selection will have an effect, ultimately, on the composition of the color range, which needs to correlate with the fabric swatches. Conversely, it is not unusual to propose the color range first, which, in turn, will direct the final choice of fabrics. This can reduce constraints right from the beginning of the creative process.

The pattern idea, textile printing and creation of the fabrics for a fabric manufacturer, or for specific products in a studio, is the job of the colorist and the model maker. In the studio, they will be able to imagine the original patterns for a collection or for particular accessory lines, in the approximate color ranges supplied according to the particular print or weave to be used.

In this chapter, some fundamental notions are explained concerning the use of color in fashion. By way of example, a selection of fabrics relating to different garments are described, as are the methods of pattern development and textile design. It serves as an introduction to this subject, as the techniques of textile design require a much deeper understanding of fabrics in general, which cannot be summarized in just a few pages. However, fabrics are discussed in greater detail in a forthcoming *Studies in Fashion* book, *Fabrics and Trends*.

Colors

The use of color in the fashion world follows the same basic rules as it does in the graphic arts. For the theoretical aspects, we refer to the color treatise* defined by Johannes Itten, who was a professor at the Bauhaus between 1919 and 1923. It was he who defined the 12 sections of the color wheel, and he is equally known for his description of the principal color contrasts.

Colors used in fashion are, however, very specific. They are different to those used in furnishing. A beautiful color range in fashion is appropriate to the garment it is intended for. For example, pastel colors tend to be associated with lingerie and baby clothes; darker colors with winter; bright colors with summer and children; metallic and shiny colors with evening wear; and fluorescent colors with sport. This very simplified classification of color by product is still pertinent today.

Certain colors are so distinctive that they themselves become the label's identity – for example, Lanvin's blue or Hermès' orange.

PALETTE

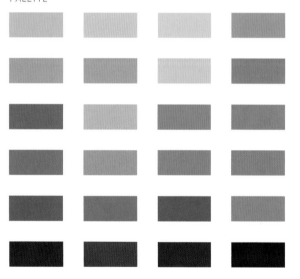

HARMONY

*Art and colour', *published in 1961*

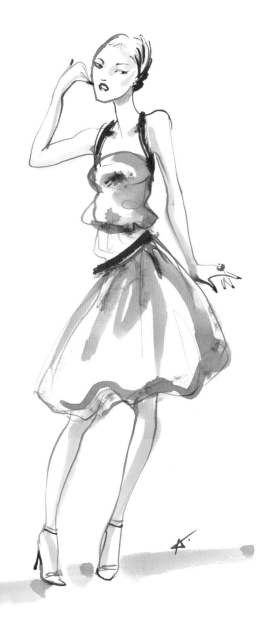

COLORWAY

PANTONE® REFERENCES
PANTONE® Cashmere blue – 14-4115 TPX
PANTONE® Leek green – 15-0628 TPX
PANTONE® Khaki – 16-0726 TPX
PANTONE® Amphora – 17-1319 TPX
PANTONE® Grape shake – 18-2109 TPX
PANTONE® Real teal – 18-4018 TPX
PANTONE® Potent purple – 19-2520 TPX

The palette

To define the colors of a collection or range, it can be helpful to choose an image or photo that is linked to the proposed theme and to extract as many colors as possible. This will then serve as the starting point for the "palette." The choice of the "mood" visual is very important, as the chosen colors will determine the next season's trends.

Furthermore, the visuals and selected colors must correspond to the fabric of the intended garment. For example, the color palette is much richer for printed garments and knitwear than it is for coats and suits.

The palette organizes the colors into "families" from light to dark: saturated (pure) colors, bright, acid, fluorescent, shiny, metallic, neutral, dark, light, pastel, grays and so on. They can also define the shades of all the tones between two colors (e.g., the shades of orange are found between yellow and magenta), color gradation (by adding white to make lighter or, black to make darker). The shades and gradations are most often used in printing.

On these and the following pages, we present two different palettes, a fall one and a summer one. If several color palettes are proposed for the same collection, it is essential that they are radically different in order to justify their use.

The colorway

From the palette, the designer selects the colors intended for the collection, classifying them from light to dark. This constitutes what is termed the "colorway." It is important that this range stays as true to the original reference image or photo as possible.

The stylist must be careful not to choose similar colors that will compete with each other. A well-balanced range will contain shades of yellow, magenta and cyan, these being the three primary colors which, with the aid of white and black, recreate all the colors perceptible to the human eye.

Note that the color ranges intended for printing are clearly broader, to allow for more freedom and richness in the coloring of the motif.

COLORWAY

PANTONE® REFERENCES
PANTONE® PALE KHAKI – 15-1216 TPX
PANTONE® NATURAL – 16-1310 TPX
PANTONE® APRICOT – 15-1153 TPX
PANTONE® MULBERRY – 17-3014 TPX
PANTONE® BEETROOT PURPLE – 18-2143 TPX
PANTONE® CANYON ROSE – 17-1520 TPX
PANTONE® APRICOT BRANDY – 17-1540 TPX
PANTONE® PLUM WINE – 18-1411 TPX
PANTONE® LAGOON – 16-5418 TPX

The harmonies

From the color range, the designer decides on the color harmonies that will be used within the collection. These can be constructed by determining the color balance between the colors themselves, and the proportions in which they are found in the different garments.

HARMONY

PALETTE

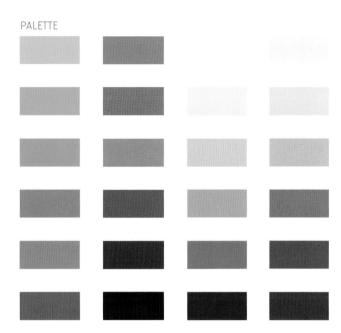

Color organization

The designer can use different media to produce the palettes, colorways and harmonies: ink, gouache, watercolor, markers for the quick "roughs," and of course graphic software.

To avoid any eventual error of color interpretation, color charts exist that are specifically aimed at professional graphic, fashion and interior designers. These classify and list the shades that correspond to particular fields (textile, for example), thus ensuring a true color reproduction.

Finally, for the ranges and harmonies, it can be interesting to use fabric samples to provide the desired color. It is the luminosity of Lurex, the matte quality of linen, the sheen of silk, the depth of wool that assist in compiling a color range.

Fibers

Understanding fabrics, and therefore the fibers from which they originate, is essential to the realization of a collection. Fibers can be of natural origin (animal in the case of wool, and vegetable in that of cotton, linen and hemp) or chemical origin (such as viscose, rayon and polyester).

They have their own particular characteristics, which determine specific applications. Linen and cotton, for example, are more likely to be used in Spring-Summer collections where lightness is important, whereas wool, with its thermal qualities, would be more appropriately used in Fall-Winter collections. Synthetic fabrics, with their strength and heat-regulating qualities, are suited to activewear such as parkas and ski clothing, whereas spandex, which is stretchy and comfortable, is found in lingerie, dance wear and swimsuits.

The yarns made from these fibers differ depending on the diameter and type of twist. These are multiple-thread assemblies that are used in a variety of ways, such as sewing, lacquering, felting, bonding and so on, depending on which fabric is being made.

Cloths and weaves

The weaving of yarns is carried out according to different processes known as "weaves," which vary depending on the fiber's origin. The three principal weaves are plain or canvas weave (straight weave), used for cotton poplin in shirts; twill weave (diagonal weave), which is used in the manufacture of gabardine for raincoats and trousers; and finally, satin or sateen weave, derived from twill weave, which works as well with silk as it does with cotton. (It is often used for cotton moleskin in certain military-style jackets.)

Knitwear and nonwoven fabrics

In addition to weaving or "yarn-dyed" fabric there is knitwear, which consists of "cut-and-sew" and knitted fabrics (see Chapter 1, p. 50). Industrially knitted yarn on a roll, like cloth (called "warp and weft"), is destined for cut-and-sew garments such as soft sweatshirt materials and jersey fabrics used in tee shirts, dresses or trousers. Knitwear made by a system of stitch gauges, which decrease at the sleeves and collars, with ribbed trimmings on the edges and cuffs, give the finished product a "hand-knitted" feel.

Finally, there are "nonwoven" fabrics that are neither yarn-dyed nor knitted, such as the felt used for the underside of suit collars and, more and more, for clothing accessories and decoration.

To illustrate these ideas, we present a selection of fabrics, by garment type, corresponding to current fashions.

France remains very competitive for the manufacture of the fabrics known as "breathable," such as poplin, silk (Lyon) and embroidered fabrics, notably lace (Calais), as well as for embellishing fabrics by washing and dyeing. Most of the time, however, these fabrics are made elsewhere.

Suppliers of other types of fabrics are spread out around the world. Germany specializes in felt and loden, Switzerland in fine cottons, embroidery and certain laces, Scotland in tweed and Italy produces all sorts of fabrics!

Professional fabric fairs such as Première Vision in Paris and New York, Tissu Premier in Lilles and the Italian fairs are a must for young designers. These provide the opportunity to meet suppliers, and serve as an indispensable source of information about new products and the latest innovative technologies in the textile industry.

Skirts

Fabrics are chosen in relation to the style: stretch jean material or stretch satin for a straight skirt, and cotton poplin or printed silk for a petticoat.

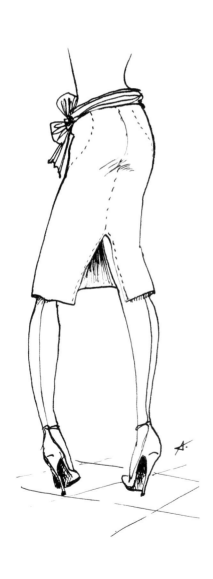

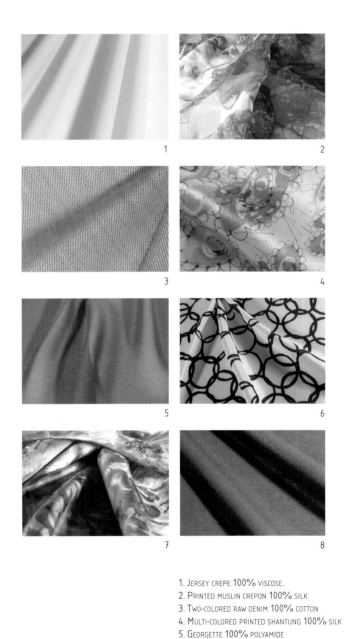

1. Jersey crepe 100% viscose.
2. Printed muslin crepon 100% silk
3. Two-colored raw denim 100% cotton
4. Multi-colored printed shantung 100% silk
5. Georgette 100% polyamide
6. Two-colored printed crepe de chine 100% silk
7. Printed satin Jacquard 100% silk
8. Woolen crepe 100% wool

Dresses

Fabrics are chosen in relation to the cut and style of the dress. Flowing jersey or voile are used for daywear, with satin, lace or taffeta for cocktail dresses or evening wear.

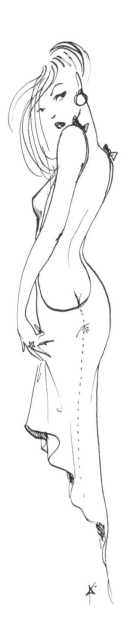

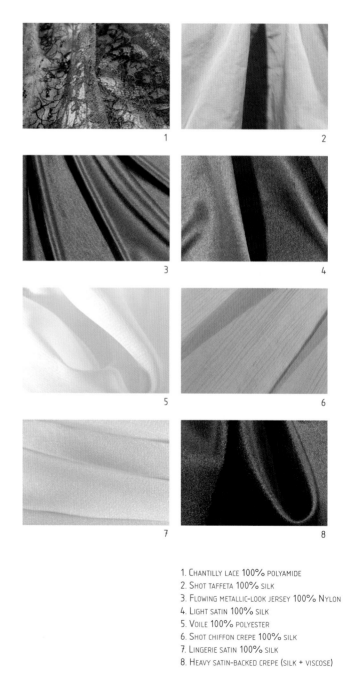

1. Chantilly lace 100% polyamide
2. Shot taffeta 100% silk
3. Flowing metallic-look jersey 100% Nylon
4. Light satin 100% silk
5. Voile 100% polyester
6. Shot chiffon crepe 100% silk
7. Lingerie satin 100% silk
8. Heavy satin-backed crepe (silk + viscose)

Trousers

Fashion favors jeans, however, the more classic trousers are cut from masculine fabrics such as striped wool or woolen poplin *fil-à-fil* (yarn on yarn, where a white thread is interwoven with a colored one). Casual trousers are made from military gabardine or soft jersey.

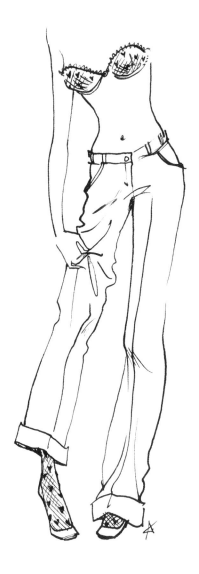

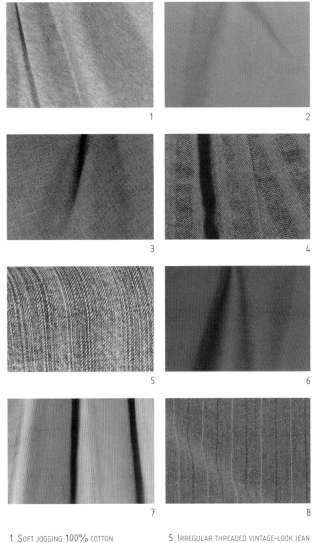

1. SOFT JOGGING 100% COTTON
2. GABARDINE CHINOS 100% COTTON
3. CREPE DE CHINE OR WARP-DYED GRAY DOUBLE CRPE (WOOL + POLYAMIDE)
4. TWO-COLORED SHADED STRIPES (53% PAPER + 47% WOOL)
5. IRREGULAR THREADED VINTAGE-LOOK JEAN MATERIAL 100% COTTON
6. MILITARY-STYLE CANVAS CLOTH 100% COTTON
7. FINE VELVET CORDUROY 100% COTTON
8. DOUBLE-STRIPED MASCULINE CREPE 100% WOOL

Jackets

The fabrics most frequently used for jackets are those inspired by military wardrobes, or sophisticated fabrics such as velvet or satin.

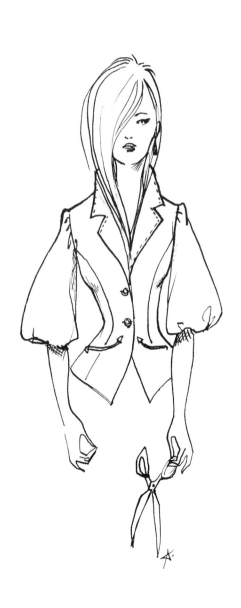

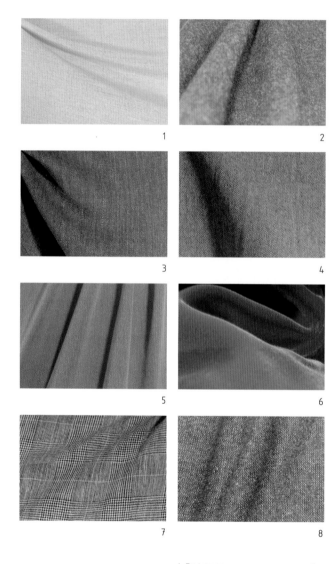

1. FIL-À-FIL OR YARN-ON-YARN SHANTUNG (LINEN + SILK)
2. FLANNEL 100% WOOL
3. MIXED CREPE (WOOL + POLYAMIDE)
4. SMALL HERRINGBONE WITH VINTAGE LOOK (LINEN + COTTON)
5. CLOUDY POPLIN (COTTON + POLYAMIDE + SPANDEX)
6. VINTAGE-LOOK VELVET (SILK + VISCOSE)
7. PRINCE OF WALES CHECK 100% LINEN
8. TWEED (COTTON + WOOL + SPANDEX)

Coats

Coat material is inspired by traditionally masculine fabrics such as tweed or woolen cloth, or those which exude luxury and warmth, such as fur or cashmere.

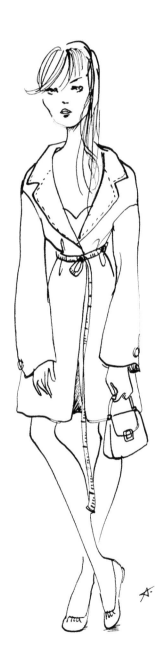

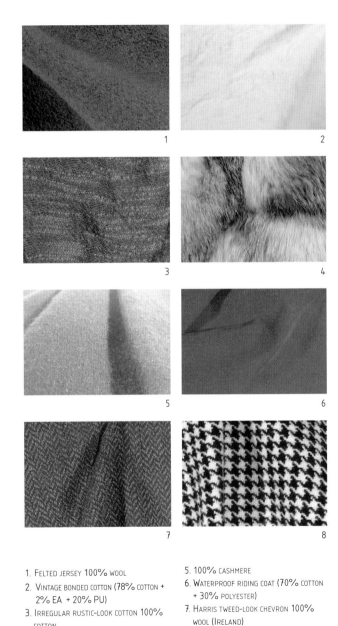

1. FELTED JERSEY 100% WOOL
2. VINTAGE BONDED COTTON (78% COTTON + 2% EA + 20% PU)
3. IRREGULAR RUSTIC-LOOK COTTON 100% COTTON
4. RABBIT FUR
5. 100% CASHMERE
6. WATERPROOF RIDING COAT (70% COTTON + 30% POLYESTER)
7. HARRIS TWEED-LOOK CHEVRON 100% WOOL (IRELAND)
8. HOUNDSTOOTH CHECK 100% WOOL

Tee shirts

Cotton jersey is the original tee-shirt material. Nowadays, comfort and lightness are sought, as well as sophistication. These are found in synthetically mixed fabrics such as cotton jersey and spandex, or silk jersey and polyamide.

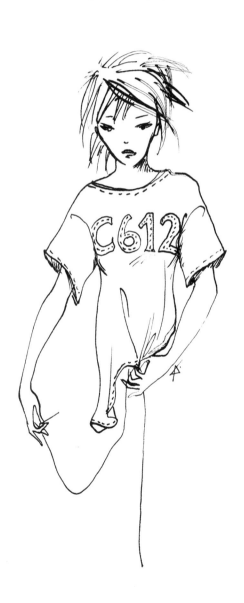

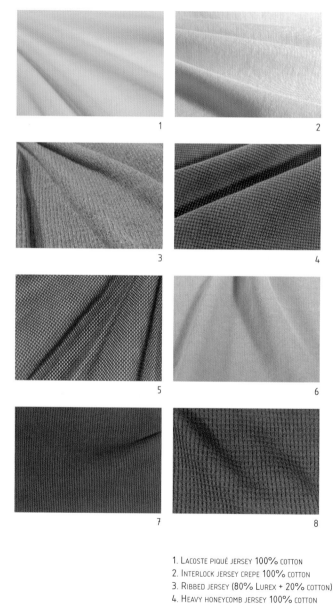

1. Lacoste piqué jersey 100% cotton
2. Interlock jersey crepe 100% cotton
3. Ribbed jersey (80% Lurex + 20% cotton)
4. Heavy honeycomb jersey 100% cotton
5. Fishnet 100% polyamide
6. Single jersey (spandex + cotton)
7. 1 x 1 Rib jersey 100% cotton
8. Honeycomb jersey (80% silk + 20% cotton)

Shirts and blouses

Fabrics selected for shirts tend to be classic, such as cotton poplin, and are often mixed with spandex. The preferred fabrics are light, and even include transparent materials such as muslin and voile.

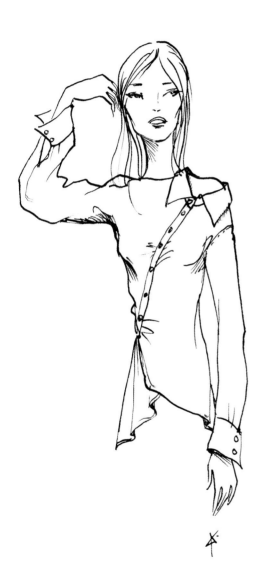

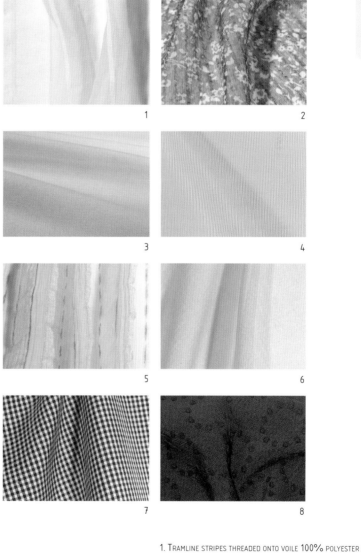

1. TRAMLINE STRIPES THREADED ONTO VOILE 100% POLYESTER
2. PRINTED GEORGETTE 100% POLYESTER
3. ORGANDY WITH GAUZE LOOK 100% COTTON
4. STITCHED COTTON 100% COTTON
5. IRREGULAR THREADED CREPON 100% COTTON
6. MUSLIN WITH IRIDESCENT-LOOK 100% POLYESTER
7. CHECKED GINGHAM 100% SILK
8. SWISS MUSLIN WITH POLKA DOTS 100% COTTON

What we understand by "motif" is the graphic interpretation of an inspiration element, used individually ("placed" motif) or in an organized composition (known as "repetition" or "repeat motif"). In the case of a repeat motif, this composition is continually duplicated to cover the whole surface of the fabric – this is referred to as "printed." The allover motif such as the regular dot, which is duplicated in both directions on the fabric, is distinguished from the "repeat" motif, which is only reproduced in one direction – as with the figurative elements of a *toile de Jouy* or with stripes. (Striped motifs are known as "bayadere stripes" when they are horizontal and perpendicular to the selvage of the fabric, and "Peking stripes" when they are vertical.)

A motif is chosen in relation to the collection's theme and will be the object of diverse developments within the range. Moreover, print can be the central focus of a range, as in the case of Louis Vuitton's line of accessories, which were designed by the Japanese artist Takashi Murakami.

Several factors define the motif, such as its graphics, colors and chosen background, and the manufacturing techniques used. The interpretation of the inspirational element can be abstract or figurative. If your image source is a flower, as in our examples, you could work along the lines of Andy Warhol's graphics, which would in turn create a pop-art print. For a more romantic print, a visit to the florist could aid inspiration.

STRAIGHT REPEAT

BRICK REPEAT

CHESSBOARD REPEAT

Design of textile motifs

To create a motif a scaled maquette and a sketch, showing its position on the garment, will be necessary. Maquettes are made by the textile designer, in gouache, as created by Sonia Delauney for Chanel and other fashion designers, or with the aid of CAD (computer-aided design) software. The technical processes are described at the end of this chapter. After digitization, in the case of a gouache or acrylic maquette, the designs are mechanically reproduced on the fabrics according to different printing techniques which are explained in the following pages.

To be precise a motif design, as well as a printed maquette, is termed a "textile design".

Several maquettes of a textile design with an allover floral motif are presented on these two pages, accompanied by an outline showing the two types of possible organization or "repeat" of the motif: straight, and half drop or brick repeat (the chessboard being just one variation of a straight repeat).

Note that the mock-up of an allover

motif varies depending on how the motif is used in the textile design (motif may face in different directions, as portrayed in the illustration on p. 77). All the variations of the motif must be taken into account before its duplication. The number of colors used must also be considered, as the multiplication of these implies a different repeat.

Square-shaped scarves can use the mirror technique, where duplication is done by constructing a motif in just a quarter of the piece.

Silk-screen printing

Screen printing is the most common method of printing allover motifs in large quantities. This is done by the yard or meter on fabrics to be used in accessory lines (scarves), home products (tablecloths) and clothes (tee shirts, blouses and so on).

In this technique, originating from traditional techniques, the motif is printed using an inked-up mesh screen upon which a stencil is placed. Areas are masked off or left open depending on the pattern. The screen was originally made of silk (hence the name) stretched over a wooden frame. Today the screens are made from synthetic gauze and the frames from metal. The colors are pulled through the mesh using a squeegee, with a different screen used for each colorway. This "false" four-color printing technique gives good-quality results and allows for large repeats. The recent inkjet cylinder technique, where the colors are all injected at the same time, does not work well for large repeats and is of inferior quality.

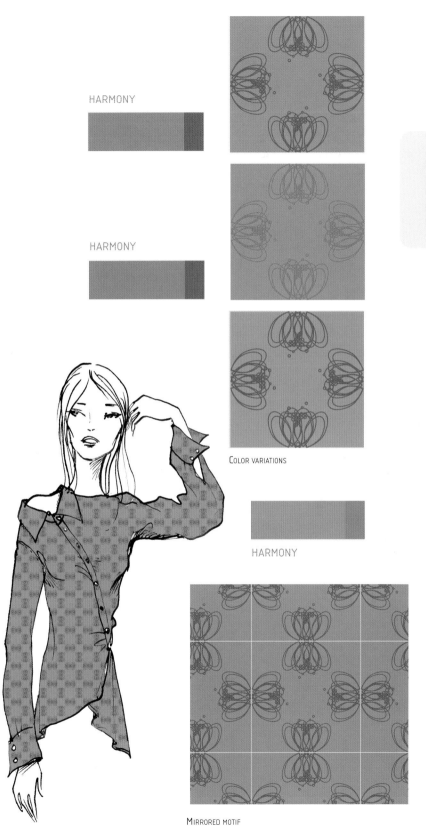

HARMONY

HARMONY

COLOR VARIATIONS

HARMONY

MIRRORED MOTIF

The size, color and frequency of the motif's repetition define the different categories of printing. The Liberty print patterns, for example, are easily distinguishable with their carpet of little flowers, and larger ones used on wallpapers. There are also "placed" flowers and figurative ones, or, contrarily, stylized and abstracted ones; those of a baroque style which use the fleur-de-lis in complex compositions; the pointillist effect of Monet's water lilies; and the glimmering of Klimt's flowers. There are an infinite number of floral motifs that can be reconstructed by researching artistic and historical references.

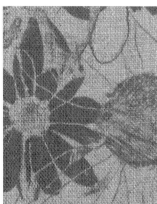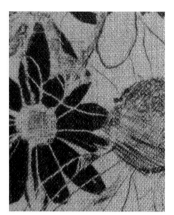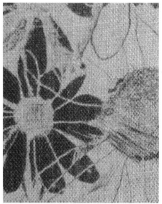

COLOR VARIATIONS OF A FLORAL MOTIF USING SILK-SCREEN PRINTING ON RAW LINEN. THE COLOR TREATMENT IS REMINISCENT OF ANDY WARHOL'S FAMOUS PRINTS. THE OBVIOUS WEFT OF THE FABRIC ADDS TO THE TEXTILE DESIGN.

Variation of motif size

Houndstooth check, its larger version and twill fabric squares that have been slightly stretched diagonally are all good examples of the effect of altering the motif size. As with these jacquard motifs, such variations make it possible to create allover patterns.

On the next page you will see two different treatments of the same allover floral-printed motif. Used on a small scale it is reminiscent of a traditional Japanese kimono, whereas when exaggerated, it acquires a pop-art look.

Choice of background fabric

The choice of background is very important as it determines the style and execution of the print and base color. The motifs and colors will appear very differently depending on the background's texture and base color and whether it is shiny or matte.

As a general rule of thumb, white backgrounds are recommended for most prints because they enable the exact reproduction of the pattern and chosen colors. Cotton poplin, for example, offers an opaque and smooth background due to its close weave, allowing for a sharp motif outline with clearly defined colors.

On the other hand, a raw linen cloth, showing the natural color of the fiber, modifies the printed colors' tones (this must be taken into account during their preparation) and will render the motif matte in appearance. Moreover, on this type of absorbent and rough cloth, it is difficult to achieve sharp definition, and it is therefore inadvisable to choose a very detailed motif. The weft, however, can give some interesting effects.

TEXTILE DESIGN SHOWING ALLOVER PATTERN WITH A BRICK REPEAT. IN ORDER TO CREATE ANOTHER APPLICATION FOR THIS DESIGN, THE STENCIL OF A FLAT GARMENT WAS CUT OUT AND PLACED ONTO THE PRINT. TO OBTAIN A TRUE VISUAL — IN THIS CASE OF A SMALL POP-ART PRINT KIMONO DRESS — IT IS NECESSARY TO MAKE A NEW MAQUETTE, DRAWN TO SCALE AND DELINEATED BY THE PENCIL MARKS, OF THE PRINT WITH MUCH LARGER MOTIFS.

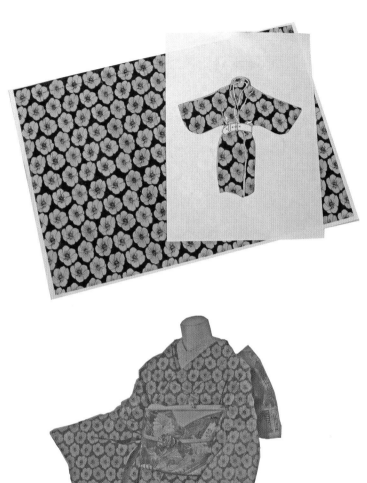

In the case of a chiffon, the transparent texture of the fabric gives a diaphanous look to the colors which, due to refraction, become faded as the light makes them less opaque.

On these three different types of background fabric, the printing of the same motif with the same colors will give a completely different results.

Color combinations and variations

A color variation can be obtained by modifying the background color without changing that of the motif, or by the reverse (i.e. by changing the color of the motif and not the background), or by a combination of the two. In the case of the motif that is initially red on a blue background, there are several possibilities. Those include a red motif on a green background, green motif on a blue background, and blue motif on a green background.

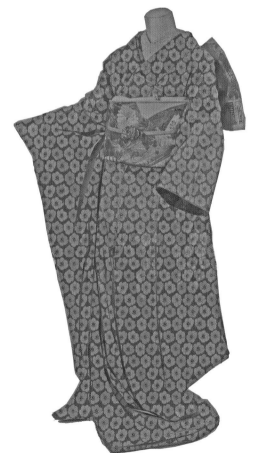

A FINISHED, SCALED MAQUETTE. THIS KIMONO SHOWS A COLOR VARIATION USING SOMBER TONES, WHICH GIVES THE PRINT A RATHER AUSTERE LOOK.

When a single motif is used on a garment, it can be applied by embroidery, patchwork, printing or transfer. The frieze pattern is a type of placed motif, running lengthwise or along the width of the fabric, thus distinguishing itself from the allover pattern. Examples of this are when motifs embellish the bottom of a garment, such as a dress or trousers, and when jacquard patterns are used in bands on knitted jumpers. To this end, it is necessary to differentiate between the jacquard motif, which is made at the same time as the weaving or the knitting of the garment, and the printed motif on a neutral background, which is applied subsequently using different techniques.

FRIEZE PATTERN

Heat transfers

This four-color reproduction technique is used for placed motifs within textile design as well as for photography. This only really works if the base color of the fabric is light and neutral (e.g. beige, white, ecru or natural) and is particularly suitable for polyesters and polyester cottons.

This system is used for pieces that include photographic images. In these cases, specialist printers lay out banks of images that have been pre-printed onto transfer paper coated with a special colorant. These papers are then placed onto the fabric and, using a combination of heat and pressure, the color and motif are transferred.

Transfers are also used for individual motifs made from other materials such as sequins or glass which are glued

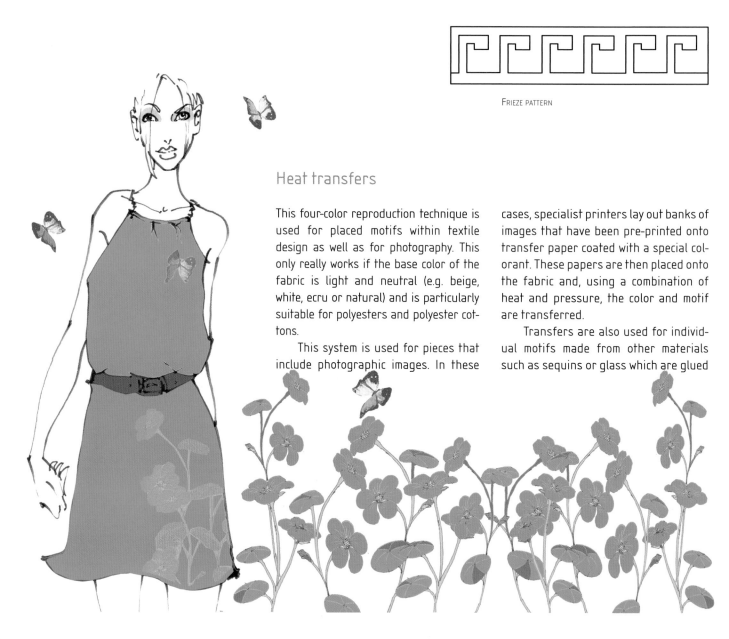

VISUAL INSPIRATION

1

2

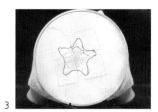

3

4

1. COMPUTER DRAWING
2. THE MOTIF IS REPRODUCED IN WASHABLE FELT PEN ONTO A COTTON CLOTH (THE FELT PEN OUTLINES WILL GRADUALLY DISAPPEAR AS THE EMBROIDERY STITCHES APPEAR). WHEN ONE WORKS WITH A NEEDLE, AS ILLUSTRATED HERE, THE CLOTH IS STRETCHED OVER A HOOP.

3. AND 4. THE MOTIF IS WORKED USING RUNNING STITCH AND EMBROIDERY COTTON. THE USE OF COLORED THREADS AND A VARIETY OF STITCHES GIVES A RICHER RESULT.

NEEDLEPOINT EXAMPLE BEING WORKED WHERE THE OUTLINES OF THE WASHABLE FELT PEN ARE STILL NOTICEABLE. THE FLOWER IS EMBROIDERED USING A FLAT RUNNING STITCH, WITH THE EDGES FINISHED IN CHAIN STITCH.

directly onto the fabric using heat. Many fabrics can be used, including satin and cotton jersey tee-shirt material. Printing onto a dark background requires a transfer technique using a white background and is described below.

Heat transfers on a white background

It is possible to print satisfactorily onto a dark fabric using the heat-transfer technique, provided a white background has previously been applied to the surface that is to be printed. This method is used mainly with sportswear and street wear where logos, numbers and emblems are important.

Flocking

Flocking is a printing technique that has become very popular today with the growth of public interest in team sports

such as football and soccer. Because of the relief and texture it gives to the printed motif, and the contrast with the printed background, this technique lends itself to sports and street wear such as swim suits, tee shirts, hats and bags, whether they are knitted or made from jersey material.

The "flock" motif, from which the technique derives its name, is most often a plain color. The technique involves printing a glue onto the fabric and projecting minute textile fibers onto it.

For the public, flocking is normally limited to a slogan, name or number, whereas for professionals, the choice is much larger and includes floral motifs velvet-flocked onto silk or polyester chiffon, or onto taffeta or woolen cloth.

Embroidery

There is a distinction between hand and machine embroidery. Nowadays the manual technique is used for original placed

motifs made from thread, such as monograms. These embroidered motifs can be more, or less, in relief according to the type of thread used (e.g., cotton, silk, viscose, metallic thread). The degree of complexity of the motifs depends on the skill of the embroiderer, who can include other materials such as ribbon, lace or pearls.

This type of work is normally reserved for haute couture, originating from top specialists in the field such as Maison Lesage.

Industrial techniques allow for greater production of badges, logos and motifs using a variety of complex threads and colors. However, the experience and skill of a master embroiderer, with his or her sharpness of eye and manual precision, remain inimitable.

The embroiderer establishes a descriptive list for each embroidered motif indicating the method of execution, the needle or crochet hook, and the type of stitch and threads to be used (even mentioning the number of strands for each thread!).

Before making a maquette of a textile design, the type of motif must be considered, i.e., whether it is an allover or a placed motif. For an allover motif, you must know the size of your printing screen, which, in turn, will determine that of your maquette: it must be a multiple of the latter so that the duplicated motifs will line up accordingly. A placed motif will be larger or smaller depending on its position on the garment. The type of repeat pattern must also be taken into account, i.e., straight or brick repeat. Finally, the maquette needs to be to scale.

These considerations are necessary whichever technique is employed. Our example here involves a color preparation stage. We recommend using acrylics, as opposed to gouache, because they dry quickly and result in a clean and sharp finish.

Place your color range and visuals on the workbench.

Begin by mixing the darkest color and working toward the lightest. Here, for example, mix the blue and the red together to produce violet, and then add the white to lighten the color, or add the black to darken it.

Dip a strip of paper into the color and compare it with your color reference chart. As gouache tends to lighten on drying, your color must therefore be slightly darker than your color reference.

Create your own colors by using the three primary colors, magenta, yellow and cyan, then adding white and black. Commercial secondary colors, which are the result of mixes with varying proportions depending on the manufacturer, can in fact prevent the desired color from being obtained.

Note: To benefit from the most neutral light, work in the daylight in front of a north-facing window when using colors.

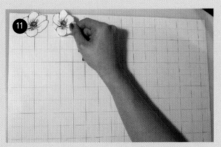

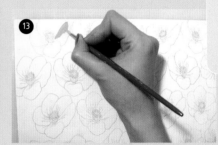

To make a square piece, such as a scarf, you can use the mirror system, which consists of placing your maquette opposite two mirrors that have been placed at 90 degrees to each other. This allows you to work on a quarter of the design while visualizing the whole.

The drawing of the motif can be done by hand or by using CAD (computer-aided design) software. If, like here, you work by hand, use a medium-hard HB pencil to trace sharp outlines. Once the motif has been finalized, make several photocopies enlarged to the desired size (according to the envisaged textile design) with a sufficient number of copies to make your design combination.

Trace a grid in pencil onto either graph paper or tracing paper, or use a computer. Place the motif copies onto the grid in relation to the chosen repeat (straight or brick).

So that the motif sits comfortably in the space, you can play with either the size of the motif or that of the grid. A small motif that has been placed onto a large grid will look lost, while too large a motif placed onto a tight grid will look too busy. To make a successful textile design, the ideal situation is to balance the full areas with the spaces.

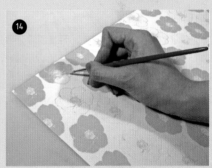

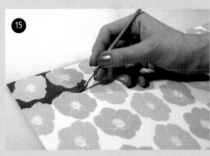

The design of a centered motif is then created, as with this rose and its mirror reflection.

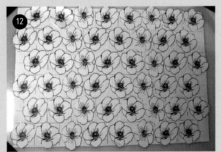

The placing of the motif is finished. Fix your motif copies onto the grid with glue or double-sided tape before placing the work onto a light box. Cover it with tracing paper and trace off the motifs' outlines using a light pencil line. This will give you a design that is ready to be colored in.

Apply your colors onto the maquette, placing them next to each other without overlapping them. Even with acrylic, overlapping is not advisable as it will alter the opacity, tonality and luminosity of the colors. It is for this reason that the background must be white. With gouache, superimposing is totally inadvisable as the colors will mix together.

These step-by-step instructions are for a Windows computer, however, if using a Mac, the apple key or command replaces the control key. Here we describe the stages required for an allover motif, using a mirror pattern initially, then a straight or brick repeat.

In Illustrator, open the file of the motif that is to be duplicated, and display the grid so that the motif can be correctly positioned. Then select the motif with all its corresponding elements. Using the Selection tool, trace a rectangle around the entire motif. Group these elements together using the Group command in the Object menu (or Ctrl + G). In the Tool palette, select the rectangular icon. Click on the workspace and move the mouse, holding the button down while pressing the Shift key to obtain a square.

Select the square and the motif, then, with the aid of the Align palette (menu Window — Align) place the motif at the top of the square, centering it widthways using the horizontally centered Align icon and Distribute icon.

To create a single object, select the square and motif again and combine them by simultaneously pressing the Ctrl and G keys.

To duplicate this object, select the grouped object and click and slide it, while simultaneously pressing the Alt (or Ctrl + V) key. Repeat this operation to create four sets. Select the first set and pivot it 90 degrees (menu Object — Transform — Rotate). Select the second set and pivot it 180 degrees. Select the third set and, this time, pivot it 270 degrees. The fourth set stays in the same place. This will give you the result shown in Fig. 7.

Select the four sets. In the Align window, select the following options: centrally vertical Align and centrally horizontal Align. This will give you the result shown in Fig. 8. Select the four sets again and select the Ungroup command in the Object menu in order to divide them into groups. Then select three of the four squares and delete them using the Delete key so that only the outline of the initial square is visible.

Select the square and begin by inverting the outline and fill properties by clicking on the small black arrow in the Tool palette. The color properties are symbolized by two squares, one representing the line, the other the fill color. The red diagonal line that appears in the color square indicates that, for the moment, no color has been selected. To add a background color, double-click on the fill key. A color selector appears. Choose the desired color and click OK. You have now set up the base motif.

Select the set and press the Shift and G keys simultaneously to create a single object. Select this object and duplicate it until you create nine of them. Using the grid, position them in such a way that a new square is created containing nine objects. The finished motif is created.

Select the object, click on it and drag it to the edge while simultaneously pressing the Shift key. This will position it in line with the previous one. Then press the Alt key to copy it. When the mouse button is released, the object will be repositioned and copied at the same time. Select the four successive objects and position them so they line up at regular intervals on the grid.

Divide the 16 objects by selecting them and simultaneously pressing the Ctrl, Shift and G keys (or select Ungroup in the Object menu). Select the squares and give them a background color as explained on the opposite page under Fig. 9. The maquette of a straight repeat pattern for an allover motif is now finished.

To make the next version of the motif, redo stages 1 to 3, followed by mirroring the motif. Once you have made your square, center the motif within it.

Select the set of four objects and drag them while simultaneously pressing the Alt key (this will duplicate them) and the Shift key (this will align the two rows) as before. Repeat the operation to obtain four lines of four objects, then, using the grid, place them at regular intervals to create a new square containing 16 objects.

To do this, select the square and the motif using the Align palette. Select the square and the motif again and regroup them using the Ctrl and G keys.

It is possible to experiment with other repeat patterns such as chessboard or brick repeat. To achieve a chessboard pattern as seen here, just select the elements to be removed and delete them by pressing the Delete key on the keyboard. To achieve a brick repeat pattern, select the elements of one row and displace them using either the mouse or the arrows on the keyboard while pressing the Shift key to keep the alignment.

The term "concept," while somewhat overused does, however, evoke a precise notion. It is the representation, according to the "eyes of the spirit," of a form, an idea or a sensation. Coupled with intuition, it is the starting point for the creative process. "Intuition without concept is blind and concept without intuition is empty." We owe this affirmation to the German philosopher Immanuel Kant (1724–1804), whose writings are essential reading for anybody concerned with aesthetics and who is known most notably perhaps for his work *Observations on the Feeling of the Beautiful and Sublime*. This quotation can be applied to all the domains of art and thinking, and consequently to the fashion world and its creative processes.

Thus, concept is upstream of "conception" as we understand it in the fashion milieu (in the developmental sense), which is the result – just as manufacture is the last stage of the creation of a garment.

Although there are numerous methods of creation, as we show here, used equally in architecture and the visual arts, they are all founded on the definition of a concept or creation principle. The general idea of the collection and its theme conform to the idea, image and concept that come from the creator or designer.

In the fashion world, the concept is the synthesis (as Immanuel Kant suggests for all the arts in general). That is why, in this book, the Concept chapter comes after Colors and Fabrics but before Visual Presentation. A theme, or an image, evokes certain colors and textures that, in turn, correspond to precise fabrics and accessories. For example, the idea "British Amazon" could suggest horse riding, and therefore leather and tweed with knee-high boots. A line stemming from this concept could include jodhpurs (as in Hitchcock's film *Marnie*), but also elegant dresses for women who ride side saddle (as Scarlett O'Hara does in *Gone with the Wind*). These two types of women are united by the same concept.

Without a solid concept, no visual representation can be properly understood. The concept is one of the requisites for good communication of ideas and information between the

designer and the merchandiser, but also between designers and their numerous collaborators. From this point of view, looking at the fashion industry from every angle, concept is, in itself, a strategy.

According to the definition given in the dictionary, strategy is "the art of advancing an army onto a theater of operations up to the point where it comes in contact with the enemy." This definition can equally suit advertising, where one speaks of advertising "campaigns" using the analogy of military campaigns, although in this case, the conquest is one of an offensive by seduction! Replacing the term "army" with "team" or "design studio," and the term "enemy" with "public" (for it is the public who need to be conquered by pleasing or surprising, as well as by anticipating their expectations), a creative strategy can be put in place for a brand or fashion house. For example, the different stages of the conceptual approach — combination of ideas, reflections and intuitive actions — can be compared to those of a military operation. In the context of a collection's conception, this will consist of transforming images

— sources of inspiration — into fabrics, colors, forms and styles in order to create a complete universe. Still likening this to a military exercise, the strategists will use every means possible to design and develop the brand.

In this chapter we break the concept down into two parts, that of the development of the concept, and that of the drawing up of the collection. The first concentrates on the conceptual creative process, while the second deals with the research of shapes and lines, through to sketches and 3D presentation, and the tools necessary for this.

Concept also encompasses the previously presented product. The variations in the complete product line, in view of satisfying clients and anticipating their demands, are in fact planned in the concept, and it is these proposed products that define the brand's image. However, the concept can also be derived from a particular garment and its feel — loose (dress, blouse), fitted (jacket, suit), structured or unstructured. In every case, the process is conducted in stages, continually redefining the product in relation to its target — the client.

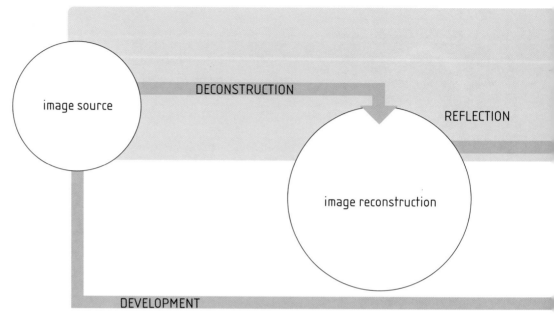

THIS DIAGRAM SHOWS THE OPERATIONAL DEVELOPMENT OF THE CONCEPT.

Stage 1

This is the research phase. The first step is to gather together the inspirational elements needed. In the chosen example, after having analyzed three "elements" – a flower (the pansy), a gladiator's peplum and his armor – we have loosely interpreted them to see how they might overlap. The image source is then deconstructed into abstract representations of the three constituent elements.

Stage 2

The second stage is to analyze the elements in their initial state: in our example we have picked up on the crumpled appearance of the flower, with its transparent petals and curved outline. From the peplum, we have taken the blousy and feminine aspects found in the folds, and from the gladiator, we have derived strength and rigor from the belt. The designer confronts these characteristics at the concept stage, then organizes them, choosing the theme that will translate his or her ideas the best. This stage defines the objectives and the direction that the whole studio will take for the season.

The designer then develops the theme using original details to give an identity to his or her creations, as in our example, e.g., large folds, pleats, drapes, blousy and crumpled look, binding, etc.

The designer defines the silhouettes by researching shapes (in this case, lightweight garments: blousy dresses, puff ball skirts) and superimposing volumes and fabrics, creating the color palette (here, bolds and neutrals), and selecting the fabrics (here, light floating ones: crepe, satin worked into gathered details, voiles and so on).

Stage 3

The third stage is the synthesis of this work process, the variation of the collection (i.e., deciding on the products – in this case, a dress and tunic), and the creation of the products' environment: boutiques, the type of event, organization of commercial showrooms, choice of models, their hairstyles and makeup, choice of photographer and setting, and so on.

The entire ensemble of these elements affirms the brand's identity.

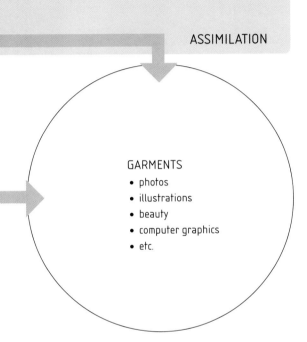

STUDIES

CONTROLS
- organization
- commercial viability
- level of innovation
- conveying of message
- originality

ASSIMILATION

GARMENTS
- photos
- illustrations
- beauty
- computer graphics
- etc.

commerciality

coherence
image control

innovation
creativity

Creation and commercialization

The prism above indicates the three points of development for the concept: creation, image and marketing. It demonstrates the balance that must be established between them in order to commercialize an innovative product that has its own identity.

However, a collection can be oriented in relation to the results of the preceding collections and the public's response. For example, if the design and image were well received last season, the next season could be directed toward a more commercial approach.

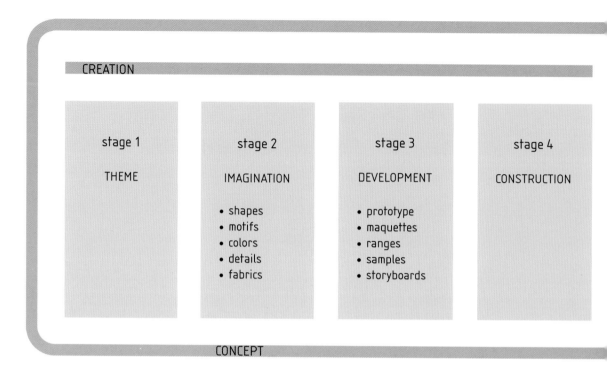

CREATION

stage 1	stage 2	stage 3	stage 4
THEME	IMAGINATION	DEVELOPMENT	CONSTRUCTION
	• shapes • motifs • colors • details • fabrics	• prototype • maquettes • ranges • samples • storyboards	

CONCEPT

The concept

The concept is the basis of the work, as it defines the direction of a collection. It determines the transformation and fusion of the various inspirational materials derived from historical, ethnological and sociological sources, or drawn from nature. The example shown in the following pages uses a cocoon as the concept. It is inspired by the same visuals as those used for the theme, i.e., the flower, the peplum and gladiator armor. However, this does not always have to be the case.

Stage 1 – Theme

The theme evolves with the seasons. There can be one, or several, in a collection. The theme is directly influenced by the concept. For example, the original concept of

Issey Miyake's pleats was derived from architecture. These have been reinterpreted in successive collections using different themes with bright and acid colors.

Paco Rabanne's concept, "space," is illustrated through the use of non-textile materials, such as metal derived from the technology world. As previously mentioned, the theme we have chosen is that of a flower combined with a peplum and gladiator armor.

Stage 2 – Conception and research

The theme is broken into subthemes, or variations, that allow shapes, colors, motifs, details and fabrics to be imagined. Each subtheme comes from the

original starting point or the general idea of the main theme. The first subtheme in our example is that of "Ode to a Rose," with generous, supple and fluid volumes in bright colors. The second is "The Valkyries," featuring wide belts and more neutral tones and the third is "The Romantic Warrior," which unifies the whole idea and illustrates the concept of "cocoon" through its shapes.

Stage 3 – Development

This is the developmental stage of the preceding research. After researching the shapes of the products, the *toiliste*, or pattern cutter, submits a prototype sample to the designer (see Chapter 5, p. 140 onward). The textile designer

IMAGE

stage 5

PRESENTATION

- photographs
- illustrations
- animations
- visuals
- sounds/music

INFORMATION AND KNOWLEDGE

- history
- folklore
- arts
- sociology
- nature
- etc.

THIS DIAGRAM ILLUSTRATES THE PROCESSES REQUIRED TO
PRODUCE A COLLECTION, FROM THE GIVEN CONCEPT AND ITS
CONCEPTUAL STAGES THROUGH TO ITS PRESENTATION.

creates the textile design maquettes (see Chapter 3, pp. 74–83). The designer then chooses the color range (see Chapter 3, pp. 62–65). The samples are then made up by the pattern cutter. Finally, the person in charge of fabrics makes a selection based on the garments that are to be produced.

Stage 4 – Collection plan

This fourth stage is the gathering together of all the elements obtained in Stage 3, in order to produce the collection. The products are fitted into the collection plan (see Chapter 1, pp. 58–59). The merchandiser plans the season and determines the look, the necessary accessories and brand for the designers.

Stage 5 – Promotion

The promotional phase is initiated right at the beginning of the collection's conception. The artistic director is the principal player in this. He or she decides what characteristics of the presentation (see Chapter 6) are intended for the press and clients, and directs the entire team.

He or she chooses the photographers, directors and public relations agencies so as to create a publicity image, and organizes the press packs aimed at the media, i.e., magazines, television and advertising.

The artistic director will also instruct an illustrator to draw the season's silhouettes and present them in a press pack for fashion editors, photo stylists from the media, and film or music companies, in order to attract magazine editorials and television and film opportunities.

Eventually, he or she will ask an animator to produce special effects intended for the brand's website, for the presentation, or for the boutiques. Finally, he or she will instruct a music researcher to choose the soundtrack music for the fashion show, which can eventually be used in the boutiques and showrooms.

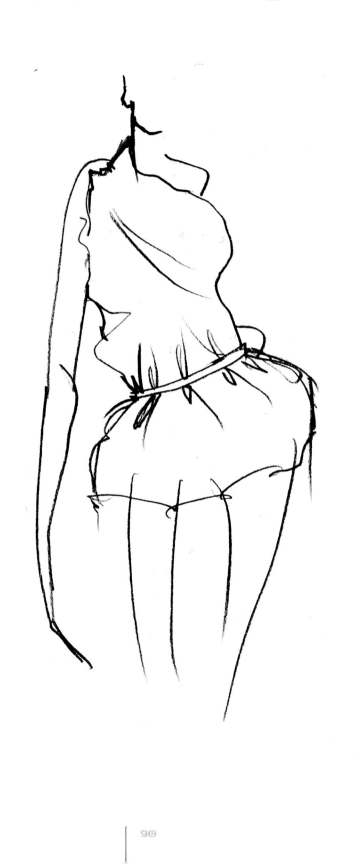

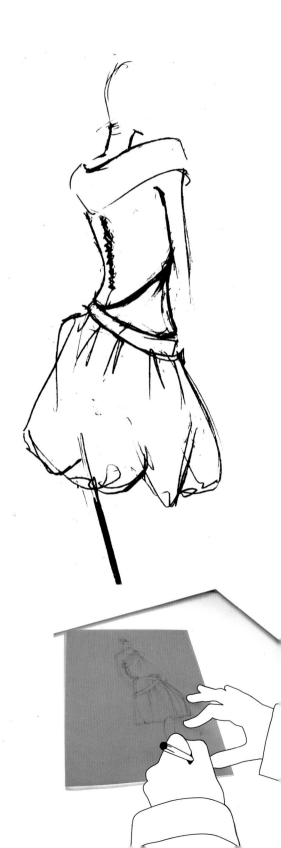

Inspired by the unity of the research surrounding the flower, the designer develops the idea further using a series of sketches that correspond to its shapes and volumes, with referrence to the fabric selection made for the season.

Traditionally, the flower suggests femininity, just as the dress is perceived as being the archetypal feminine garment. These associations are at the core of the example that we show here. The historical theme of antiquity and the peplum relates to the flower through the use of drapes, overlays of fabric, deep folds and pleats, transparent areas that contrast with opaque ones, and tonal nuances. The belt of the gladiator's armor, with its crude appearance, balances the product by reinforcing the lines, and tempering and directing them. The coming together of all these inspirational elements as a unit determines the silhouettes, making for ample and voluminous shapes.

The flower is interpreted in a very graphic style corresponding to the general design of the project. While sketching, the designer must keep in mind the inspirational "unit" as he or she creates the collection, and not venture too far away from it. The silhouettes are drawn up, balancing and harmonizing volume and lengths, as the collection starts to take shape.

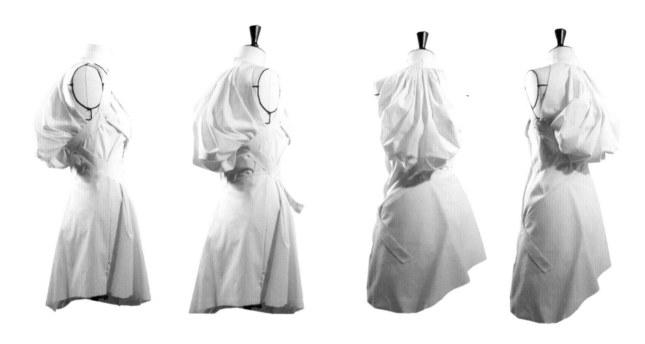

Alongside the sketches, the designer uses a tailor's dummy, also known as a dress form, to imagine his or her idea in three dimensions. The papier-mâché dummy or mannequin provides two essential reference points: the vertical axis, which is placed in the center front or grain line of the dummy; and the horizontal axis, perpendicular to the first, which is fixed at the waist.

The fall of the fabric

Shape research consists of exploring the fall of a fabric on a dummy with the help of the reference points. The fabric itself has a vertical direction known as a length, which refers to the lengthwise or straight grain line of the fabric, parallel to the selvage. The length varies depending on the chosen garment, whereas the width of the roll is fixed (for example, at 30–54 inches for silk and 58 inches plus for cotton and wool). The lines traced widthways, which are perpendicular to the grain line, are called the crosswise grains. All of these give balance to the garment.

The bias is the diagonal of the fabric (45 degrees to the selvage and the cross grain) (see Chapter 6, p. 150–151). When fabric is cut on the bias, it allows for more flowing shapes and a more subtle fabric fall. This particular technique was used a lot in the 1930s when making drapes and pleats.

Draping the fabric

The grain and direction of the fabric can be played with. By using a series of pivoting and sliding systems the designer or *toiliste* can reduce the volume of the drapes using tucks, pleats and gathers in the narrow areas of the body, such as the waist.

The same process can be used to exaggerate the volume and warp the silhouette. The result of this draping is known as the *toile*. This is a trial garment, made from calico or muslin and used to test pattern and fit that can be adjusted before making the pattern (see the section regarding "draping" in Chapter 5, pp. 150–157).

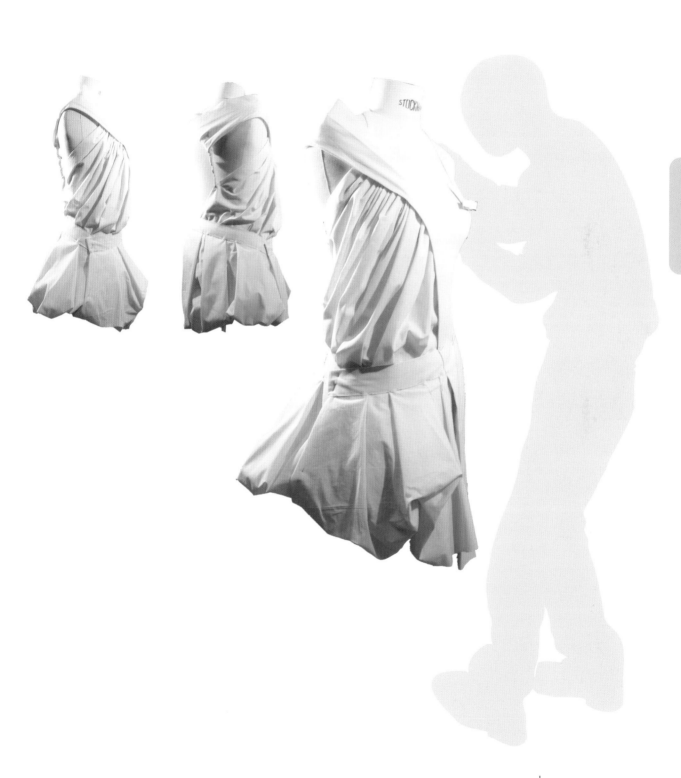

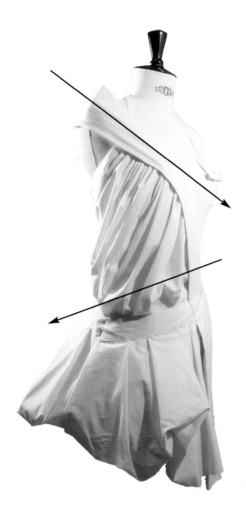

When working with asymmetrical shapes, it is advisable to visualize guidelines in order to harmonize the volumes and balance the whole. The eye naturally perceives balance and imbalance. Two diagonal lines following the same direction will be interpreted by our eye as falling. To re-establish symmetry, a line in the opposite direction will give the effect of balancing the garment.

In order to understand the notion of symmetry in fashion terms, imagine a series of matchboxes piled up on top of one another to form a vertical column. If you open one of the drawers, the building could become unbalanced and fall down. On the other hand, if you simultaneously push two of the drawers in opposing directions, it will remain balanced.

The human form follows the same laws of gravity. When we start to move our legs, the pelvis becomes lop-sided, making the spinal column move sideways. At the same time, the shoulder axis counteracts this imbalance by leaning in the opposite direction to that of the pelvis axis. Dance, in fact, is the art of mastering the body by balancing these movements in a sequence of harmonized poses. In the fashion world, asymmetrical creations require an understanding of symmetry and the balancing of volumes in the right proportions.

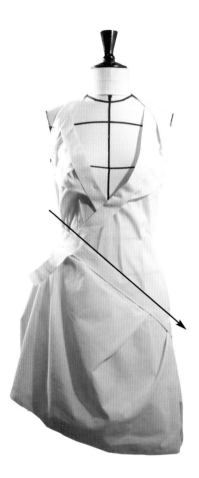

THE VOLUME OF THE BASE GIVES THE IMPRESSION OF AN OVER-SIZE SKIRT, WHICH IS FINE IN THIS EXAMPLE, AS IT SITS NATURALLY ON A SIMPLE TUNIC: A HAPPY ACCIDENT.

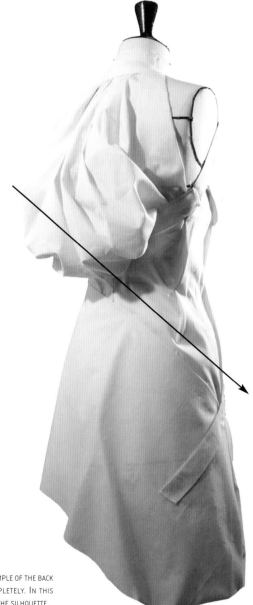

AN OVER-EXAGGERATED VOLUME, AS IN THIS EXAMPLE OF THE BACK OF THE DRESS, CONTORTS THE BODY LINE COMPLETELY. IN THIS CASE IT IS ADVISABLE TO MINIMIZE THE REST OF THE SILHOUETTE.

Valkyrie theme

COLORWAY

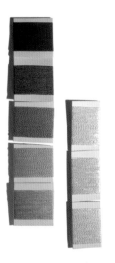

FABRICS

ISEULT
WIDE DRESS HELD BY SHOULDER STRAP, BILLOWING AT THE WAIST
WITH ATTACHED "FALLING" BELTS. HIDDEN SIDE FASTENING.

The fashion illustration is different to that of the silhouette (see Chapter 1, pp. 32–35 and Chapter 5, p. 148–149). The silhouette shows the volumes, shapes and lengths of the collection, whereas the illustration shows the products or garments. The illustration is integrated into the conceptual process as a logical progression after the stages of shape research, sketch and three-dimensional work on the mannequin. It represents a maturing stage in the development of the idea for the collection.

The fashion illustration is the result of great consideration and cannot be reduced to a generic drawing. It must, therefore, have its own individual identity in depicting an aspect of the world conceived by the designer. Even badly executed, an illustration with a strong identity will be far more interesting than the correct and well-proportioned examples seen in some rigid sketches! Nevertheless, it is very important to understand the proportions of the human body before trying to exaggerate them.

COSIMA

SLIGHTLY FLARED STRAP DRESS WITH AN INVERTED PLEAT IN THE FRONT AND ASYMMETRICAL BIAS-CUT YOKE ON THE CHEST. SKIRT WITH INLAID BELTS AND FLARED HEMLINE. HIDDEN FASTENING IN THE CENTER OF THE BACK.

Characteristics

The modeler (the person who makes the *toile*, or trial version of the garment) uses the illustration as a model for the proposed product. The illustration serves as a method of communication between the designer and the modeler. It carries a name (or number) and is accompanied by a legend describing the garment. It is then presented along with the corresponding fabric samples or swatches.

The technique used, i.e., the type of drawing tool, is generally decided by the designer based on the product. For example, the fabric for a soft sweater could be expressed by using pastels, whereas that of a gabardine raincoat would require a sharper line, possibly using a felt-tip pen. The style of graphics can be set by a company in its method plan.

It is not necessary to add color to the illustration immediately, as the colors may be altered if the materials chosen for the prototype are not suitable.

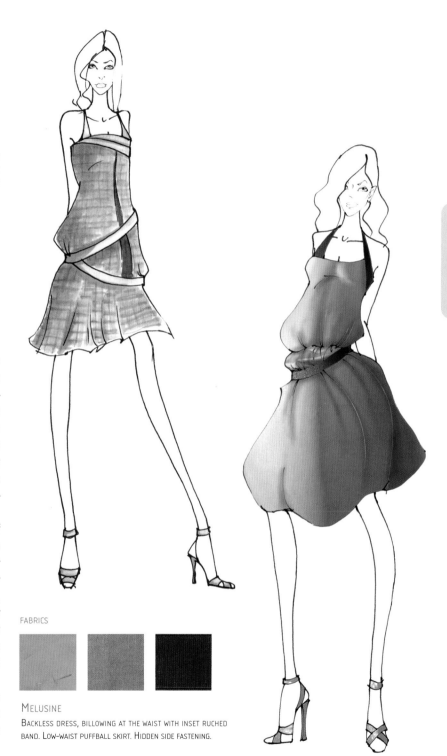

FABRICS

MELUSINE

BACKLESS DRESS, BILLOWING AT THE WAIST WITH INSET RUCHED BAND. LOW-WAIST PUFFBALL SKIRT. HIDDEN SIDE FASTENING.

CHAPTER 3
Concept

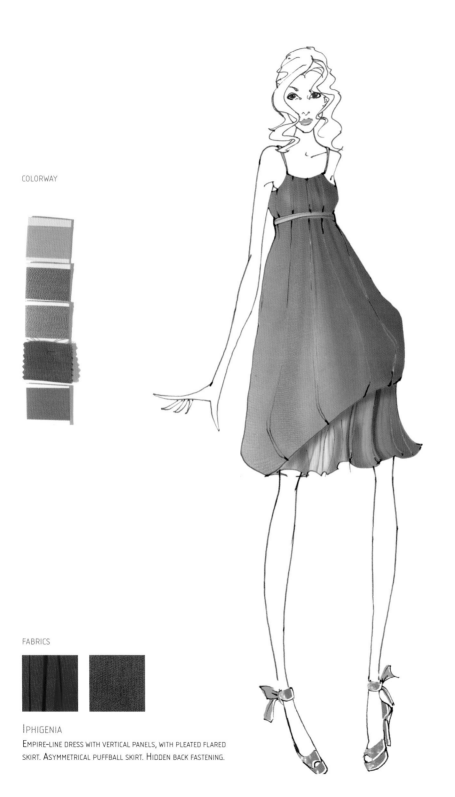

COLORWAY

FABRICS

IPHIGENIA
EMPIRE-LINE DRESS WITH VERTICAL PANELS, WITH PLEATED FLARED
SKIRT. ASYMMETRICAL PUFFBALL SKIRT. HIDDEN BACK FASTENING.

Graphic standards

The line of the illustration needs to be
detailed and precise. Every element of
the garment, such as the front, must be
easy to understand and all the pieces
that it consists of must be included, i.e.,
the side, sleeves, neckline, pleats, folds,
yokes, cuffs, etc. Even the seams should
be detailed, showing the precise manner
in which they are to be assembled, such
as flat, lapped or top-stitched on one
another.

Romantic warrior theme

If the lines in the product are symmetrical, they will need to be reproduced as accurately as possible in the drawing. For example, if the angle of a neckline or collar (which is normally the symmetrical part) is not represented as symmetrical in the illustration, but is instead leaning left or right, the *toiliste* may in turn make an error. It is therefore extremely important that the illustration is as true to the idea as possible, to avoid any erroneous interpretations concerning volumes, lengths or details, as this can hold up the production of a collection, as well as cause bad feeling within the team.

To facilitate the understanding of a drawing in the studio, it is advisable to leave the illustration in black and white. This also allows it to be scanned, after which the designer can use the computer to add fabric effects and render it in original and specific colors. The different techniques of achieving this are explained on the following pages.

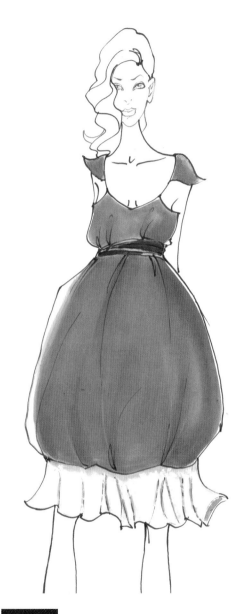

FABRICS

EUPHROSYNE

PUFFBALL COCKTAIL DRESS WITH FANCY STRAPS AND RIBBON WAIST-BAND ON A PLEATED FLARED SKIRT. HIDDEN BACK FASTENING.

Color rendering with a felt-tip pen

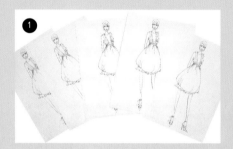

Photocopy the illustration several times so that a number of different fabric effects and color harmonies can be tested; this way if a mistake is made you can simply work from another copy.

Place the illustration onto a pad of rough paper to protect the table. This also allows the ink to be absorbed and avoids it "bleeding" outside the outline of the illustration.

Felt-tip or marker pens are essential tools for a designer as they allow rough sketches to be color rendered quickly. They can be used for the final presentation (fashion plates) in conjunction with other media, such as colored pencils, paintbrushes and pen and ink. Although simple, felt-tip pens can give a certain high quality to the work.

They exist in a wide range of colors, and shades can be obtained by mixing different colors together. Felt-tip pen manufacturers supply neutral tones (Pantones® Cool Gray and Warm Gray) for monochrome drawings, which are used to accentuate shadows. The markers are also equipped with interchangeable nibs in various shapes, e.g., wide, fine, round, square, angled, rigid and flexible, which allow for a variety and precise of lines.

The nibs are made from felt or fiber. The felt ones, being more durable, are used for quick color application and flat color rendering, whereas the fiber ones tend to be used for more detailed work.

Specific papers, such as layout paper, are compatible with marker inks as they do not allow the ink to come through the page or to "bleed" outside the outline of the illustration.

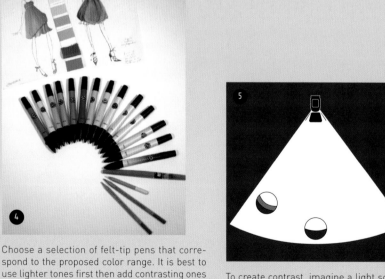

Choose a selection of felt-tip pens that correspond to the proposed color range. It is best to use lighter tones first then add contrasting ones later.

Watercolor pencils can also be used to emphasize the colors and accentuate the fabric effects.

To create contrast, imagine a light source coming from either the left or the right of the illustration, depending on shapes that are to be accentuated. An area of shadow and light is then achieved.

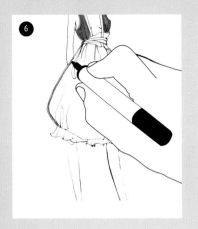

Fill in the colored areas of the dress, taking care not to go outside the outline of the illustration.

Use different colored pens for the hair tones. For the face, use a Pantone Blender and mix it with a skin-tone color to give it slight shadowing and texture. Then apply the makeup using watercolor pencil, which will give it a look of transparency, similar to cosmetics.

Color in the shaded areas. In the case of a thick fabric, accentuate the shadows with opaque colors. If, however, it is sheer, use transparent colors to enhance the idea of luminosity.

To accentuate shadows, apply several layers of marker ink, allowing it to dry between each layer, and for a particularly contrasting effect, use the complementary color.

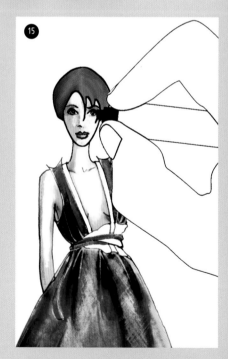

> To represent gold, silver and lamé, add white dots and stars.

Use watercolor pencils to emphasize the highlights of a fabric — white for light areas and somber colors for the folds and so on.

Use the same technique for the hair. The combination of marker pen and watercolor pencils gives a more interesting effect than if used separately.

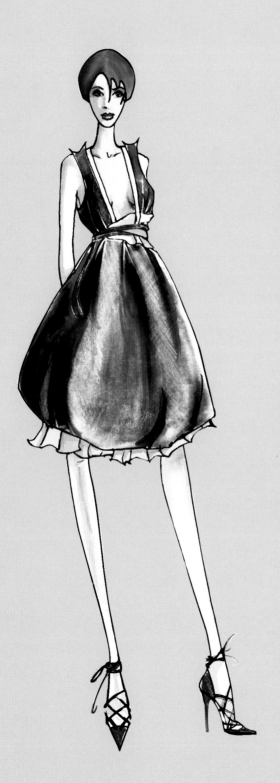

Romantic warrior theme

To accentuate a glimmering effect, use a fixative that allows the colors to fuse into one another. Once the fixative is dry, it is advisable to retrace the outline as it will have faded slightly.

FABRICS

PHRYNE
PUFFBALL COCKTAIL DRESS WITH PLUNGING SQUARE NECKLINE.
PLEATED GODET SKIRT UNDERNEATH ECHOING THE INLAID FABRIC
OF THE HIGH WAIST AND BELT. HIDDEN BACK FASTENING.

Layering and color rendering using Photoshop

Once the silhouette and the fabrics have been scanned, open them up in Photoshop.

The speed with which this computer work can be executed largely depends on the quality of the original drawing. It is important to make sure that the outlines of the garments are continuous lines without any gaps. This is not an absolute rule, but in this case it will greatly facilitate the project. Once all the checks are done, scan the drawing to a suitably high resolution. Here, the drawing has been scanned at 600 dpi. Scan the chosen fabrics onto the illustration using the same resolution. A high-resolution scan can even show the weave of fine fabrics.

The degree of tonality can be determined by using the Tolerance parameter. The greater the tolerance value, the greater the size of selected area. For example, 0 value is equivalent to an area of a few pixels, whereas a 100 value represents a much larger area.

Now use the Magic Wand tool, found in the Toolbox, to select the areas on the illustration where you wish to overlay the fabrics. This Magic Wand allows you to select areas of color that have the desired tones.

› A numeric image shows information about the resolution. This defines the degree of detail that will appear on the image. (The resolution is determined at the time it is numbered and when it is printed.) An image's resolution is defined by the number of pixels in relation to a unit of length. It is expressed in dpi (dots per inch).

Set the Tolerance parameter to 20, then select all the areas on the dress by clicking inside the outline. These areas will be highlighted, as is shown in the diagram to the left. To add another area to the selection, use the Shift key on the keyboard. A little + sign will appear. Note: if the selected area is clicked accidentally, it will become "deselected."

It is also possible, even recommended, to use the Zoom icon in the Toolbox to show up small areas that are not noticeable on a smaller scale: nothing else will be altered by doing this. You can then zoom in and out, as desired, then use the Magic Wand to complete the selection.

⑤

To be able to use it afterwards, save this selection by clicking on the Select menu and selecting Save Selection.

⑥

A dialog box will then appear. In the Name field, type in the title of this selection, then click on the OK button to confirm. Repeat this process of selecting and saving for the other parts of the garment.

To aid the rest of the process, take care to select the bottom, middle and top of the skirt. You will then have, in this example: the «dress» selections, «dress-bottom», «dress-middle», «dress-top» and «bands».

⑦ ⑧

Once this has been achieved, the fabrics can be imported into your document. This is a simple operation: just select the document containing the fabric, open it while the illustration document is open, then choose the Move icon in the Toolbox.

All that is necessary then, is to drag and drop the fabric image onto the illustration document.

⑨

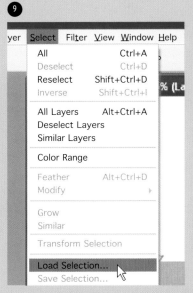

A new layer is created automatically. Reselect the previously saved dress selection and click the Invert box. (Figs. 9, 10, 11) This will have the effect of selecting everything that is outside of this area or zone. Then press the Remove (or Delete or Backspace) key to remove the fabric that is outside the dress outline (Fig.12)

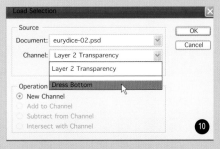

⑩ ⑪

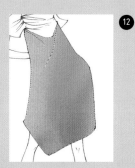

⑫

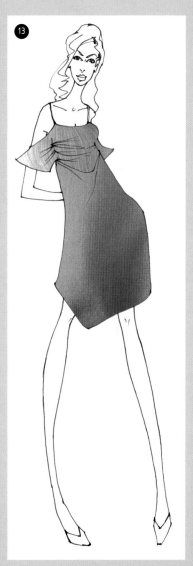

⑬

Repeat the same operation to overlay the bands of fabric as seen in Fig.13.

PAINTBRUSH TOOL

ERASER TOOL

GRADIENT TOOL

To develop the work further and give the illustration a bit of volume, make use of different tools such as the Gradient tool (for the color), Paintbrush and Eraser.

The first stage consists of giving general volume to the dress. Use the Gradient found in the Toolbox. On selecting this icon, a dialog box appears under the menu bar (Fig.15). Click on the button indicated by the mouse, and the Gradient window will open (Fig.16).

Using the different color and transparency settings (Fig.17) a personalized gradation can be created. The small cursors situated above the gradation bar control the transparency; the ones below, the color. An infinite number of cursors can be inserted, whether for color or transparency.

Shadow-01

Gradient Type: Solid

Smoothness: 100 %

New

Finally, it is important to safeguard the newly created gradation by naming it, then clicking on the New button to validate it (Fig.18).

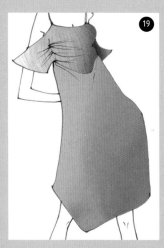

Once the gradation settings are saved, close the dialog box to return to the illustration. Before applying the gradation, you will need to create a new layer in which the previously saved dress selection will be found (Figs. 9 and 10). The gradation will only appear in the selected area. Click once with the tool to define the start of the gradation. The length and direction of the gradation can be established by moving the mouse. It is equally possible to start and finish on the inside as on the outside of the selected area in order to add shading. Having shaded the dress, the gradation of the dress bands can be added (Fig.19), following the same process and creating another layer to add the shadows.

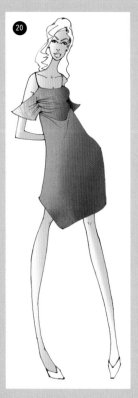

This same system can be used to apply gradation to the skin and hair colors and the accessories in your illustration, providing the following steps are taken:
1. Select the area on the illustration layer.
2. Create a new layer and apply the gradation to it.
3. Create a new layer for each new gradation, then, when satisfied with the result, fuse the different layers together to obtain one single layer. In the example shown here, there are seven different layers merged into one!

At the finishing stage, once everything is saved, the work can be refined by using the Paintbrush and Eraser tools to adjust the volume, if necessary. When using the Paintbrush, the ink flow settings can be defined (similar to using an airbrush), which means transparent color strokes can be corrected using the Eraser.

COLORWAY

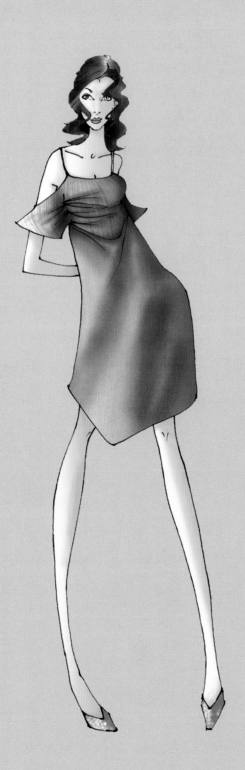

Ode to a rose
theme

FABRICS

EURYDICE
OFF-THE-SHOULDER, SHORT-SLEEVED DRESS HELD UP BY STRAPS.
SLIGHTLY FLARED WITH HIGH WAIST UNDER THE BUST. INVISIBLE
BACK FASTENING.

applying flat color using Photoshop

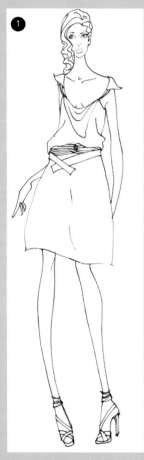

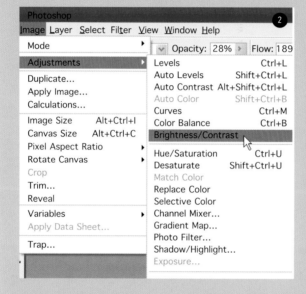

A quick, easy and frequently used way of giving life to a drawing is to apply color using the flat method. In the absence of a realistic effect, this technique provides a very good idea of the color harmonies used in the outfit.

Scan the illustration into Photoshop, taking care to adjust the contrast appropriately using the Brightness/Contrast function in the Image menu.

> The contrast of a drawing depends on the number of tones used between white and black. The stronger the contrast, the fewer gray tones. By increasing the contrast in your drawing, the rest of your work will be made easier.

To add color, the main task is to separate out the different areas that make up the garment as different layers. If they do not appear on the screen, they can be found in the Window menu, or by pressing the F7 key on the keyboard.

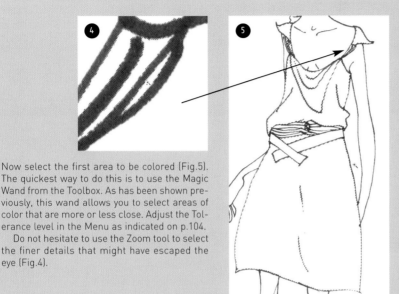

Now select the first area to be colored (Fig.5). The quickest way to do this is to use the Magic Wand from the Toolbox. As has been shown previously, this wand allows you to select areas of color that are more or less close. Adjust the Tolerance level in the Menu as indicated on p.104.

Do not hesitate to use the Zoom tool to select the finer details that might have escaped the eye (Fig.4).

Once a selection has been made, you will make a new layer onto which the color can be applied. Go to the Layer menu and click on the little arrow in the top right of the layer window (Figs. 6 and 7).

Name each of the layers, as this will help you quickly identify which elements correspond to which (Fig.7).

You can now proceed to the Color Picker. By using the Color Picker, misinterpretations can be avoided. However, there is also a difference between the color on the screen and that which is printed. Various factors determine this, such as the type of paper or ink used, printer quality and so on. We suggest using the Pantone® references — these are universally used colors, whichever the industry.

To choose a color, click on the foreground color in the Toolbox (Fig.8). The dialog box of the Color Picker will then appear (Fig.9).

The last stage consists of filling the selected area with your chosen color (on a new layer). To do this, click on the Fill button in the Edit menu (Fig.10).

Once the dialogue box in Fill appears, take care to select Foreground Color!

Choose a color from the palette, then click on the Color Libraries button. The Pantone® shade will appear with the color and reference of your choice.

Finally, the area has been filled with your chosen color (Fig.14). All that is left to do is to repeat the process for the remaining areas.

Following the same principle, it is possible to give the garment volume by creating shadows. This is done using the polygonal Lasso tool (Fig.15), and selecting the area that is to be filled with a darker or lighter color.

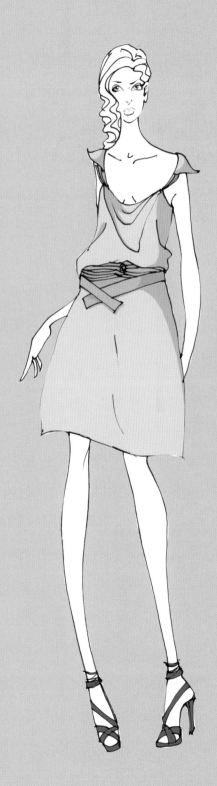

Ode to a rose
theme

FABRICS

HELENE
FANCY-STRAPPED DRESS, SLIGHTLY FLARED WITH A DRAPED
NECKLINE AND INLAID BELT. HIDDEN BACK FASTENING.

The merchandiser compiles a collection plan that is more commercial than the one intended for the press and industry professionals.

The design team complete or adapt certain items, and detail them in what is known as a style book.

In response to the demands of the textile industry or distributors, targeted catalogs are further developed by an independent style agency whose job, among others, is to determine the trend and its corresponding products. One of their services is to offer sourcing with forecasting studies. The proposed items will be used as they are, or reinterpreted by licensed partners.

In the case of licenses, the catalogs are developed by designers in licensing offices. Although they have a tendency to disappear, largely due to a fear that the brands will ultimately have more control over the image, their job is to finalize the coordination of the different collections and lines using the brand.

In this chapter we detail the content of these catalogs necessary for the manufacture, commercialization and distribution of fashion items, paying particular attention to the quality of their organization and presentation. We have taken the opportunity to explain how to compile a similar publication. It is very important that a young designer is capable of producing a style book, in the

Chapter 4 — Visual presentation

same way that he or she can create a curriculum vitae, as it will become a vital part of the project.

The books we present here have been inspired by those produced in studios that offer a series of coordinated products between them. A style book must contain all the information necessary to facilitate a good understanding of styling. This personalized and focused book must demonstrate your style, in general terms, to future work partners.

Thanks to computers, it is much easier today to compile a portfolio that enhances the value of a product line and its content. The visual impact of a catalog depends on two essential factors: firstly, a good arrangement of the outfits is required, i.e., overview, page layout and development; and secondly, specific graphic aspects, such as the selection of dominant colors, logo treatment and page setup.

This chapter explains how to develop an efficient house style and define a brand identity. The organization of the visual presentation must in fact demonstrate a coherence that fully relates to the concept.

This book lists all the costs incurred in a commercial collection by detailing all the products. It also contains technical and thematic information relating to these items, such as:

- the seasonal indications for the year (Spring-Summer or Fall-Winter);
- the themes depicted on the storyboards, which reveal the various sources of inspiration;
- the details of the product collection, which have been developed to identify the brand and season;
- the color ranges and harmonies, shown by theme and with each product item;
- the silhouettes, which establish the balance between the products and their proportions;

- the collection plan, organized by category (shirts, tops, dresses, jackets, trousers, etc.);
- the fashion illustrations, which propose the coordination of the products, accompanied by color swatches and fabric samples;
- the shapes on the dress form or tailor's dummy, which enable the modelers to interpret the designer's ideas as closely as possible; and
- precise directions regarding the manufacture of the items.

As we have seen in the introduction, this book has several uses. Not least, it serves as a very useful communication tool between the brand and the various manufacturers, as is outlined below.

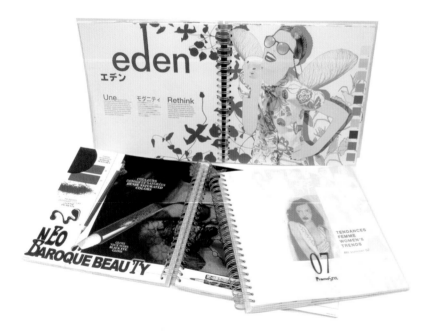

COVER AND INSIDE PAGES OF A PROMOSTYLE, SPRING-SUMMER 2007 — A WOMEN'S TREND BOOK. THE TITLE FEATURES ON THE COVER, AS DOES THE SEASON AND THE TARGET MARKET. THE DOUBLE THEME PAGE "EDEN" INCLUDES A SMALL PIECE OF PRESENTATION TEXT, AND A FASHION ILLUSTRATION SHOWING A PRINTED BLOUSE AND ITS COLOR RANGE. THE COSMETIC PAGE DESCRIBES A RANGE OF MAKEUP SUITABLE FOR THE COLOR THEME. YOU WILL NOTICE THAT THE COLOR RANGE USED FOR THE COSMETICS (POWDERS, LIPSTICKS, EYE SHADOWS) IS PRESENTED IN THE SAME MANNER AS THE FABRIC SAMPLES.

House brands

A prêt-à-porter brand uses different manufacturers, each with their own speciality, which make only one type of product: knitwear, dresses, suits or leather, for example. Here the information established by the design team will assist in understanding the collection in its entirety, enabling a coherence between the different lines and distribution sites.

Style books are particularly important when the brand uses delocalized manufacturers, particularly those in developing countries such as India or China. The company, in this instance, economizes on space and salaries, as there is no production studio to take into account. The prototypes are made by factory pattern cutters, then approved by a design team from the brand before being put into production. In this situation, the designer's professionalism is essential to the success of the brand.

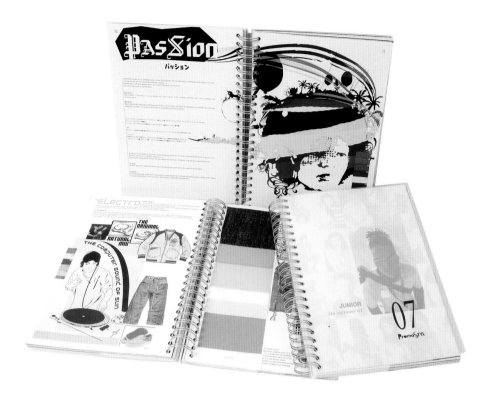

COVER AND INTERIOR PAGES OF THE JUNIOR PROMOSTYL SPRING-
SUMMER 2007 NOTEBOOK. ABOVE: A DOUBLE-PAGE SPREAD WITH
THE THEME "PASSION". LEFT: A DOUBLE-PAGE SPREAD PRESENT-
ING THE BASIC PRODUCTS AND SAMPLE COLORS.

The licenses

In the licensing field, a team within an international licensing office of the brand and its designers establishes the books by product type (men's, women's or children's prêt-à-porter; accessories; home and interiors). The collections are either used as they are, or adapted for different markets by in-house designers under license, making sure the brand identity is respected: before distribution, all the modified products must be approved by the international license office. Here again, the book serves as an indispensable support, guaranteeing that the brand's image is respected.

It should be noted that, in this case, the designer will more than likely have to visit the factories to make sure that the products are being made to the specifications detailed in the book.

The labels

In the textile industry, a distributor can call on design consultants to produce one or several collections presented under different labels.

This outsourcing allows the company to significantly reduce salary costs, as in-house designers are not used.

Using the products books supplied by the design consultants, the manufacturer will be able to make the prototypes, either for itself or for a distributor.

The portfolio

"Jazz" portfolio of Hanako Chiba, student. The trend defined here is associated with music and lifestyle. The vinyl disc and the plastic cover evoke a past era, reinterpreted in a contemporary way, giving a new dimension to nostalgia.

Portfolio

Title page. The choice of using a vinyl disc, rather than the New Orleans group itself, for example, shows that the idea is more about evoking a mood linked to jazz than about the culture from which it originates.

Mood page making reference to *Shadows*, a film by John Cassavetes about jazz in the 1950s. The presentation of the color range is symbolic of the jukeboxes of that era.

A portfolio consists of personal projects, as opposed to the product book aimed at industry. It is normally packaged in such a way as to give it a distinct identity. As an example, we have chosen a portfolio that evokes a mood, or feeling, resulting in a trend-setting collection – in this case it is both musical and intellectual. This portfolio demonstrates the capacity to carry out iconographic research, and the ability to analyze as well as summarize it by means of illustrations – essential qualities required by design consultants. In fact, consultants need designers who are capable of gathering a large number of elements around a theme (along with the development of color schemes and fabric swatches) in order to define the trends.

The portfolio must target the fashion sector that the designer has identified: luxury end, design, textile industry, design consultancy, fabric construction, etc.

In line with the chosen speciality, the emphasis will be put

ILLUSTRATION SET IN A CULTURAL ENVIRONMENT.

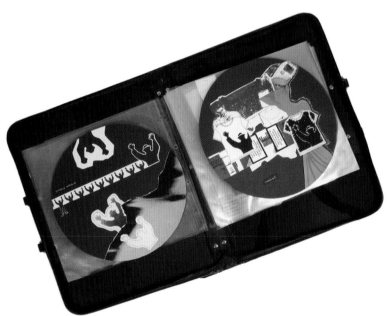

MOTIF VARIATIONS SHOWING A CONSISTENT DEVELOPMENT OF THE MOOD OR FEELING.

on illustrations, fabrics, colors or the concept of the garment. The elements that feature in the portfolio will be selected, in relation to the target market, from among the following:

- text presenting the project or projects;
- pages of captioned research images (to aid understanding of the subject);
- fashion illustrations;
- product display (suggesting moods, shop presentations);
- pages of fabric research and swatches;
- pages of color schemes;
- pages of textile motifs and patterns;
- flat drawings with details and captions to aid understanding of the garment.

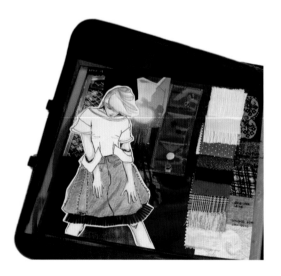

FABRIC PAGE SHOWING COORDINATED PRINTS FOR THE COLLECTION AND SOME DETAILS AND FINISHES. THE ILLUSTRATION CONFIRMS THE STYLE AND MOOD BY BALANCING THE PAGE.

ILLUSTRATION SHOWING OVERALL "LOOK."

Good presentation of the portfolio is of the utmost importance, with particular care being paid to the graphics and colored "flats." It is equally important to demonstrate a broad range of techniques that show the designer's strengths and knowledge. If the portfolio has been largely produced on a computer, it can be a good idea to produce certain elements freehand, as this will bring richness and texture to the presentation, showing a sensibility for the materials.

Also, coherent planning of the different elements will underline the designer's style (see the overview or layout diagrams on the following pages).

The portfolio is the designer's world. Other than showing

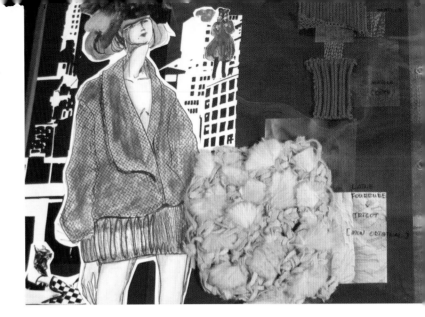

ILLUSTRATION SHOWING OVERSIZE KNITTED CARDIGAN, WITH SAMPLES OF DIFFERENT STITCHES AND THREADS.

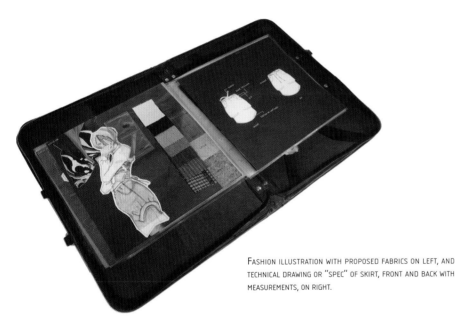

FASHION ILLUSTRATION WITH PROPOSED FABRICS ON LEFT, AND TECHNICAL DRAWING OR "SPEC" OF SKIRT, FRONT AND BACK WITH MEASUREMENTS, ON RIGHT.

COLOR SCHEME MADE FROM SILK THREADS. THIS COMPLEMENTS THE RICHNESS AND TEXTURE OF THE "SPEC" DRAWINGS SHOWN PREVIOUSLY.

his or her skill and sophistication, it must reflect the culture of this milieu — makeup, hairstyles, fashion photography and styling, as well as aesthetic references, musicals, films and so on — and his or her interpretation thereof. In fact, it is the designer's personal identity, and his or her capacity to project this into the fashion world, that must come through in this book.

Before beginning a project, it is important to draw up a plan, which in this case corresponds to a layout sequence. This will include all the elements in your specifications book.
Establishing this system gives structure to your style book, port-folio or any other aspect of your project. It is the first stage of their construction. As with a book or a magazine, the work is presented in a logical manner that draws the reader's attention and indicates a continuous progression.

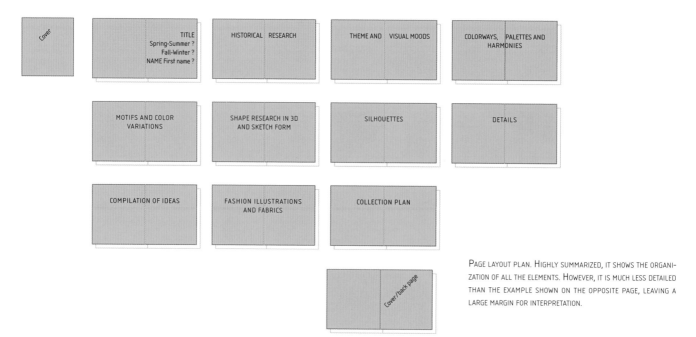

| Cover | TITLE
Spring-Summer ?
Fall-Winter ?
NAME First name ? | HISTORICAL RESEARCH | THEME AND VISUAL MOODS | COLORWAYS, PALETTES AND
HARMONIES |

| MOTIFS AND COLOR
VARIATIONS | SHAPE RESEARCH IN 3D
AND SKETCH FORM | SILHOUETTES | DETAILS |

| COMPILATION OF IDEAS | FASHION ILLUSTRATIONS
AND FABRICS | COLLECTION PLAN |

Cover/back page

PAGE LAYOUT PLAN. HIGHLY SUMMARIZED, IT SHOWS THE ORGANI-ZATION OF ALL THE ELEMENTS. HOWEVER, IT IS MUCH LESS DETAILED THAN THE EXAMPLE SHOWN ON THE OPPOSITE PAGE, LEAVING A LARGE MARGIN FOR INTERPRETATION.

What is a layout sequence?

In the press and publishing world, a page layout is a schematic representation of all the pages making up a magazine, a newspaper or an illustrated book. In this case, it allows the illustrations to be distributed harmoniously throughout and gives the book a rhythm, as well as working out the number of necessary pages and work plan.

The page layout is arranged on one single sheet, so that the entire project can be seen immediately. Ideally, it should be hung on the wall so that it can be consulted at any time, allowing for the inevitable modifications to be made as the project progresses.

Structuring advice

The organization of a portfolio must, above all, reflect a coherence of ideas from the designer. Do not present all your work under the pretext of showing everything you can do: too many exercises will look too much like a schoolbook. The portfolio is designed for professionals, who will be judging your professionalism, so strategies and assurances are necessary. It is preferable to choose a precise theme and rework certain elements that have been particularly successful. This can be done by selecting graphics that complement the idea, rather than juxtaposing a series of unrelated and disparate pieces of work. By the same token, an interesting element lost in a discordant presentation is likely to be considered accidental, rather than deliberate.

Therefore, begin by making a rigorous selection of the factors that best illustrate your design. Knowing how to compile a style book, successfully produce fashion plates and execute precise technical drawings are the vital elements that must be mastered. In the portfolio, however, it is the relevance of your topic and style that will be the proof as to whether it is worth pursuing. Readers want you to be surprised by your astuteness and professionalism.

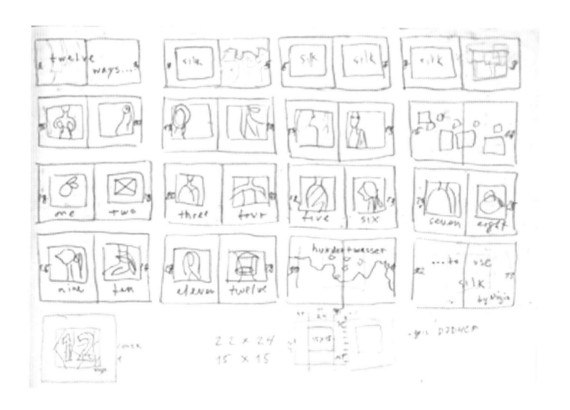

Page layout in form of a storyboard, with roughs giving an idea of visual presentation variations (close-up, zoom, plan view, etc.). It proposes a concrete image and gives vitality to the project.

To summarize, the portfolio is the filter that demonstrates your ingenuity and captures the imagination of its readers because you stand out!

As a working tool, the product book deals with the practical demands of the project and will be organized in a more precise manner.

It is advisable to divide it into several parts or chapters. The first part introduces the subject: here you present the theme and the concept upon which you have based your ideas, as well as the shapes, colors and fabrics, mood pages, silhouettes, and finally details and finishes.

The second part consists of the design development, with fashion illustrations, and the products accompanied by technical information (larger plans of details, fabrics and model descriptions). We suggest that you present a fashion illustration on one page, and on the opposite, a technical drawing of the product, detail sketches (collars, sleeves, fastenings, and so on) fabric samples, color variations and so on. The more detailed the technical information, the less difference there will be between the finished product and your original idea.

Finally, it is helpful to include an appendix to your work, as this will assist in understanding the project. For example, this could include the origins of your idea, research on already existing products, and complications of ideas prior to your theme research. These supporting documents will give depth to your portfolio.

A final word of advice: it is better to have a project with a lot of pages and a small amount of information on each page than the contrary – this makes for much easier reading and comprehension.

The name of a project can be treated as a logo. These two examples show graphic research in the tradition of the proportion and shape studies of the Bauhaus, which perfectly illustrate line and shape work.

To present another example using a motif, but keeping the same house style, the background texture can be accentuated by lessening the contrast between the back and the foreground.

What is a house style?

After having organized the contents of your portfolio, you will have to create its visual impact by applying its house style. This is a document that specifies a set of visual norms or standards, to be used by a company or organization or for a project. It defines the visual identity of the above and ensures coherent communication. House styles are devised for magazines, newspapers and television channels, advertising campaigns (television, cinema, the press, billboards, etc.) and on the Internet — every type of media, in fact. In the case of a product or brand, the house style ensures a visual link between these different forms of communication.

A style book is also a visual communication document. Creating a house style before beginning the page layout work will immediately give you a structure and unify your presentation, which in turn will help your efficiency.

The house style revolves around three complementary elements: the logotype (logo), the typography and the colors. All of these contribute significantly to the overall feel of your chosen mood, provided, of course, that they are in keeping with your proposed theme — for example, design, vintage, romantic or punk.

Logos and brands

These are names, symbols or other small designs adopted by organizations to identify their products, as the following examples show: a logo can identify a company (American Airlines, Microsoft), a brand (Hermès, Louis Vuitton, Chanel) and even a product or product line of a brand (Nike Air, L'Oréal's Studio Line), as well as an institution (United Nations, World Health Organization), a sporting event (Olympic Games, World Cup) or a cultural event (Cannes Film Festival, Golden Globe Awards). It is normally a name, set in a specific typeface, placed in a particular manner. But this can be extended to a logo being just an image (sometimes a simple sign), the first letter of a name or an acronym. Brands such as Lacoste (with the crocodile) or Gucci (with the horse's bit) have been using their

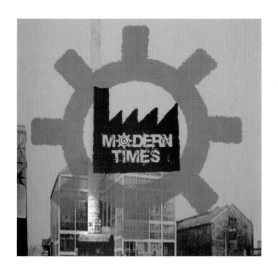

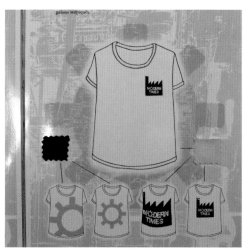

THE INDENTED WHEEL, EVOKING MACHINERY, THE DRAWING SYMBOLISING A FACTORY, THE WEATHERED OUTLINES OF THE TYPOGRAPHY AND THE GENERALLY BRUTALIST TREATMENT DEPICT THE THEME OF THIS BOOK: THE INDUSTRIAL WORLD OF PREWAR AMERICA ILLUSTRATED BY THE CHARLIE CHAPLIN FILM.

MODERN TIMES. YOU CAN COMBINE, AS SHOWN HERE, THE LOGO TEXT AND BRAND NAME OR CLOTHING LINE. THE BRAND WILL BE ABLE TO BE USED IN A VARIETY OF WAYS, LIKE HERE, WITH A PLACED MOTIF ON A TEE-SHIRT.

Creating a logo

logos on their clothes and accessories for more than 50 years.

During the last two decades, it has become a basic identifying element for many casual and sportswear brands, such as Nike (the tick), Adidas (three stripes) and Quicksilver (the wave), whose designs have been based around it. In some cases, the logo becomes more important than the clothing itself! The logo is also a distinctive sign of belonging to a particular group.

As a reaction, certain brands have adopted, for several years now, a type of reverse politics by not using any logo at all, for example, American Apparel, Muji and Nobrand. But to communicate in this way, these brands still have to develop a house style, which leads us to note that among the three important elements, the logo is not the most important.

A logo is designed, most commonly, by a graphic designer. However, when used in conjunction with a clothing line, it is produced in collaboration with the fashion designer. A good example of this is the collaboration between Yohji Yamamoto and the Adidas brand for the clothing line Y-3.

To personalize your project, you could design your own logo. Don't forget that there is a plethora of signage in everyday life such as signposts for airports, for example, that are simple yet immediately understood. These could serve as good starting points. Analyze the commercial message conveyed by logos in magazines or on billboards: your logo must demonstrate an organized thought process. The more specific it is, the more it will be justified.

It is necessary to imagine this logo in relation to the project theme and intent: clothing line, mood or personal presentation work. Numerous factors need to be taken into account, such as the size of the letters, the colors and the shapes. As a general rule, a round-shaped logo will give the impression of security and well-being, triangular shapes symbolize innovation and state-of-the-art technology, and square shapes will evoke stability and sturdiness.

A logo can be a combination of an image and a word. Do not hesitate to make several attempts, by arranging the text and image in different ways and altering their size until you arrive at a balanced composition.

Arial, Helvetica, Univers, America Sans, ITC Avant garde, BiTDUST TWO, Blue Highway, bubble boy, Myriad, Isonorm, df667 chlorine, Blippia, BLOCHOUT, Alba, ...

Times New Roman, Albertus MT, ARSIS, Bitstream Vera Serif, Book Antiqua, Cantabile, City D, Courrier, Garamond, IM FELL DW Pica, Palatino Lynotype, STENCIL STD, ...

Arial Regular — Corps 08
Arial Bold (gras) — Corps 10
Arial Italic (Italique) — Corps 12
Arial Bold Italic — Corps 24

The letters

Typography is an essential element of any house style. It originated with the printing industry in the 15th century as the art of assembling letters to form words, phrases and texts. Typographic letters are classified into typefaces (Arial, Helvetica, Garamond, etc.), which correspond to the letters of alphabet and are composed of different fonts (bold, italic, different sizes, etc.).

The typefaces themselves are grouped into families of letters (11 in total, according to the international classification Vox-ATypI, used by professional graphic artists.

Here we present a simplified classification in two families: serif font, meaning there are nonstructural details on the ends of some of the strokes; and sans serif font, meaning those without. This is done to guide you through the innumerable typefaces that exist.

There are a lot of Internet sites entirely dedicated to typography, and it is possible to freely download a number of typefaces (www.dafont.com, for example). All you have to do is ensure that the typeface you choose is compatible with your software (though the majority of typefaces used nowadays are compatible with Mac as well as PC), and to copy the files into the font library on your computer.

HERMÈS

Dior YVES SAINT LAURENT

DOLCE & GABBANA

Calvin Klein

CHANEL

THE TYPOGRAPHY OF THESE FAMILIAR BRANDS CULTIVATES A CER-
TAIN IMAGE OF SOPHISTICATION. THEY USE SIMPLE, SOBER AND
TIMELESS TYPEFACES IN PARTICULAR, FOR AN ELEGANT THEME.

AVOID FANCY TYPEFACES THAT WILL COMPLETELY CONTRADICT
YOUR PROJECT'S STYLE. A VERY DISTINCTIVE TYPEFACE CAN
APPEAR OUTDATED VERY RAPIDLY.

Choice of typeface

It is strongly advisable not to use too many different typefaces, as you will lose readability: a maximum of three will suffice. The first one is used for the titles. Select one that corresponds to your theme. For example, for a classic, elegant theme choose a simple, sober type face such as Arial, Tahoma or Helvetica; for a punk theme, a deconstructed design could work, or one that looks like it has been eroded by chemicals such as Got Heroin, Broken 15 or Depraved; for a psychedelic theme, typefaces used on record sleeves of that era could work, such as Fillmore, Bell Bottom Laser or Butterfield.

It is possible to choose a different typeface for the subtitles. However, you could just alter the size of the one that you have used for the titles. Finally, for the text, legends and captions, use simple ones such as Arial, Helvetica, Times, Myriad or Tahoma. If the more unusual typefaces work well for your titles and subtitles, stick to simpler ones for long texts, as these have to be read and not deciphered!

As a general rule, avoid eccentric and fancy typefaces. In preference, use simpler ones that, most importantly, work in conjunction with your theme. It tends to be the case that sobriety and simplicity are synonymous with elegance.

Use bright, happy colors for a children's clothing project. Note that the color samples and finishing details added provide colored areas within the book. Their positioning helps to balance the pages.

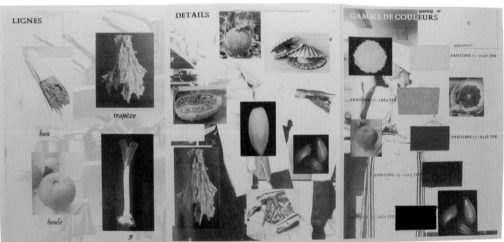

On this spread, the empty spaces play a very important role, as they highlight the colors that have been chosen to illustrate the "food" theme. The impact of the naturally bright colors reinforces the neutrality of the background.

Color is the housestyle factor that will have the most impact on the mood of your presentation. From the physical point of view, colors have differing wavelengths of light, which are measured in microns. The human eye can only distinguish the light waves ranging between 400 and 700 microns. The colors that have the longer wavelengths are the strongest, and are therefore perceived more quickly. For example, reds (600–650 microns) give the impression that they are jumping out at you, whereas blues, with fewer microns (460–480 microns), are more soothing.

Symbolically, colors are associated with different concepts and meanings depending on the era and the place. For example, white, which in the West is associated with purity, innocence and peace, is, in fact, the color of mourning in Asia.

So that there is harmony between your choice of colors and your project, we recommend that you use the ones from your color range or palette. However, a neutral background is often the best means of emphasizing your work.

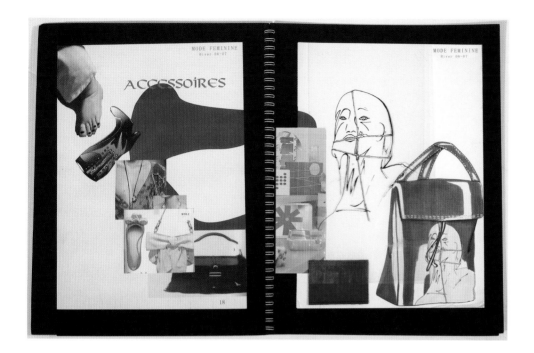

Neutral tones, such as the white here, accentuate the vivid colored areas, communicating a vitality to the reader. The black background paper plays an equally interesting role: by creating a contrasting effect, it focuses the attention on the center of the composition.

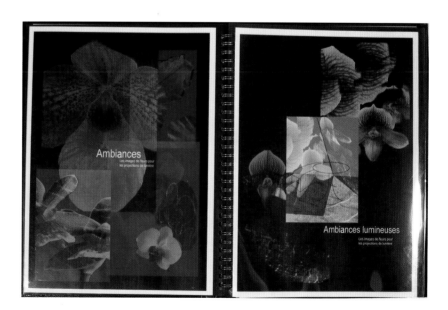

Black, particularly in the fashion world, conveys an impression of elegance, luxury and modernity, as well as mystery. This is particularly well portrayed in this double-page spread.

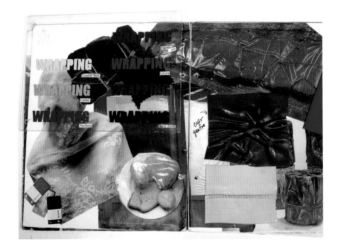

MOOD SPREAD. THIS HARMONIOUS COMPOSITION OF INSPIRATIONAL IMAGES SHOWING A COLLECTION OF MATERIALS, INCLUDES UP TO FOUR DIFFERENT PLANES. USING A SHEET OF PERSPEX, TO WHICH THE TEXT HAS BEEN ADHERED, ACCENTUATES THE RELIEF. THE ORGANIZATION OF THE DIFFERENT PLANES PRODUCES A WEALTH OF INFORMATION ON THE PAGE.

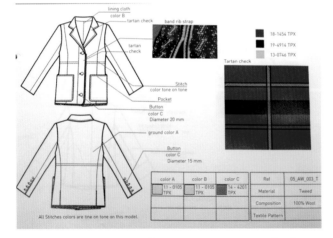

THIS SPECIFICATION SHEET SHOWS A "FLAT" DRAWING OF THE FRONT AND BACK OF A JACKET, ACCOMPANIED BY THE NECESSARY EXPLANATIONS, CHOICE OF FABRICS AND PROPOSED PRINT. THIS HAS BEEN CARRIED OUT USING A COMPUTER, AND ALTHOUGH EXTREMELY PRECISE, REMAINS AESTHETICALLY PLEASING.

BY PLACING AN ILLUSTRATION UNDER A PLASTIC SHEET, IT SUGGESTS A PARTICULAR MOOD. THE MATERIALS ARE PRESENTED IN SUCH A WAY AS TO MAKE YOU WANT TO TOUCH THEM.

The page layout determines the overall impression of the project. If you have chosen to keep it fairly subjective, it is very important to adhere to certain rules that will emphasize the work.

A successful page layout presents the content of the document in a harmonious and logical manner. Reading it will be made easier if the blocks of text and the images and colors are balanced and contrasted.

The first rule to follow in design can be summed up in two words: clarity and style. And just as the words suggest, this also applies to page layouts.

The second rule, which is just as important, is that of coherence: your page layouts must echo the theme and mood of your project. You will need to choose a format, paper and style of illustration that correspond to your theme. For example, for a rural theme, you could use textured paper and natural colors; for a jazz theme (such as in the example on p. 116), you could opt for a circular format and plastic-coated black paper reminiscent of the old vinyl records that could be bought at Saint-Germain-des-Prés. Whatever it is, you must avoid, at all costs, superfluous decorations such as little bits of ribbon that have been used simply "to make it look pretty." The elements that are presented must contribute to the understanding of the project, and not detract.

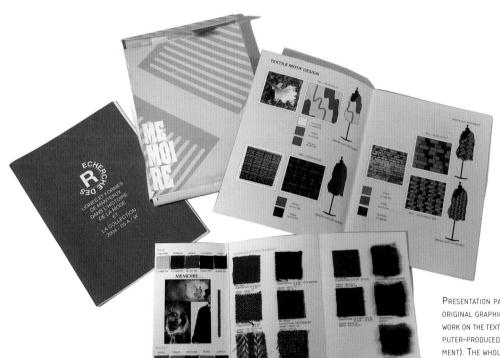

PRESENTATION PACKAGING (MADE AS A BOX, OR CARTON, WITH ORIGINAL GRAPHICS), TITLE PAGE (MENTIONED ON P. 122) AND WORK ON THE TEXTILE DESIGN (WITH INSPIRATIONAL PHOTOS, COMPUTER-PRODUCED MAQUETTES AND POSITIONING ON THE GARMENT). THE WHOLE PACKAGE IS VERY GRAPHIC, INCLUDING THE PAGE LAYOUT AND THE SUBJECT ITSELF. A WELL-STRUCTURED ARRANGEMENT HELPS THE READER. NOTE EQUALLY THAT THE FABRICS PRESENTED CREATE A RELIEF EFFECT AND GIVE SUBSTANCE TO THE WORK.

Page composition

Following the layouts that you have already prepared (see p. 120), you will now have selected all the elements you wish to include page by page, i.e., text, photos, illustrations, technical drawings, sketches and, of course, the fabrics. However, make sure that you do not consider the pages in isolation: they must interconnect with each other. Also, when one flicks through a book, it is not just one page, but two, that are seen at the same time. It is therefore important to work on the impact of a double-page spread. Now, ask yourself the following questions: Which is the most important element to be presented on the spread? How do I emphasize it to catch the reader's eye? How do I attract his or her attention and make him or her follow my thought processes?

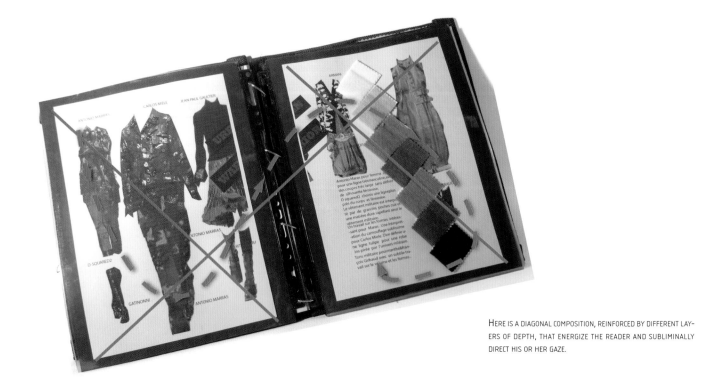

HERE IS A DIAGONAL COMPOSITION, REINFORCED BY DIFFERENT LAYERS OF DEPTH, THAT ENERGIZE THE READER AND SUBLIMINALLY DIRECT HIS OR HER GAZE.

ADDITIONAL FABRIC SAMPLES OF YOUR PRODUCTS ARE DOUBLY INTERESTING: THEY HELP THE READER APPRECIATE THE TEXTURES, WHILE CREATING RELIEF IN YOUR PAGE LAYOUT, AS IS THE CASE WITH THESE FURS IN THE FOREGROUND.

Composition advice

- Each double-page spread of your project creates a visual whole, the composition of which can be likened to the work of a painter or photographer. It is necessary, therefore, to imagine the lines of composition around the image and text blocks, which ultimately guide the reader. Note that a diagonal composition will give the impression of movement and energy, whereas a horizontal or vertical composition will seem calmer and more measured.

- Make sure that the different blocks are equally spread out in order to balance the pages. Their positioning must guide the reader naturally. Look at

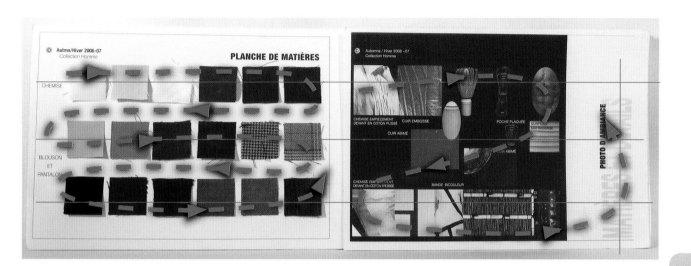

THIS SPREAD SHOWS THE SAME BALANCE IN THE ARRANGEMENT OF
THE FABRICS, ON THE LEFT, AND THE VISUAL INSPIRATION PAGE, ON
THE RIGHT. THE RESULT IS A FEELING OF CONSERVATIVENESS. THE
EYE FALLS NATURALLY TO THE LEFT-HAND PAGE, THEN FOLLOWS ON
TO THE RIGHT, READING FROM THE TOP TO THE BOTTOM AND FROM
LEFT TO RIGHT, AS WITH WESTERN WRITING.

fashion magazine advertising to inspire you. These advertisements are always composed in such a way that we notice the two most important things: the product and the brand.

- Think about altering the size of the letters and images in order to prioritize the information and emphasize the details that you judge to be important. It will be necessary to increase certain items, decrease others, or superimpose them to create different planes.

At the same time, you will be able to create depth and rhythm in your spread. Going outside the margins, or bleeding off the page, gives the impression of depth and creates movement.

- Placing elements across the two pages (a title or an image) links them visually.

- Do not overload the pages; too many elements will make the composition look confused.

- If you use a background image on a page, make sure it does not affect its readability.

- Finally, do not make your presentation too routine or repetitive. This can lull the reader into bored inattention. On the contrary, create surprises that will constantly renew his or her interest. While still adhering to the basic principles you have chosen for the presentation, consider changing the rhythm of your compositions – from one chapter to another, for example. Bear in mind, however, that the technical part of your portfolio must be as clear as possible, so as to be easily understood.

Portfolio of work

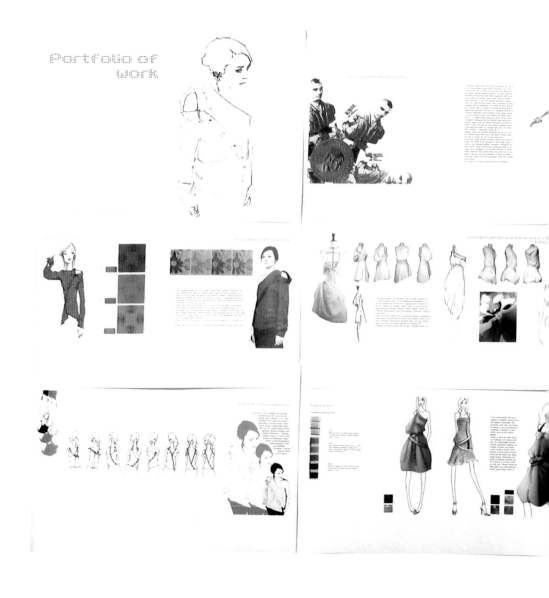

Looking at your work as you go along, while the project progresses, is essential as it will allow you to judge the balance within your portfolio. It is a question of placing your double-page spreads side by side, in the page order indicated in the layout. Attach them to the wall with masking tape, take several steps backward, then slightly narrow your eyes.

By doing this you will be able to notice any faults in the choice of colors, fabrics, typography or information ordering, and the absence or redundancy of particular elements. It is important to look critically at your work; by doing this often, you will be able to train your eye. Do not hesitate to ask someone else's opinion, as they will be removed enough to evaluate the coherence of the project.

For fashion magazine editors, this process irons out and

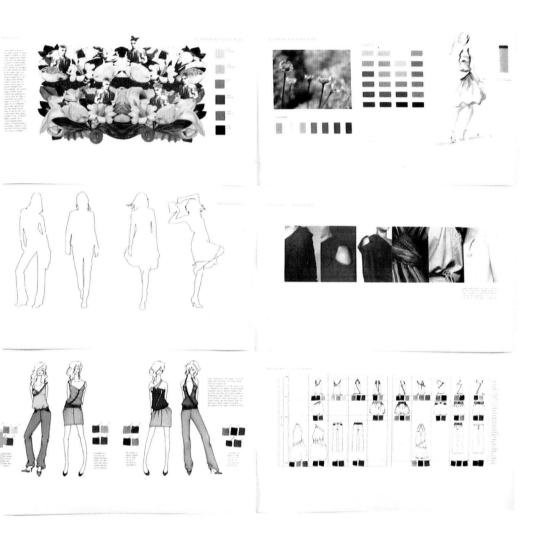

corrects the imbalances between the editorial departments (which work on the magazine's house style) and the advertising departments, which must, despite their differing roles, be able to integrate harmoniously to produce the magazine.

Fashion magazines are a good example to follow, as they are always produced in an interesting and attractive manner. A design student must practice this type of research regularly so that he or she can identify and clearly understand particular constants evident in the presentation. In fact, the fashion world has its own codes of communication, visible in the treatment of current events whether they be artistic, architectural, musical, sporting, economic or social – usually the main topic headings in fashion magazines.

This chapter details the internal organization of a design studio and its relationship with the other services of the prêt-à-porter business, giving the reader an insight into the work of a designer. A collection cannot be improvised. What is more, professional designers must not isolate themselves within their creative world and ignore the realities of the textile industry and the fashion market. The success of a great fashion designer is linked to his or her profound knowledge of these elements. Karl Lagerfeld, for example, has demonstrated his creative genius to great benefit with brands such as Chanel, Lagerfeld Gallery and Fendi, and by respecting the individual image of each one, he has managed to compile truly original and distinctive collections.

If the production of the style book for the companies under license stays within the studio, the studio's principal focus is on creating or designing. Essentially, it is dedicated to the choosing of themes, to the definition of concepts, and to the development of the collections (see Chapter 3). This involves teamwork, where designers and different consultants, under the overall authority of a creative director, work together by combining their skills: the design studio is a lively, versatile place where ideas circulate freely. Designers, like artistic directors, generally work on a freelance basis. They are normally linked to a company by the terms of a joint contract for a variable length of time, which can be extended for several seasons.

Over the past ten or so years, new technologies have modified the structure of the work within the studio. This has meant there is faster communication between different departments in

the company, as well as with suppliers and external consultants, who no longer have to move around as frequently.

The professional designer works in close collaboration with the *toiliste* who makes the collection's prototypes. This is why a good understanding of all the manufacturing constraints is necessary, so that he or she can be fully informed about the possible choices concerning finishes and fabrics.

In this chapter, we invite you to follow all the phases of development necessary for a collection by visiting the design studio and workroom, or atelier, of the brand Lutz, which was created in 2000 by the designer Lutz Huelle and his partner and financial director, David Ballu. To facilitate understanding of the work of a workroom we have carefully broken down the various modeling stages: first of all the draping, which consists of

making the *toile* shape; developing the first *toile*, trueing and checking the balance; trying the model on; pattern making (the transfer of the different pieces from the *toile* onto a pattern card); and finally the cutting and assembling of these pieces into a garment.

At the end of this chapter, you will find the explanations necessary for the technical or specification drawings that make up the basis of the modeler's work. This type of "flat" representation requires a complete understanding of the garment. The precision of the model's proportions and suggested dimensions is paramount, to guarantee a clear interpretation by the atelier. The flat drawings are also an essential element for the eventual production of a series.

Photo documentary at Lutz's studio

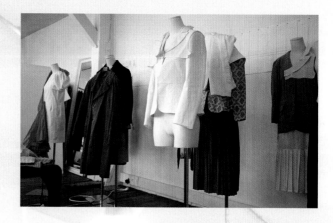

The team

The number of people working in a studio will vary depending on the structure and financial situation of the company. The team can be supervised by a creative director – as in the case of Alber Elbaz with Lanvin, Marc Jacobs with Louis Vuitton or Jean Paul Gaultier with Hermès, to name but a few – and by a studio director, such as Françoise Plaud with Lanvin, Anne-Marie Munoz with Yves Saint Laurent or Rosemary Rodriguez with Thierry Mugler. The team includes at least one designer, and may include several, who specialize in certain areas such as patterns or accessories, or are responsible for the fabrics, assistants and student placements. And finally, there is a house model, who, meeting the aesthetic requirements of the designer with her modeling skills and movement, enables all the garments intended for the catwalk to be tried and tested.

This model, whose measurements do not correspond to those found out on the street, serves an inspirational role for the designer or artistic director. Her principal function is to confirm the look, silhouette and fall of the prototypes, and to harmonize the proportions and sizes of the different items of the collection.

External consultants

The design studio will sometimes call on the help of a fashion editor for advice on a collection and an external contribution regarding fashion-show styling (for "look" development see Chapter 6, p.173). This external advisory role has been played by Carine Roitfeld, chief editor of French *Vogue* since 2001, for Givenchy; by Babeth Djian of *Numero* for Lanvin; and by Marie-Amélie Sauvé, designer and former editor of French *Vogue*, for Balenciaga.

A graphic designer will be used for the layout of the collection's promotional information such as invitation cards, catalogs and press packs.

Finally, depending on the collection's requirements, the studio will call upon a number of specialist workshops or ateliers, such as pearl embroiderers at Maison Lesage, Montex and Co. or Vermont and Co.; fine dressmakers at Maison Gripoix, Robert Goossens or Delphine Charlotte Parmentier; feather makers such as Lemarié; milliners such as Jacques le Corre, Philip Treacy or Maison Michel; corset specialists such as Mr. Pearl or Maison Cadolle; glass and crystal specialists such as Swarovski; furriers such as Yves Salomon, Saga or Furs of Scandanavia; knitwear manufacturers; metal suppliers; printed tee-shirt specialists and so on.

The designer chooses the items from the manufacturer's archives or orders bespoke (made to order) item directly tied to the collection's theme. The fabric and sewing suppliers can also produce original designs for the collection.

The fashion calendar

The studio's calendar is governed by the fashion shows. The two seasons, Spring-Summer (SS) and Fall-Winter (FW) are presented, respectively, between July and October, and January and March. The collections presented in July and January are often pre-collections; they herald the season and are intended for the large distribution groups, which place orders at this point. At certain periods, the designer can be working on the SS and FW collections simultaneously.

A work planner assists in organizing the team's work. The first stage is the research phase. It begins in January for the SS and in July for FW, for the season of the following year, and generally stretches over a period of one to two months. The designer carries out trend research so that themes and color palettes can be defined. Sources come from current art and theater events, daily news, Internet research, international travel, vintage inspiration, visits to flea markets, and shopping (see Chapter 1).

The second stage involves visiting trade shows to select fabrics and sewing items for sampling.

The third stage, which normally corresponds to the third month, is that of designing the garments for the collection. These are represented by fashion plates with fabric swatches and or flat drawings. The items can be either organized in a collection plan or presented as a fashion-show display: in the latter, the different looks are sketched and then posted onto the wall.

At the fourth stage the prototypes are launched. Here, the design team works in close collaboration with the atelier technicians. The designer explains his or her drawings to the modeler, and the prototypes are developed. When the atelier is overloaded with work, the designer will most likely outsource the work, calling on a specialist studio to make the *toiles* and prototypes.

The fifth stage involves the designer preparing to present the collection to the company's marketing and publicity offices. Internal catalogs are developed where the drawings are cross-referenced with photos of the prototypes, including the variations of fabrics and colors, which enables the marketing department to establish costs.

The catalog is shown at the same time as the collection plan. Before the showroom sale, which coincides with the presentation of the pre-collection, the merchandiser chooses the looks and introduces them into the marketing catalog as photos and drawings. This has the effect of drawing attention to particular products.

Promotion and fashion show

Furthermore, the designer can arrange for a photo shoot (see Chapter 6, pp. 176–177). In this case, he or she will be taken to meet the photographers, in order to establish casting choices for the models, as well as to perform accessory styling. By collaborating with the photographer, the designer selects the shots and proposes a page layout maquette, which is eventually prepared for the catalog by a graphic designer.

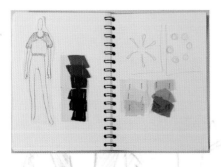

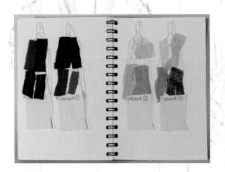

EXTRACTS FROM LUTZ'S SKETCHBOOK. PAGES SHOWING FABRIC SAMPLES AND PROPOSED COLOR SCHEMES PER MODEL

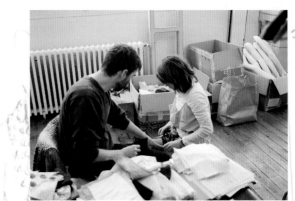

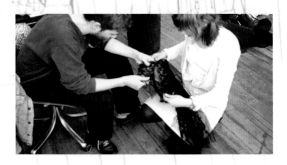

WORK SESSION WITH AN ASSISTANT DESIGNER PROPOSING FABRIC SAMPLES. THE COLLECTION PLANS OF THE MODELS, WITH THEIR CORRESPONDING FABRICS, ARE PINNED ONTO THE WALL (BOTTOM OF OPPOSITE PAGE).

Other work factors

Finally, unless he or she decides to use a production company that specializes in producing fashion shows, such as La Mode en Image or Alexandre de Betak, the designer proposes the feeling or atmosphere of the fashion show. This is done in collaboration with the production company, hairstylists and makeup artists. He or she can also choose the music and suggest the invitation cards. On the other hand, some designers prefer to use the services of a specialist design production company such as Hervé Sauvage.

Design work also includes numerous brainstorming sessions and technical research trips. This research normally entails trips to other countries to discover new manufacturers and specific product suppliers (for baskets, hats, etc.), and to visit trade shows such as the Italian Linea Pelle for leather, Moda In or Prato Expo for fabrics, and Pitti Filati for knitwear.

Meetings with the brand's public relations personnel are regularly scheduled to ensure that the collection's direction, marketing targets and brand image are all on course.

Finally, there are meetings with the financial department to establish the budget allocated to the collection — a consideration that the designer will need to have been aware of during the project.

The internal management of the design studio also plays an important role: the fabric and print samples need to be classified, and the product drawings and accumulated documentation such as magazines and books archived. Over the course of time, this manner of archiving assists enormously in creating

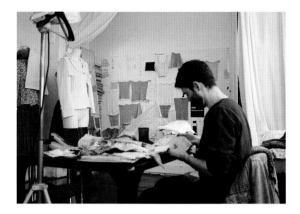

FABRIC SELECTION. THE FABRIC SAMPLE SHEET FOR THE COLLECTION IS PINNED TO ONE OF THE WALLS OF THE STUDIO.

a form of mini library and information center.

The studio assistants, among other things, tend to take care of the interior decoration of the studio by buying objects that relate to the collection's themes and contribute to the style and well-being of the studio.

The Lutz studio

For Lutz, shape research is a daily quest. Using his "travel notebooks," he collects and catalogs information while in the street, on vacation, visiting exhibitions, and so on.

He also makes use of archives of his past collections, revising the details of previously designed garments and breathing new life into them. Equally, his vintage clothing collection serves as a starting point, for he is able to adapt products and details and bring them up to date.

Finally, while all his collections have their own identity, Lutz also writes what he calls a "never-ending story." Here,

each one becomes a supplementary chapter of history that expands, collection after collection. There are certain recurring elements in his collections, notably the use of knitwear. Lutz admits he has an affinity with this material. He prefers the freedom and infinite design possibilities it offers, as well as the technical expertise it requires, to the constraints of a finished woven material.

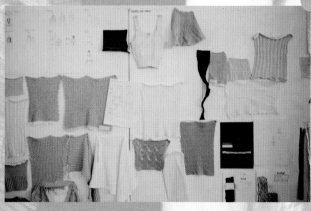

SHEET OF KNITWEAR FABRICS.

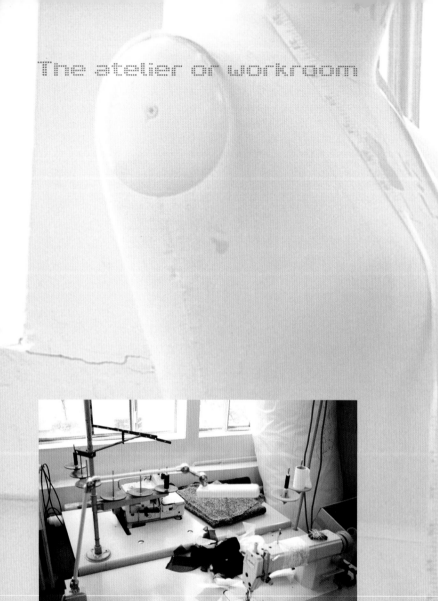

A number of different people work in the atelier, namely the manager, one or two modelers who work from the designer's drawings, the sample machinists who make the prototypes, and the students, who work there during the collection period. If it is a haute couture or luxury prêt-à-porter atelier, there is the addition of extra hands and specialist craftspeople.

The designer's success depends on the professionalism in his or her workroom. For example, it is in his or her best interests to allocate the work in line with particular fields of expertise e.g., dressmaking, tailoring or knitwear, so that people are dealing with familiar concepts and processes.

The atelier must be equipped with appropriate materials in order to make the prototypes. Without these, it will be necessary to call on the help of a design consultancy, or a specialized manufacturer equipped with the right materials and expertise to work in a particular area, for example with fur, leather, knitwear or lingerie.

Nevertheless, the designer must fully understand the workings of an atelier and be able to give clear instructions, so that the personnel are capable of interpreting the designer's wishes as closely as possible.

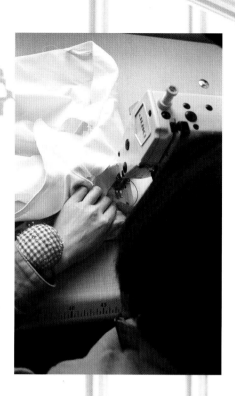

THE MACHINIST ASSEMBLES A PART OF THE TOILE ON A SEWING MACHINE.

Daily communication between the designer and the atelier is of the utmost importance. During the collection period, the team will be required to make what are sometimes very difficult items. However good the drawings, or well researched the fabrics, these will never replaced the reality. For there are occasions when fabrics react differently to what was expected, and further research is required to develop the definitive model. The designer, therefore, might have to modify several pieces of the collection, and even abandon others that the team has spent a lot of time working on.

An atelier must be clean, orderly and organized, as the handling of particularly fragile fabrics demands discipline and care. The atelier is also a place of development for the prêt-a-porter items, standardizing them according to the brand's different markets and communicating with the various production sites. The atelier is also responsible for the initial model being adapted for specific international markets, taking into consideration all the different physiques that exist (see p. 146). In this case, the costs linked to materials can be partially controlled. For example, the modeler will recommend the most economical way to position the pattern on the fabric. But in other

désignation	fournisseur	rèférenece	coloris	laize	qté/m/pc	qté total
tissus						
tissu	BELSOIE	LU3501 Satin léger	99/noir	1,35	1,2	90
doublure	GOUMIEUX	LU300	99/noir	1,38	0,85	63,75
fournitures						
thermocollant	GLUTTY	NX1029	noir	1,5	0,2	15
gallon	GALLONADE	art.4430	noir		2,3	172,5
crochet	Captain	crochet	noir		1	75
zip/boucle	YKK	invisible	noir	35cm	1	75
façon						
façon modèle	CHIC COUTURE					
Composition		51%SE 49%CO	100%AC		1	75
griffe					1	75
36					18	
38					40	
40					17	
42						
44					75	

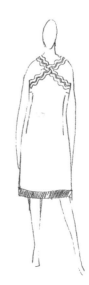

Technical production sheet (above). This chart was used by Lutz (a French designer). It lists the fabric references, stiffening and linings, their lengths per model and the quantities to be ordered, by color, for the season, as well as costing the sundries. The model sketch, and the name, reference and season details appear automatically.

Technical sheet produced by the designer for the toiliste. All the finishes are detailed so that the prototype can be made as closely as possible to the initial sketch.

cases, such as when using leather, it is the material that dictates the cut: a sheepskin only measures about 6 feet, i.e., six times 0.3 m² (or 1.8 m²); and the pieces are cut depending on the skin's quality, i.e., quality A for the center or "flower," quality B for the chest area, and quality C for the sides (where numerous faults can be hidden).

When there are difficulties with a particular product, Lutz uses precut pieces, as well as sketches, to assist the toiliste. The toiliste produces a "half-toile" in a fine plain weave made from fine, medium or thick calico. The prototype is then made in a fabric close to the final fabric, but not as costly (wool instead of cashmere, for example). Once the desired model has been achieved, it will finally be cut in the fabric chosen for the collection.

It is important to know that fashion show fabrics are 30 to 40 percent more expensive than the same fabrics used in production. This is because those in the first case are sold by the meter, while those in the second (known as fabric pieces) are sold by the roll in 50 m lengths.

For making prototypes, the fabric supplier delivers a length or "sample length" that varies from 3 to 15 m depending on the designer's needs, on which the price is marked up.

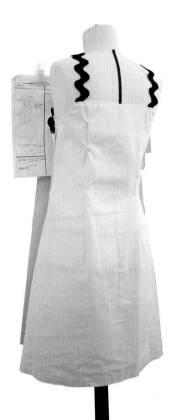

These pages show the first stage of model making where a toile is pinned onto the dress form. The toiliste prepares the pattern, adding the seam allowances. From the toile, a rigid pattern card is made, then hung on the dress form. This is made up of the different pattern pieces which will be cut out from the fabric and assembled to form the garment.

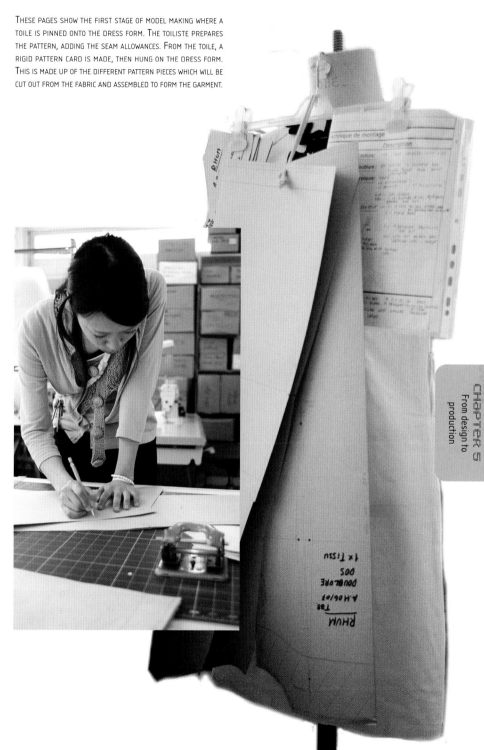

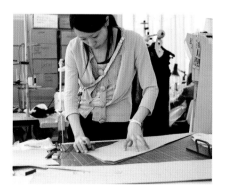

It is essential for the fashion designer to have some knowledge of body proportions. In spite of the differences in physique, there are certain constants in measurements that determine the basis of standardized sizing.

MEASUREMENT CHART.

MEASUREMENTS	SIZES (CM)				
	36	38	40	42	44
Nape to waist back	41.5	42	42.5	43	43.5
Neck to waist front	37	38	38.5	39	39.5
Waist to floor	105	105	106	107	108
Bust height	22.5–25.5	23–26	23.5–26.5	24–27	24.5–27.5
Half cross bust	9	9	9.25	9.5	9.75
Half bust girth	42	44	45	47	49
Half waist girth	31	33	35	37	39
Half hip girth	44.5	46.5	47.5	49	50.5
Half neck girth	17	17.5	18	18.5	19
Half back width across back	17.5	17.75	18	18.25	18.5
Half cross front	16	16.25	16.5	16.75	17
Crown height	13.5	14	14.5	15	15.5
Armhole (armscye) girth	37	38	39	40	41
Shoulder length	12.2	12.6	13.1	13.4	13.8
Total length of arms	58	60	62	64	66
Arm girth	25	26	27	28	29
Wrist girth	15.75	16	16.25	16.5	16.75
Height from waist to knee	57	58	59	60	61
Body rise	25	25.5	26	26.5	27

Body measurements

When compiling a specification sheet, the designer must consider a certain number of length and width body measurements.

Lengths are calculated in this way: the back is measured from the eighth vertebra (the prominent bone that protrudes at the top of the spine at the nape of the neck). The reference point for the front is the shoulder point, which is situated where the base of the neck intersects the shoulder line. From these points several measurements can be established: chest height, from waist to chest, from waist to hip, from waist to knee, from waist to floor, from waist to back and from waist to front.

The widths correspond to the measurements around the chest, waist and hips. The degree of shoulder slope will vary from one product to another. For example, a tee shirt will vary from a jacket. However, this can be easily checked by using a protractor.

Manufacturers use standardized sizing, which is generally classified as size 8–16 in the UK (36–44 in Europe). A thorough knowledge of these measurements, which are listed in the chart above, is essential. You will notice that they increase by 4 cm per size. Therefore, for a size 10/38, which is the reference size, the waist circumference is 66 cm, whereas it is 70 cm for a size 12/40.

Note that standard widths are established on a very variable basis that does not correspond to any garment. A designer must therefore look at finished garments, and measure them, in order to have a good idea of the lengths and widths to give to his or her samples. An idea of the desired volume for the garments will also need to be developed at this point.

So that the proportions and balance of the original model are respected, all the measurements corresponding to the different sizes are carefully transferred onto the pattern (see p. 156). Larger size models, those bigger than size 16/44, will require a new set of measurements and a new pattern. The same is necessary for the smaller sizes, which can either use children's sizing, or become custommade orders.

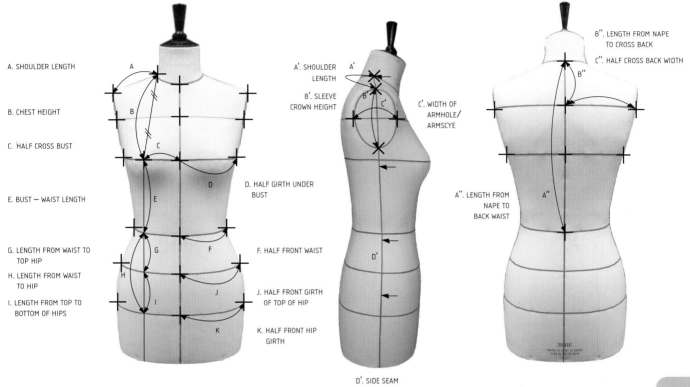

A. SHOULDER LENGTH

B. CHEST HEIGHT

C. HALF CROSS BUST

E. BUST — WAIST LENGTH

G. LENGTH FROM WAIST TO TOP HIP

H. LENGTH FROM WAIST TO HIP

I. LENGTH FROM TOP TO BOTTOM OF HIPS

D. HALF GIRTH UNDER BUST

F. HALF FRONT WAIST

J. HALF FRONT GIRTH OF TOP OF HIP

K. HALF FRONT HIP GIRTH

A'. SHOULDER LENGTH

B'. SLEEVE CROWN HEIGHT

C'. WIDTH OF ARMHOLE/ ARMSCYE

D'. SIDE SEAM

B''. LENGTH FROM NAPE TO CROSS BACK

C''. HALF CROSS BACK WIDTH

A''. LENGTH FROM NAPE TO BACK WAIST

Female dress form size 10/38, with the principal lines needed for making a garment.

Dress form measurements

The dress form is an essential piece of studio equipment, with measurements that correspond, in this case, to the standard size of a female body. This three-dimensional representation of the female form serves as the link between the fashion illustration, the flat drawing, the human body and the garment. It is a useful aid in evaluating the garment and making the toiles.

In order to visualize the different parts of the body, measurement lines are marked onto the dress form using narrow black tape. These lines correspond to the reference points found on the fashion illustration (see p. 147), and to the lines traced onto the pattern (see pp. 156–157). Three vertical axes symbolize the center front, the center back and the sides. The front is 2 cm bigger than the back. The line on the side is always shifted 1 cm toward the back so that the seams do not appear on the front of the garment.

Perpendicular to these axes, the horizontal lines on the widest part of the back, chest, hips and waist allow the different garment pieces to be connected and balanced. The "cut" then encourages a natural fall to the fabric. It is important to visualize these location marks on the body and take into consideration the need to move and breath easily. A garment can seem balanced on a dress form, but in reality it can be another matter, so adjustments might need to be made. When designing a garment, it is important to try and visualize the piece in three-dimensions by imagining the volumes and proportions and reinterpreting them through illustrations.

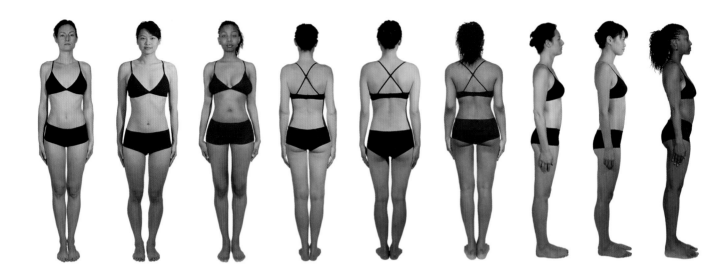

Physical types

Body shapes vary according to the different regions of the world. Taming and overcoming nature in order to create an environment to live in, man sculpted his own body. From the fashion world's perspective, it is important to consider the physical differences, that determine most of the constraints in designing products intended for particular markets.

Here, we consider three large groups – European, African and Asian – that we feel are representative of the physical types most likely to be encountered. Naturally, there are also diverse body types within each of these groups. Among European body types, for example, there is a distinction between Mediterranean and Nordic women, whose hips and chests measurements vary. There are obvious differences between particular African groups and, likewise, between Japanese and Vietnamese people. Nevertheless, we feel that these three large categories appropriately sum up the diversity that results from the constant that migration and inter-mixing of these populations – a fact that has existed from the beginning of humankind.

Certain products have to be completely reconsidered according to the specific markets they address. Whether it be European, African or Asian, it is fundamental that the designer understand and be capable of creating garments that correspond to women from a particular morphological group.* Proportionally, one could say that the lower-back region of the African body shape is more arched than that of the European, which gives the sub-Saharan woman a shorter chest and a higher crotch. On the other hand, in the Asian woman, the chest is longer, the legs shorter and the pelvis larger than in African and European women. This diversity continues ad infinitum and it has come full circle, for, although it is the wish of some women to make their silhouette appear somewhat unusual, the real world, the street and its "natural" models are constant sources of inspiration for the fashion world, and vice versa.

Certain items of clothing, such as the kimono, are the result of aesthetic research in relation to body morphology.

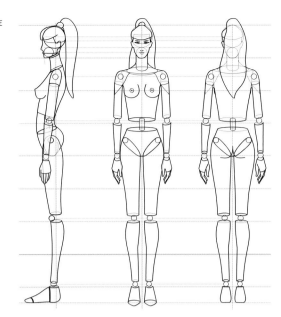

THE DEVELOPMENT OF A FASHION ILLUSTRATION.

1. USING THE VOLUMES AND PROPORTIONS FROM THE BASIC ILLUSTRATION, A LOPSIDED FIGURE IS DRAWN. THE SUPPORTING LEG MUST BE POSITIONED ALONG THE AXIS THAT GOES FROM THE NECK TO THE FLOOR. THE HIGHEST PART OF THE HIP IS IN THE EXTENSION OF THE SUPPORTING LEG. THE LINE OF THE SHOULDERS SLOPES IN THE OPPOSITE DIRECTION TO THE LINE OF THE PELVIS.

2. THE DRAWING IN FIG. 1 IS PLACED ON A LIGHTBOX. A WHITE SHEET OF PAPER IS POSITIONED OVER THE TOP OF IT AND THE OUTLINE IS TRACED WITHOUT THE REFERENCE LINES.

3. THE GARMENT IS THEN DRAWN ONTO THE OUTLINE.

4. THE ILLUSTRATION IS STYLIZED BY USING INK, FELT-TIP PEN, PENCIL, ETC., TO ENHANCE THE OUTLINE. THE ACCESSORIES, MAKEUP AND HAIRSTYLE ARE ADDED.

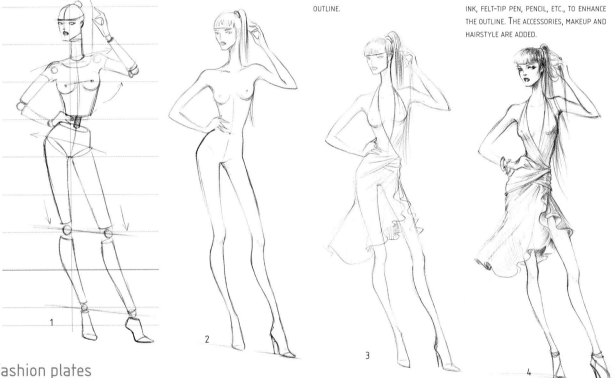

1

2

3

4

Fashion plates

These illustrations allow the designer to liberate him- or herself from the reality and constraints of specific body shapes. They do not represent a real female body, as their androgynous appearance gives them idealized proportions. Gradually, the designer gives the drawings a highly stylized form that results in the finished fashion illustration.

These systematic illustrations have the advantage of providing reference points that the designer can use to express his ideas for the "flat" drawings and simulated volumes. It must be noted that the fashion illustration is not an artistic piece of work, but rather a work tool. It is also better if it remains as consistent as possible, to avoid any confusion in the interpretation of the design.

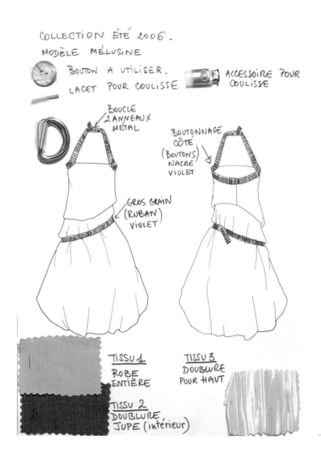

The technical drawing sheet contains handwritten notes:

COLLECTION ÉTÉ 2006.
MODÈLE MÉLUSINE
BOUTON A UTILISER.
LACET POUR COULISSE
ACCESSOIRE POUR COULISSE

BOUCLE
2 ANNEAUX
METAL

BOUTONNAGE
CÔTÉ
(BOUTONS)
NACRÉ
VIOLET

GROS GRAIN
(RUBAN)
VIOLET

TISSU 1
ROBE ENTIÈRE

TISSU 3
DOUBLURE POUR HAUT

TISSU 2
DOUBLURE JUPE (intérieur)

Réf. modèle prod : 3501/99	Réf. modèle studio : R58

Tissu 1
Tissu 3 (Intérieur haut)
Tissu 2 (Intérieur jupe)

Observations:

Tissu 1: Taffetas changeant DENIS (Extérieur)
Tissu 2: Doupion violet BELSOIE (Intérieur jupe)
Tissu 3: Lamé plissé CARLO VALLI (Intérieur haut)
Ceinture ey bretelles: Ruban gros grain violet

Observations du fabricant:

-Tissus fragiles: Ne pas repasser avec la presse à vapeur
-Attention au sens du tissu pour le taffetas changeant

Date: 20/05/2006

Réf. modèle studio: R 58 Réf. modèle prod: 3501/99				Fabricant CHIC COUTURE	
Fournisseur	Ref Tissu	Coloris	Laize	Composition	
BELSOIE	Réf prod.: BE 350 Doupion	Violet	140cm	100 % Soie	
DENIS	Réf prod.: DE 628 Taffetas	Vert pâle	150cm	51 % Soie 49 % Acétate	
CARLO VALLI	Réf prod.: CV 732 Lamé plissé	Or pâle	140cm	51 % Soie 49 % Polyester	
Fournitures	Fournisseur		Réf	Qté	Emplacement
zip	YKK				
Ruban	Galonnade				
Griffe	Léon Weil		n°863/C		
Crochet	Léon Weil		n°45/A		
Boucle	Léon Weil		n°37		

A FLAT DRAWING OF A SPEC SHEET INTENDED FOR THE WORKROOM. IT SHOWS OUR MODEL OF THE DRESS MESULINE, WHICH IS PRESENTED IN THE FINISHED ILLUSTRATION ON P. 97.

IN CONTRAST TO THE WORKROOM SPEC SHEET, WHICH GIVES ALL THE INSTRUCTIONS NECESSARY FOR THE PROTOTYPE'S MANUFACTURE, THE PRODUCTION SPEC SHEET HAS MORE DETAILED INFORMATION CONCERNING FABRIC QUANTITIES AND TRIMMINGS REQUIRED FOR SERIES PRODUCTION.

The "flat" drawings, which accompany the fashion illustration, are stylized in the general spirit of the project. For example, if the project is about pop art, then one can opt for flat drawings that emulate the graphics and style of the super-heroes in American cartoons, with a graphic feel close to that of pop artist Roy Lichtenstein.

When the technical drawing, or spec, goes to the workroom, it will be accompanied by instructions for the pattern cutter about the fabrics and trimmings. However, when these working drawings are intended for the production department, they are very rigorous and much more precise, for the modeler needs as much information as possible about the garment. This includes symbols that indicate the position of stitches and other essential details, as well as the all important measurements. Certain measurements, however, will only be given as an approximation. This is because too many restrictions will hamper the modeler, inhibiting his or her creative input regarding volumes and so on.

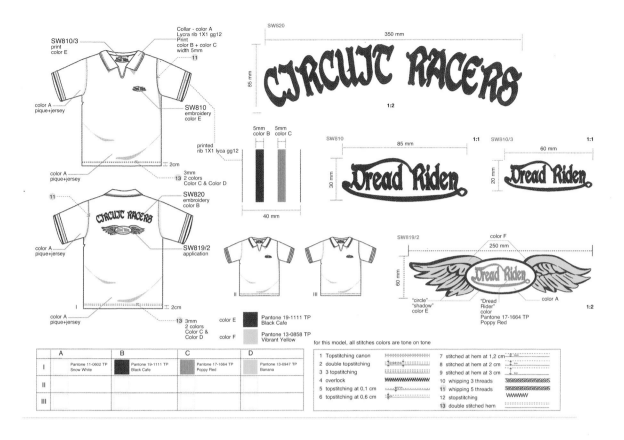

Flat drawings for outsourced production. The sheet
includes all the Pantone® references for the printing,
and the relevant instructions for the types of stitches,
positions of motifs and techniques used (embroidered or
appliquéd).

The production spec sheets include a sketch, and all the instructions concerning the fabric (reference, weight, composition), manufacturing details and necessary trimmings (shoulder pads, buttons, zippers, cloth, lining, etc.).

So that a particular detail can be easily understood, the designer might draw a close-up of the product, or present the same detail from different angles. For example, the drawing of a pair of trousers might show them with the zippers closed, and then a close-up of them open, to explain the finish.

Some technical drawings are so precise that they can be replicated as a working method, such as for knitwear where the diagrams indicate the manufacturing process and stitch textures.

A technical drawing must be explicit and give exact instructions. If in doubt, it is best to ask the atelier or supplier what material constraints should be considered and which essential instructions should feature.

It is important to be aware of the machines and tools to be used in the manufacturing process, as the technique can vary depending on the factory equipment used.

For the production of a prototype garment, such as the dress made by the Lutz brand (pp. 144–145), certain decisions will be made by the design consultants at the factory.

In the case of outsourced manufacturing, such as with the polo shirt above, the spec sheets are very detailed, as they will be used to make the prototype, which the designer will then approve before launching into large-series production.

At the end of this chapter there is an example of an original construction technique, demonstrating how to easily make flat garment drawings.

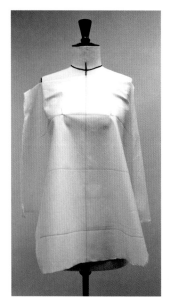

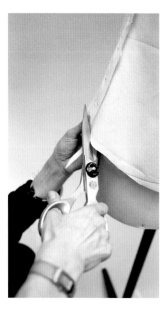

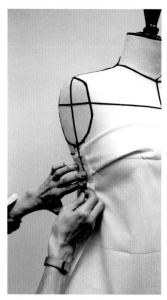

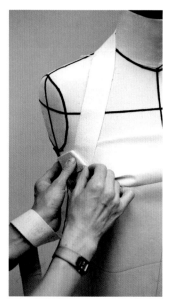

THE TOILISTE BEGINS BY PINNING THE TOILE ONTO THE DRESS FORM, MAKING SURE THAT THE CENTER FRONT GRAIN LINE (ALREADY TRACED ONTO THE TOILE) COINCIDES WITH THE CENTER FRONT LINE ON THE DRESS FORM. THEN PIN THE MOST PROMINENT PART, IN THIS CASE THE BUST, ENSURING THE OTHER LOCATION MARKS COINCIDE.

SCISSORS ARE USED TO SNIP OFF ANY EXCESS FABRIC ON THE TOILE.

ANY EXCESS MATERIAL CAN BE INCORPORATED INTO A DART ON THE BUST.

THE SHOULDER STRAP IS PLACED IN SUCH A WAY THAT IT RESEMBLES A HALTER NECK, AND AGAIN THE EXCESS FABRIC IS ABSORBED INTO A PLEAT.

Using the technical drawing supplied by the designer, the toiliste makes the prototype. There are two main ways of developing a garment shape: flat pattern drafting or draping on a dress form.

Flat pattern drafting consists of precision tracing, two-dimensionally, the different pieces that make up the garment. They are then cut and assembled three-dimensionally.

Draping involves fitting a toile fabric directly onto the dress form.

We have chosen the draping technique for our Melusine example, as it is the most appropriate method for the cut of the shape and the natural fall of the material – giving a lively and stylish look to the garment.

Draping is difficult to master and a highly regarded skill. Therefore, it is important not to obscure the fabric while researching the garment shape. Someone with a practiced eye, and who is familiar with fabrics, will derive great pleasure from draping a shape on a dress form, and will obtain a better result than a modeler who has not yet mastered this art. We consider it a mistake to start one's apprenticeship by flat pattern drafting, as it can be somewhat imprecise, rigid and limiting for the toiliste. Besides, there are certain shapes that would be impossible to make without draping them first.

Before starting the process, the modeler irons the toile to remove any

finishes that might be on the fabric. By mastering this technique from the outset, sharp, precise results can be obtained.

Then, using a mechanical pencil with a fine lead (0.3) that is quite hard, trace the straight grain and the crosswise grain onto the fabric. These will assist in assembling the different pieces in order for the balance of the garment to hang straight. The straight grain coincides with the center front line, the crosswise grain with the chest, waist and hip lines. The squares of this grid must always line up exactly in the middle of the side seams.

When fabric is used on the bias (to create drapes and flares; or for collars

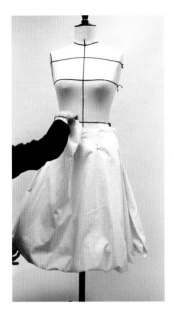

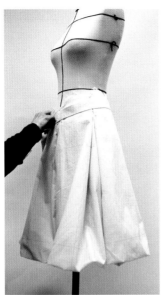

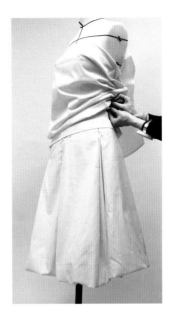

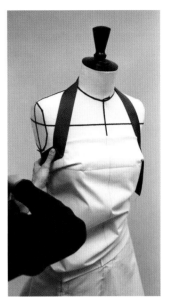

After having taken the top part of the toile off, the toiliste takes care of the skirt volume. Pleats are positioned around the waist.

Positioning an asymmetrical waistband onto the skirt.

Once the skirt is finished, the toiliste replaces the top to make up the dress.

To give a more finished look, the toile's shoulder strap is replaced by a piece of grosgrain fabric planned for the finished garment.

and belts where more stretch is required), the straight grain is at 45 degrees to the center front line and to the waist line. The toiliste rotates the fabric 45 degrees then traces the new waist, center front and cross-grain lines onto the toile to coincide with those on the dress form.

The notion of balance is crucial to the draping of standard designs, and demands regular practice in order to understand and master it. The modeler begins by pinning or taping the toile in the center front of the dress form (the garment's axes of reference being the center front and waistline).

Volumes are achieved by working with folds, pleats, gathers, etc. However, the natural fall of the fabric must be considered, otherwise the garment will end up looking tortured and fall badly. Being able to master the rotations and swings of a fabric will result in a well-cut garment, and, therefore, the directions of the grain lines and bias must be taken into account for each piece.

The tools used for draping consist of pins, tape, tape measure, scissors, pencil and tailor's chalk. To give the garment some volume, the excess is snipped off using the scissors, and different colored tape, either adhesive or ribbon, is used on the dress form to show the position of the shoulder straps and cutting lines. The folds, pleats, tucks and notches are marked using a pencil. (The notches are very useful when piecing together the different sections of the garment.) Pins are placed at regular intervals from the top to the bottom, slightly slanted so as to avoid any injury when removing.

Once the piece has been completely pinned and the toiliste is happy with the result, he or she uses a needlepoint tracing wheel along all the lines. These small holes will assist in the adjustment of the garment once it is removed from the dress form. The pins are carefully removed from each piece. Before removing the toile, the toiliste checks that there are no areas where he or she has forgotten to mark a seam, due to it being hidden by the pinned fabric.

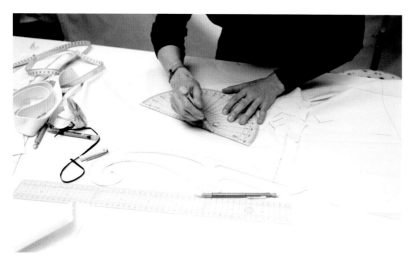

THE LINES ARE RETRACED ONTO THE TOILE USING A PROTRACTOR
AND COLORED PEN.

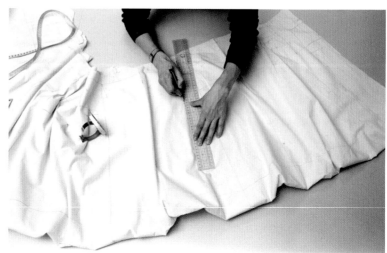

ONE AFTER THE OTHER, THE PINS ARE REMOVED FROM THE PLEATS,
THEN THE DIRECTION, EDGES AND PLEATS ARE MARKED USING A
COLORED PEN AND JAPANESE RULER.

When the garment is symmetrical, only one side of the toile is worked on (the right side); however, if it is asymmetrical, the entire model is worked, as in our example. Once the toile has been removed from the dress form, all the pieces are ironed before being laid flat on the cutting table.

The different pieces of the toile are placed onto the table, with the back and the front side by side (the center backs and fronts parallel). The remaining pieces that make up the pattern are then positioned, resembling a puzzle.

Adjustments consist of measuring and re-establishing the lines in relation to the grain line; checking the balance points of the pieces; and verifying the armholes and necklines, the sides and hems, and also the crotch in the case of a pair of trousers. The pleats, darts and folds are measured. The length of the darts in the front must not exceed 9 cm from the waist on the skirt part; however, those on the back can be up to 12 cm long.

The notches are checked and adjusted in relation to each other, if necessary.

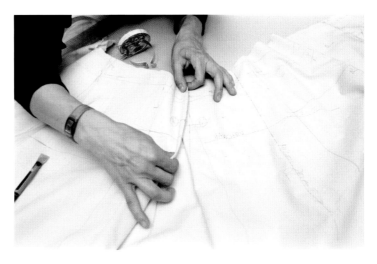

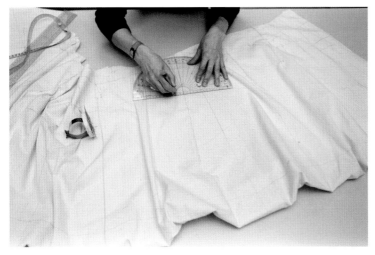

PLACING A LOCATION POINT WITH THE AID OF A PROTRACTOR
INDICATES WHERE THE PLEAT WILL BE SEWN.

When assembling the front and the back, it is important they do not form folds at the armholes, collar, waist or hem of the garment. To avoid this, the pieces must be lined up at right angles, and, so that natural curves are obtained, they must be pointing along the axes of these lines.

The heights, lengths and widths are measured and eventually adjusted to the desired size. It is also important to ensure that the front and the back are always 2 cm different.

A colored pen is used to mark precisely, clearly and neatly all the corrections that have been marked on the toile.

Finally, the seam allowances need to be made large enough for any correction, if necessary, during the fittings.

After finishing the adjustments, the toiliste returns the toile to the dress form so that the fall can be verified, and if the work has been carried out carefully, the toile will give a precise indication of what the final garment will look like.

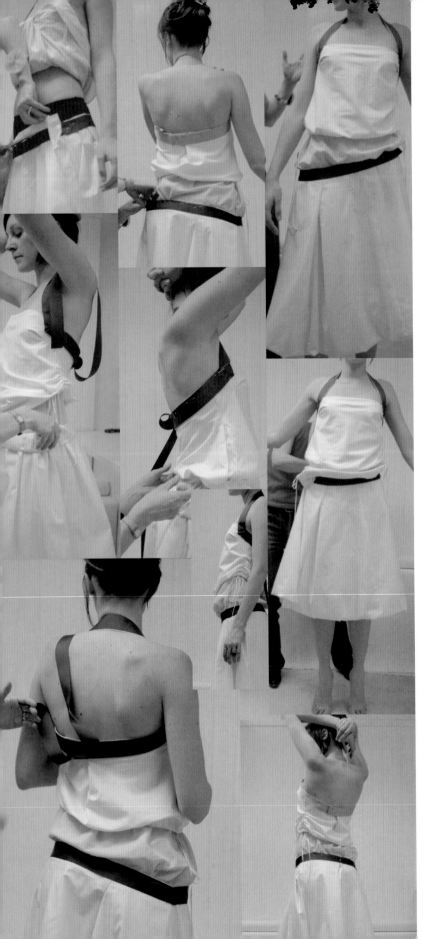

The different fittings are carried out in front of the designer, the atelier manager and the toiliste, with the aim of refining the garment on a real model. Depending on the complexity of the garment, the number of fittings and adjustments before the pattern-making stage can be more than the two we show.

First fitting

The fitting that happens after the first adjustment indicates whether the designer's sketches have been adhered to in relation to proportions, lines and style. It is also the first time that the designer and the modeler will collaborate. As we have already seen, the first reaction to the garment and the fall of the fabric can prompt further research, which is why it is important to choose, in the first place, the materials best suited to the garment. At this point, the person in charge of fabrics proposes the other samples that have been ordered as sample lengths from the fabric supplier. These will be folded or rolled, and hung on a clothes rack in the atelier.

The unlined garment is not sewn, but tacked (using large stitches to hold the seams together, that are easy to undo if necessary) or simply pinned. It is essential, at this stage, that the modeler anticipates the seam allowances, making them big enough for any eventual alterations. Tailor's chalk or tape is used to mark any alteration lines directly onto the garment. In spite of their practical aspect, waxy chalks that disappear when ironed are not advisable, as they can leave marks on delicate fabrics.

Second fitting

For the second fitting, before the pattern-making stage, the sample is cut from the sample-length fabric that the designer has chosen to make the prototype sample in.

The garment is assembled, using large stitches, with its lining. It looks like the finished item but the details will be added later. In order to make assembly easier, or modify its overall look if necessary, allowances need to be taken into account, as with the first fitting. The seams are indicated by a tacked thread that allows the modeler to easily find the original lines. However, it is important to be aware that with certain materials, such as silk and leather, the tacked seams will leave an impression.

The prototype sample will not be able to be altered after the fitting, and so will be abandoned and a new one made. These test pieces, however, can be sold on in the press sales that are held after the fashion show.

Final fitting

This fitting is where the final alterations are made and is used particularly with haute couture items. The sample is adjusted on the model who is going to wear it at the fashion show, or on the client, in the case of an order. Great care is taken with this sample in particular, for it is the finished article and a unique garment that is regarded as a work of art. The finishing touches and ironing can take hours. The collars, cuffs and hemlines must not be crushed, so they are rolled to keep the fullness of the fabric. The garment is entirely supported by reinforcing materials (linings, interlinings, interfacings, shoulder pads, etc.) and held by tacking threads that are pulled out once the sample is finished.

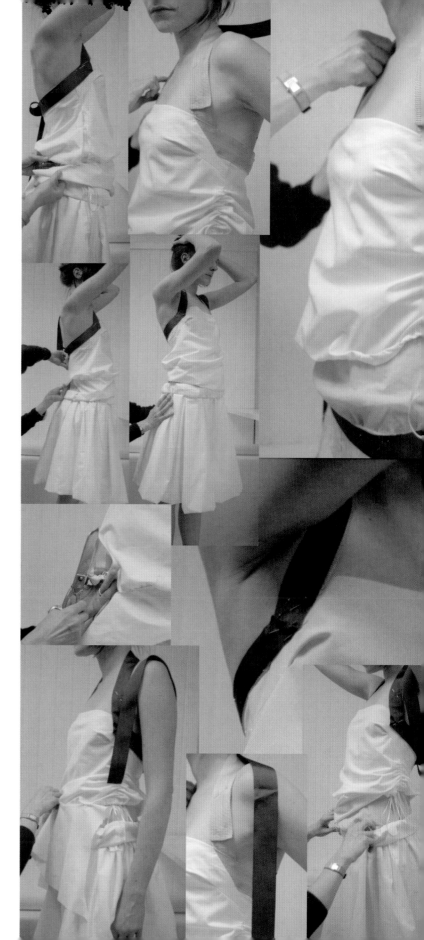

THE MEASUREMENTS ARE MADE USING A PERSPEX RULER AGAINST A SET SQUARE.

THE ARMHOLES AND DIFFERENT CURVES ARE MADE USING A FRENCH CURVE.

THE ANGLE OF THE SLOPE FOR CERTAIN LINES, SUCH AS THE SHOULDERS, IS MADE USING A PROTRACTOR.

THE PATTERN CUTTER MAKES SURE THE CENTER FRONT AND CENTER BACK LINES ARE PARALLEL BEFORE CHECKING THE PATTERN. THE PIECES ARE PLACED NEXT TO EACH OTHER IN THE ORDER OF ASSEMBLY.

To make a pattern, a flat impression is produced of all the corrected toile pieces that will eventually make up the finished garment. Using a pattern tracing wheel, the pieces are traced onto a sheet of flexible card for woven fabrics, or rigid card for leather. These pieces then become known as the pattern.

Even in the case of an asymmetrical item, these are then traced out as a complete shape, for in industry the cut is always made with the fabric open and not folded (see p. 161). The center front, center back and waist are marked on the pattern. These axes allow the item to be created in four additional sizes: 8/36, 12/40, 14/42, 16/44. Smaller or larger than these, and a new prototype will need to be made.

The modeler uses different colored marker pens to distinguish the different tracing lines – black for the main fabric, red for the linings, and green for fusible interfacings. Instructions are written on the right side of the pattern, which will then be placed face up on the fabric for tracing.

The pattern cutter then uses a pair of compasses to transfer the outline of the garment, taking into account the seam allowances: 1 cm generally for classic seams, 0.5 cm for necklines and cuffs, and 3 cm for a single-folded hemline. These measurements can, of course, vary depending on the machines and tools used during assembly.

THE MODELER USES A PATTERN NOTCHER TO MARK THE PATTERN.

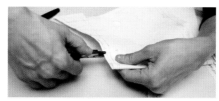

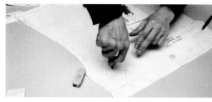

THE END OF A DART IS MARKED USING AN AWL.

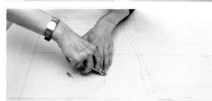

THE DIRECTION OF A PLEAT IS MARKED USING A PATTERN TRACING WHEEL.

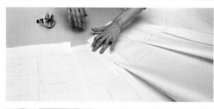

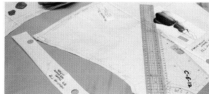

THE PATTERN CUTTER ADJUSTS THE DIFFERENT PIECES OF THE PATTERN OF A PLEATED SKIRT BEFORE RETRACING THE WAISTLINE.

THE GARMENT SKETCH, NAME, REFERENCE AND PATTERN SIZE ARE MARKED ON THE BACK PATTERN PIECE.

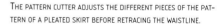

The sewing notches will indicate the arm-holes, hemlines, waist and position of inlays and zipper fastenings, etc. Every detail is meticulously marked.

The card is perforated in the places that correspond to the extent of the pins and the pocket outlines, so that they can be marked onto the fabric for the cut. This last procedure is essential when assembling mass-produced items.

Finally, special templates are made for pockets, collars and buttonholes – the curves, angles, directions and widths all need to be precisely detailed. These templates include the details of the pattern piece concerned, without the seams. The number of pieces that make up the pattern is marked on the reverse of each piece, along with their reference numbers. Information such as the season, the collection, name of item, reference, size and accompanying sketch is also included here.

The entire pattern is carefully laid out, with the smaller pieces fitting in between the larger pieces of the front and back. As they are placed in reverse on the fabric, this arrangement leaves all the information and inventory easily visible. Once made, all the pieces are attached together either by using tape, or with a pattern hook passed through a perforated hole in the cards.

THE CUTTER USES SHEARS TO CUT A NOTCH IN THE FABRIC ACCORDING TO THE PATTERN INSTRUCTIONS.

THE PIECES ARE CUT FOLLOWING THE LINE OF THE TAILOR'S CHALK. ONE HAND CUTS WHILE THE OTHER HOLDS THE FABRIC FLAT ON THE CUTTING TABLE.

In the workroom

The fabric, which has been rolled up on its right side, is unrolled and the different pattern pieces are positioned so as to waste the least amount of material possible. This positioning defines the lay plan that will be followed for the mass production of the garments, while the linings and supporting fabrics have their own lay plans. All these plans are attached to the item's technical file.

The cutter must take into account the fabric's direction when placing the pattern pieces. They must be positioned in the straight grain line, along one direction or another depending on the nature of the material – for example, the nap of a velvet fabric looks different depending on the direction, as is also the case with printed fabrics. The notches will help indicate the balance and direction of the pattern.

To make a prototype sample, the cutter traces the outline of the pattern pieces onto the fabric using tailor's chalk, and marks the notches and pockets in pencil. For greater precision, and to gain time, a symmetrical item can be folded in two, face to face, and cut with shears exclusively reserved for this process (although, as already mentioned, this does not apply to industry).

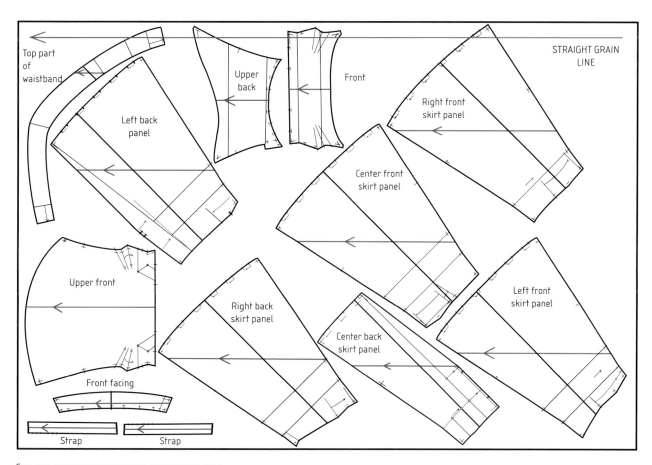

Top part of waistband

Left back panel

Upper back

Front

STRAIGHT GRAIN LINE

Right front skirt panel

Center front skirt panel

Left front skirt panel

Upper front

Right back skirt panel

Center back skirt panel

Front facing

Strap

Strap

CUTTING PLAN SHOWING THE POSITIONING OF THE PATTERN PIECES ON THE FABRIC.

In industry

For mass-produced items, the outlines of all the items are traced onto pattern paper (similar to, but thinner than, tracing paper). This is then placed onto the opened-out fabric.

From a large, horizontal fabric roll, the pattern cutter and an assistant unroll the necessary lengths of fabric onto the cutting table. There needs to be sufficient fabric to make a set number of samples. He or she places as many layers of fabric on top of each other as there are items to be cut – this makes up what is known as a "mattress," which can be made up of different colored fabrics if necessary.

The marking of notches, darts, pockets and buttonholes is done with a heated drill, or laser. Electric shears, with circular or vertical blades, are used to cut through the layers of fabric.

Some factories are equipped with laser-cutting material. Certain equipment manufacturers, such as Gerber or Lectra, provide tracing software programs and fully-automated cutting equipment to the industry.

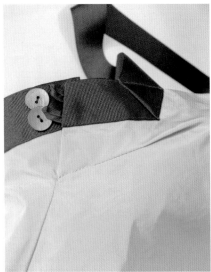

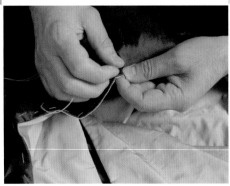

A DETAIL OF THE LEFT SIDE SEAM AT THE TOP OF THE DRESS: TWO LOOPED BUTTONHOLES, WITH BUTTONS, PLACED ON A GROSGRAIN RIBBON. THE EXCESS FABRIC ON THE BUST IS TAKEN UP BY A DART THAT ENDS IN A SMALL FOLD. IT IS NOT FLATTENED OUT WITH IRONING BUT LEFT TO BOUNCE BACK.

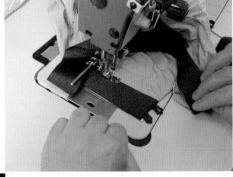

THE MACHINIST BEGINS BY SEWING THE WAISTBAND BY HAND. IT IS FIXED ONTO THE DRESS USING A SEWING MACHINE AND STRAIGHT STITCH.

The sample machinist

This is the person, in an atelier, who very carefully assembles the prototype pieces. It is at this stage that any problems with the pattern are flagged and corrected for production. The machinist works in close collaboration with the toiliste who made the sample, both at this point and at the pattern-making stage, for a skilled sample machinist understands cutting and pattern making. He or she will advise the toiliste on the best techniques for making the details, which tend to be the simplest and most tasteful. It is with this expertise that the garment is completed. For example, the machinist will be able to correct certain errors, or hide an excess of material within a seam.

The seams can be pressed open, or pressed to one side and topstitched. Topstitched seams are usually used on garments that require strengthening, such as sportswear, casual wear, children's wear and work clothes. Certain materials, such as leather, automatically require topstitching, as do details such as flat pockets, which can only be fixed to a garment by this technique. The sample machinist adjusts the length of the topstitch and can change the color of the

thread to give it the appearance of a saddle stitch.

In the haute couture world, all the finishing details are carried out by hand. Bias cutting and pleat work demand particular care – reminiscent of the dresses of Madame Grès and Madeleine Vionnet – and can only successfully be done by hand.

The final stage of this process is the ironing, which helps with the overall fall and finish of the item. Certain items require hours of ironing, in particular those with sleeves and suit collars.

The industrial machinist

In industry, the machinist is a specialized craftsperson who deals with the rendering and assembling of the piece, without correcting any eventual mistakes. This is why the corrections identified by the sample machinist must, without fail, be transferred onto the pattern by the toiliste (or by the design consultants).

A range of equipment is used depending on the different requirements. For example, when assembling seams, a flat sewing machine is used; shirts are made using a machine that specializes in American or "felled" seams; leather is worked using double or triple cams; a finishing technique that overlocks and assembles the garment in one operation is used for knitwear; blind hemming is used on scarves, and so on.

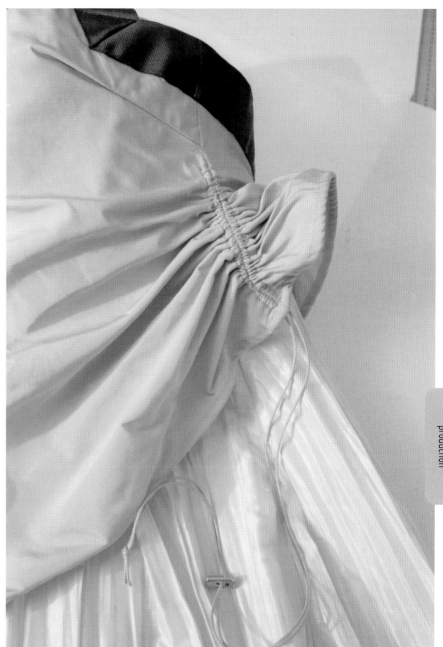

DETAILS OF THE LEFT SIDE SEAM AT THE TOP OF THE DRESS: A DRAWSTRING MAKES A SERIES OF GATHERS. THE HEMLINE IS FOLDED UP TWICE.

Flat drawing for a straight skirt

Flat drawings are constructed on a reduced scale that must be defined before the tracing is started. We have used measurements in this example that correspond to a size 10/38 in reality.

Each product needs to be based on real garment measurements so do not be tempted to do it freehand!

Trace the depth of the back waist (*ae*). Sometimes this depth can be confused with the waistline, as in our example (*e* = *a*).

Trace the depth of the front waist (*af*).

On the right, mark point *g* which corresponds to the height of the hips. This is situated at 7¹⁵⁄₃₂ - 7⅞ inches (19-20 cm) from point *a* in a size 10/38.

Trace a quarter circumference of the hips (*gg'*), which is equal to 36¼ inches (92 cm) divided by 4 (fitting tightly on the dress form), therefore 9¹⁄₁₆ inches (23 cm) more or less for a size 10/38.

Trace half the hem width (*bh*).

Trace the height of the waistband (*cc'*), (*ff'*), (*ee'*).

Join the points *f* and *c*, *c* and *g'*, *g'* and *h*, *h'* and *b*, to obtain the line of half of the front of the skirt. Then join points *e'* and *c'*, *f'* and *c'* to trace the waistband.

Place the starting point for the dart (*i*). The darts are placed 2⅜-2¾ inches (6-7 cm) from the center front under the waistline (*fc*) — the lengths of which must not exceed 3½ inches (9 cm) in the front.

If there is a secondary dart, put it halfway between the first dart (*i*) and the side seam of the skirt (*c*) for a classic style.

Draw the topstitching, darts, fastenings and all the other details that figure on your model.

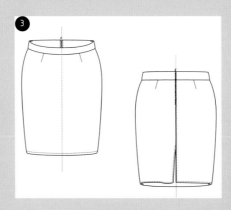

Trace the other half of the skirt, taking the center front line as your symmetry axis (*fb*).

From the front impression, trace the back, placing a seam in the center back, if necessary. Symbolize the zip with a zigzag.

Trace the skirt length (*ab*).

Trace half the circumference of the front waist (*ac*), which is equal to 26 inches (66 cm) divided by 4, therefore 6 ½ inches (16.5 cm), for a size 10/38. To make it look better, you can slightly reduce this measurement.

For a low waist, the waist is placed 3½ inches (9 cm) below the waistline. Consequently, the half circumference of the front waist (*ac*) will vary.

> Don't forget the skirt openings, using zippers or buttons. If a zipper is used on the side, place it on the left.

Flat drawing for a pair of straight-legged trousers

from the center front of a size 10/38 pair of trousers.

Trace the lines perpendicular to line *ij* from point *h'* for the knee line, and point *f* for the trouser bottom. Plot points *H*, *H'*, *F* and *F'* on these lines so that *h'*, *H'* = *H'H* for the knee line, and *fF'* = *F'F* for the bottom. These measurements will vary depending on the shape of the trousers.

Join points *F*, *H*, *g*, *e*, and *c* to trace half the trouser front. Plot points *a'*, *c'* and *e'*. Join points *a'* and *e'*, *e* and *c*, and finally *a* and *e* to determine the height of the waistband.

Place the dart, if there is one, under the waistline *ec*. This falls on the straight grain line *ij*.

Trace the total height (*ab*, equal to 43�5⁄16 inches, or 110 cm, for example), the depth of the front of the waist (*ac*), the height of the rise (*cd* — more or less 9⅞ inches, or 25 cm) and the quarter circumference of the waist (*ae*).

Plot point (*d*) on the line (*ab*); this determines the height (*cd*) of the rise. Then trace the line (*dg*), perpendicular to the line (*ab*). This corresponds to the quarter circumference of the pelvis. (Note: This is called the hip measurement, even if in reality it is situated below the hips.)

Finally, trace half the spread of the legs (*bf*). Trouser legs are very spread out (approx. 15¾ inches, or 40 cm). On your drawing, reduce this measurement to 7⅞ inches (20 cm) to make it look better. Then divide this measurement by two, as only half the drawing is traced.

Join the points *f* and *d*.

Plot point *h* on the line *ab*; this corresponds to the height of the knee. *ah* is equal to the length of the waist to the knee (22²⁷⁄₃₂-23⅜ inches, or 58–60 cm). On the drawing, plot point *h* halfway along the trouser length (at 21²¹⁄₃₂ inches, or 55 cm, i.e., 43�5⁄16 inches, or 110 cm divided by two). This will make it look better.

From point *h*, trace a line perpendicular to line *ab*. This cuts *fd* at *h'*. Plot point *h'* so that *h'h"* equals the width of the knee. Extend *bf* and plot point *f* so that *ff'* equals the width of the trouser bottom.

Plot point *i* in the middle of *ff'* and point *i* in the middle of *h'h"*. Trace the line that passes through *i* and *i'* and place point *j* at the intersection of this line and that of line *ae*. This line corresponds to the straight grain line of the trousers. Here you can check the precision of your drawing: after having scaled it up to life-size, verify that point *j* is 2⅜–2¾ inches (6-7 cm)

› Do not forget to convert the measurements marked here to the scale of your drawing.

Flat drawing for a pair of straight-legged trousers

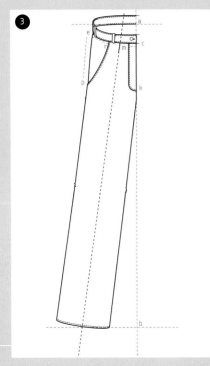

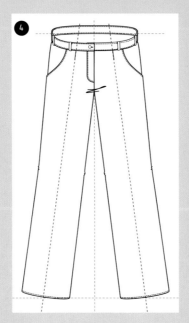

Trace the entire front of the pair of trousers, symmetrically. Using the impression of the front, trace off the back, with all the details, paying attention to the crotch at the back, which rises higher than at the front. It is very important to include the profile, as this shows the style of trouser, i.e., straight, wide, flared, etc.

Align the three drawings on the same reference points (waist, crotch, knee and bottom lines) to check that the heights all correspond.

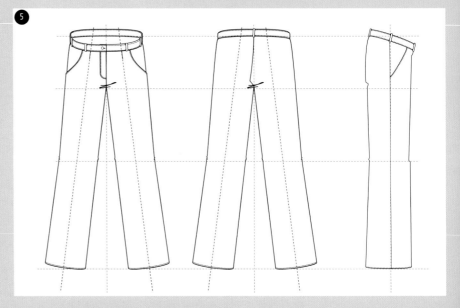

Now position the details. Trace the height of the fly opening (*ck*), the width (*mc*), the height of the pocket (*ep*), and the pocket opening (*er*).

From point *m* trace a line parallel to (*ck*) that curves around to end at point *k*. The zipper opening will vary again depending on the style of the trousers. Finally, trace on the belt loops (normally, for each half, one on the front, side and back) and all the other details by joining up the corresponding points.

Flat drawing for a long-sleeved tee shirt

To begin, trace half the front left body, then the sleeve.

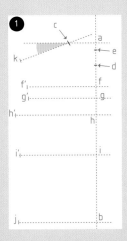

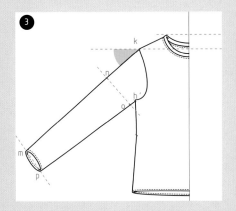

kh' is equal to the height of the armhole (5½–7⅛ inches, or 14–18 cm).

Join points *e, c, k, f', g', h', i', j, b,* and *d, c* to trace the outline of half the front.

Plot points *c', e'* and *d',* so that *cc' = dd' = ee' =* the height of the collar.

Trace line *ab*, which corresponds to the entire length of the tee shirt. Then trace a line perpendicular to *ab*, passing through point *a* and plot point *c*, which corresponds to the shoulder point on this perpendicular. Length *ac* is equal to half the neckline.

Plot points *d* and *e* on the line *ab*, *ad* being equal to the depth of the front of the neckline. Plot points *f, g, h* and *i* on *ab*. The following lengths are then determined: shoulder point/cross chest ((*af*) = 4 inches, or 10 cm); shoulder point/cross bust ((*ag*) = 5½ inches, or 14 cm; shoulder point/chest ((*ah*) = 9¹⁄₁₆–10¼ inches, or 23–26 cm); chest/waist ((*hi*) = 6⅜–7¹⁄₁₆ inches, or 16–18 cm).

From these points, trace the perpendiculars onto the line *ab*, and plot points *f', g', h', i'* and *j* so that *ff'* is equal to the front top half-chest, *gg'* to the lower front half-bust, *hh'* to the front half-chest, *ii'* to the quarter circumference of the waist and *bj* to the half-width of the bottom of the shirt.

From the neckline, point *c*, use a protractor to trace the shoulder line, taking into account the angle (in our example it is 20 degrees). On this shoulder line, plot point *k*; *ck* is equal to the shoulder length (4–4¾ inches, or 10–12 cm).

Using a light box, from the center front line trace the other side symmetrically. This will give you the entire tee shirt. Use the front impression to trace the back, modifying the cross back and the neckline.

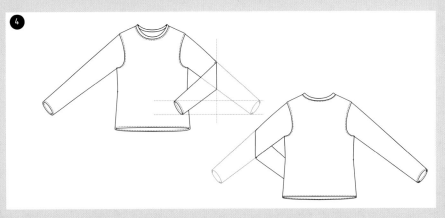

From point *k* which corresponds to the shoulder limit, use a protractor to trace the line above the sleeve, taking into account the angle of the slope (about 30–35 degrees). Plot point *m* at this juncture; *km* equals the sleeve's length (22²⁷⁄₃₂–23⅝ inches, or 58–60 cm).

Plot point *n* on the line *km*; *kn* being more or less 4¾ inches (12 cm). From point *n*, trace the perpendicular *no*; this equals the width of the arms. From point *m*, trace the perpendicular *mp*, which equals the opening at the bottom of the sleeve. Join up points *k, m, p, o* and *h'* to obtain the line of the sleeve.

Do not forget to draw on the stitching, pockets and all the other details that figure on the model. The more the drawing is like the original, and the fewer details it has, the more likely it is to work.

Flat drawing for a shirt

The order of tracing for a shirt is as follows: front left half body, collar, button stand, other details, cuff, and lastly the back.

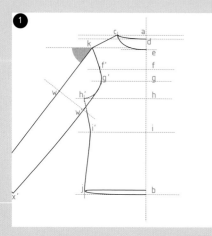

Use the same process as for the tee shirt to trace the front of a shirt. However, pay attention to the shoulder-to-sleeve angle (40–45 degrees), which is more pronounced on a shirt. The shoulder angle, on the other hand, stays the same (20 degrees). Trace the sleeve, without the cuff, in the same manner as for the tee shirt.

ab = center front, total length;
ac = neckline opening;
ad = back neckline depth;
ae = front neckline depth;
ff' = ½ cross front; *gg'* = ½ cross chest
hh' = ¼ chest circumference; *ii'* = ¼ waist circumference;
bj = ½ bottom front width; *ck* = shoulder length;
kx = sleeve length (without the cuff);
xx' = opening at bottom of sleeve;
ww' = sleeve width.

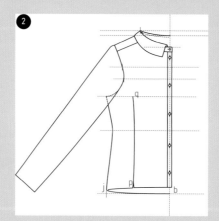

Trace on the button stand, indicating the direction of the buttonholes.

The buttonhole at the base of the collar is always horizontal, whereas when they are on the stand, they are vertical. Place the buttonholes on the axis *ab,* making sure they are symmetrical. Once this is determined, the width of the stand will become apparent.

Trace the length of the front dart (*pq*), chest pockets and shoulder strips if there are any on your model. Every detail of the shirt must figure on the flat drawing, with instructions concerning stitches and seams in particular.

Using a light box, trace off symmetrically the center front left.

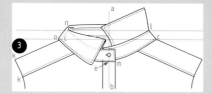

When you trace the collar, consider lifting one side of it to show the assembly (stitches). Trace *cl*, the height of the collar and *no*, the fall of the collar. The overlap measurement (*em*) varies depending on the size of the buttons used. When tracing this, make sure that the buttons are placed in the center front of the shirt. You must, therefore, take the measurement between point *m* and the axis *ab*. The height of the yoke (*kk'*) depends on the type of shirt.

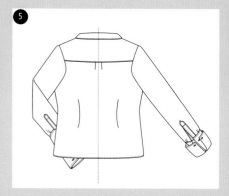

Trace the height of the cuff (*st*), the height of the shirt stand (*uv*) and the width of the buttonhole stand (*ww'*).

Fold one sleeve back so that the front and back details of the sleeve's cuff and opening figure on the same drawing. If the cuff is of a musketeer type (as in our example), then consider drawing it both folded and unfolded. Square off the buttonhole stand.

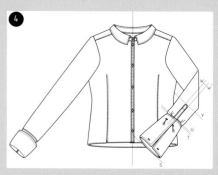

From the front impression, trace off the back. Think about modifying the yoke, the armholes, the width between the shoulders and the pleat (for men, rounded, hollow or flat), or state whether the model has gathers, etc.

Flat drawing for a suit jacket

Use the same method as for the shirt, considering the collars, armholes and other details that are particular to this product.

Be careful not to use the drawing of a tee shirt, or shirt/blouse, as each of these products has a completely different cut: the tee shirt is knitwear and the shirt is a nonfitted product, like a dress, while a jacket is a tailored cut.

Sleeve tracing.

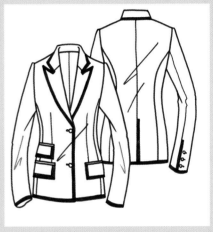

Other examples of flat drawings of the front and back of a straight suit jacket.

Body tracing.

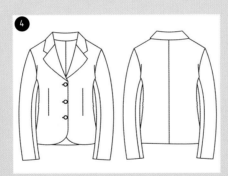

Flat drawing of the front and back of a straight suit jacket, lined, with three buttons.

Collar tracing and its angle.

> You can also show the sleeves folded, as we have done in our example for the tee shirt and shirt. This allows you to present the cuffs, front and back, on the same drawing, which is most important in the case of a shirt.

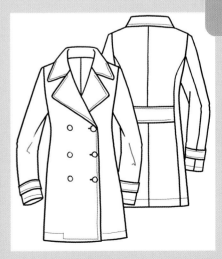

Examples of flat drawings of the front and back of a long reefer jacket.

Nowadays, the fashion sector requires ever-increasing budgets to take care of the promotional and marketing campaigns of its brand images and product sales. A company's public relations (PR) department will organize a whole range of high-profile media events, including fashion shows, product launch parties, and "happenings" for boutique openings – an example of this being the opening night of Louis Vuitton's large department store on the Champs Élysées – in Paris, with performance artist Vanessa Beecroft.

The planning of a fashion show involves a large number of people, including a producer, who is responsible for arranging the place and for the choreography of the show (either by him or herself or with the help of a choreographer), and a media officer, who takes care of the invitations and press coverage. Eventually, bookings will need to be made for the models and their entourages, which include hairstylists, makeup artists and dressers. Other necessary people include a variety of technicians for sound mixing and lighting, security guards, caterers, artists and musicians. Finally, all sorts of assistants will be recruited to coordinate the event.

A veritable "armada" is needed to ensure the successful promotion of a collection: merchandisers, who choose the commercial pieces that need to be incorporated into the show; PR companies or independent press officers; event organizers; publicity agents; fashion journalists, who work in collaboration with the show's producer; fashion editors; stylists; photographers; illustrators; interior decorators; graphic designers, etc. To ensure maximum exposure the media is courted, as the fashion show (and its buildup) will be televised, in the press and on the Internet.

Today, it is the artistic directors, whose styles are synonymous with particular brand images, who orchestrate these events. For example, John Galliano or Hedi Slimane for Dior, Karl Lagerfeld

for Chanel, Nicolas Ghesquière for Balenciaga, or Alber Elbaz for Lanvin. The store windows also contribute greatly to the fashion show's promotion, for it is often the artistic directors themselves who dress them, as in the case of Alber Elbaz for Lanvin.

Film festivals, such as Cannes and Deauville, and the presentation of the Oscars, are also significant promotional platforms. It is here that the press office will solicit celebrities to wear clothes and accessories from a particular brand. In some cases, fashion stylists are employed to dress the stars, which in turn contributes to the promotion of the fashion house. Finally, top-level sporting personalities can be sponsored by a particular brand. All of these activities increase the level of high-profile exposure.

The key to successful promotion, however, lies in publicity campaigns with the press, advertising, radio and the increasingly thriving Internet. (Note that there are a vast number of sites and blogs dedicated to the fashion world, which are easily accessible and where information is updated daily.)

The press, which is largely financed by advertising, makes an increasing effort to satisfy advertisers by offering regular editorials.

Today, brands will call in specialized design collectives such as *Surface to Air Paris* or *Work in Progress* to help with promotion, as they are able to target larger market sectors.

In this final chapter, we have chosen to illustrate the promotional aspects of a product by accentuating the fundamental role of the media office and PR department, as well as to depict a "fashion product" using a series of visual means. Therefore, to represent our dress Mesuline, we have enlisted the help of illustrator Antoine Kruk and photographer Stephan Schopferer.

We also explain the work of the fashion stylist and photographer, makeup artist and hairstylist, then conclude by going backstage at a fashion show.

It is the person in charge of public relations who is ultimately responsible for the brand's promotion, and that of its products. This can be someone who is incorporated into the brand's company, with the title of "director of communications," or someone working in an independent PR company. The latter use showrooms where they present and promote different products and brands. Their role is to place a product into the market, promote its image to the public and make sure that the brand image is respected or redefined, if necessary, in close collaboration with the artistic director and merchandiser. They can also be the link between the company and any eventual partners in the case of a license (where a designer works in conjunction with industry, and royalties are involved).

Press release

This contains text regarding the presentation of the brand, the designer, and the season's themes, as well as visuals (photographs or illustrations) showing the look. This is the stage where the fashion stylist and photographer establish a coherent iconography. The press release also includes descriptions of the items, a list of retail outlets for the brand and a price list.

Events management

The PR person is responsible for planning strategic publicity events such as product launches, store or boutique openings, presentation of the collections, new lines and products, or even an event marking the presence of the brand in a new country (see Sourcing and sales representatives, next page). The main events that he or she organizes are the launch parties and the fashion shows, as well as all the arrangements concerning the location, the model castings (for the shows), the invitations, the press releases, etc. He or she compiles an extensive list of contacts which includes press, art, film and theater personalities, VIP clients, and buyers from large department stores and buying houses.

Press conferences

The PR person, being the interface between the company and the media, is the one who organizes press conferences, press packs and exclusive interviews in order to establish a dialog with the media.

Mail shots

Mail shots help to keep journalists informed of special events, such as press sales and open days which maintain good and positive professional relationships.

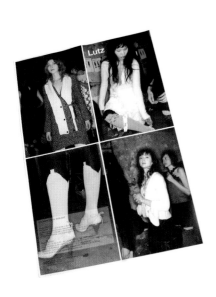

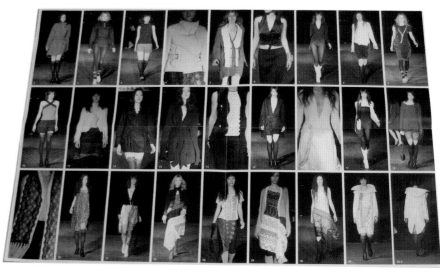

Lutz's Fall– Winter 2006–2007 collection is presented as a brochure (both sides being shown here). The photos were taken during the fashion show.

Advertising

The PR person works in collaboration with advertising agencies in order to define and maximize the client's image, choosing to advertise in, or on, various formats: posters, billboards, newspapers, specialist magazines, and advertising slots on television or the Internet, at the cinema or theater, etc.

Sourcing and sales representatives

In some cases, the sales representative's office will intervene in the distribution strategy of a brand, adapting its image to suit the market. This practice is common in the United States and many Asian countries.

Sponsorship

This is where companies and/or institutions form partnerships with individuals or groups and work symbiotically for mutual publicity. The largest groups within the international textile industry have also associated themselves with sporting personalities and events – for example, Louis Vuitton and the 1998 World Cup with the famous football that was immortalized by the work of the sculptor Arman, or Nike with Michael Jordan or the Brazilian soccer team. Another example is the participation of the famous champagne house, Moët et Chandon, at the young designers' fashion shows, which associates design with luxury.

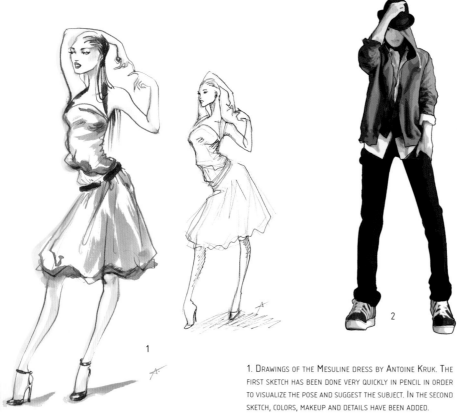

1. DRAWINGS OF THE MESULINE DRESS BY ANTOINE KRUK. THE FIRST SKETCH HAS BEEN DONE VERY QUICKLY IN PENCIL IN ORDER TO VISUALIZE THE POSE AND SUGGEST THE SUBJECT. IN THE SECOND SKETCH, COLORS, MAKEUP AND DETAILS HAVE BEEN ADDED.

The influence of digital technology

Today, an illustrator is more often than not a graphic designer who has mastered new technologies and is able to create images by combining photography and illustration.

"Digital" styles appeared in the 1990s due to the evolution of graphic and photo-enhancing software, coupled with the rapidly expanding trends of street and sportswear. It was only logical that these two market sectors, working to develop new materials from new technology, would look to a new generation of computer-literate illustrators to promote their brands.

Graphic designers have the advantage of being versatile: they can create a brand's visual image and develop it in a range of different media (posters, advertising booklets, on billboards; etc.). This digital process has been facilitated by the advent of tools, such as graphics tool boxes that replace the mouse with a "digital pencil," scanners that allow you to digitize a drawing, and photographs that can be reworked on a computer. Notable exponents of this type of work are Annette Marie Pearcy, Stephane Goddard, Tatjana Jeremic, Autumn Whitehurst and Ling Chen.

These differ again from the technical drawing or the fashion illustration – both of which are necessary for the sample's manufacture – as they are high-quality stylized sketches that are full of energy and generally somewhat abstract.

It is essential to be able to capture a mood or atmosphere, and to incorporate movement and life into the drawing. Concentrating on proportions, lines of direction and colors is more important than the construction details, in this case. An era is marked by its illustrations, graphics and moods. The illustrations of *La Belle Époque* by Alphonse Mucha are emblematic of art nouveau at the beginning of the last century; in the 1920s it was Erté's roses; in the 1950s it was the illustrations of René Gruau for Dior; in the 1970s, those of Antonio Lopez; in the 1980s, those of Thierry Perez and Tony Viramontes; and in the 1990s, those of Mats Gustafson. However, during the 1960s, photographers were more in vogue than illustrators, a trend that is affirmed by Antonioni's film *Blowup*.

The beginning of the 21st century sees a strong return to illustration, with, among others, Julie Verhoeven and Jean-Philippe Delhomme. A current example of this is the concept store Colette in Paris, which does not hesitate to use the talents of up-and-coming illustrators for the visuals in its store windows.

The look

The choice of illustration used to present the "look" of a collection is interesting, as it can exaggerate certain characteristics, like a caricature does, and translate different stereotypes into one homogeneous whole. Normally, the look defines the image that one wants to portray to others, allowing for a succession of different identities.

It encompasses the comfort of a classic identity, the confrontational spirit of others such as punks or goths, and can even depict a kind of social or professional "belonging," as with a uniform.

The look presents typical silhouettes that have a dress code belonging to a particular urban "tribe" – the way the garments are coordinated confirms the social group with which they identify themselves.

The phenomenon of urban tribes is perhaps a consequence of the disappearance of social divides and of the supremacy since the 1970s – with the feminist movement, and the androgynous model incarnated by Jane Birkin – the eternal, asexual adolescent. This supremacy is evident in the masculine collections of Kenzo and Paul Smith, where the men are covered in floral patterns, and in the work of Hedi Slimane for Dior's men's collection, where the models are young, slight men, barely out of their teens – contrasting dramatically with the muscle-bound men of the 1980s. Soft, supple fabrics and women's accessories have found a new "niche."

The study of "looks" is a new sociological approach and it is necessary for designers to recognize and understand them in today's society. Equally, the look is a fashion phenomenon; it follows trends from the futuristic silhouettes of the 1960s with Courrèges, Pierre Cardin and Paco Rabanne, right up to complex shapes that deconstruct the body, including djellabas, tunics and bell-bottom "hippie" trousers, to the structured lines of the 1980s with Thierry Mugler and Claude Montana, and the minimalism of the 1990s with Prada, Helmut Lang and Jil Sander – to name but a few!

To demonstrate some current looks, we present here some images from fashion illustrator Antoine Kruk's book, *Shibuya Soul*. These different street attitudes have been taken from the trendy areas of Tokyo, such as Shibuya, Harajuku and Daikanyama.

1. CLUBBER
2. NEO-HIPPIE
3. STREETER
4. DAIKANYAMA LOLITA
5. PORNO-CHIC LOLITA
6. SHOPPER
7. ROCKER
8. PIN UP
9. CLASSIC CHIC

Defined by Rebecca Leach

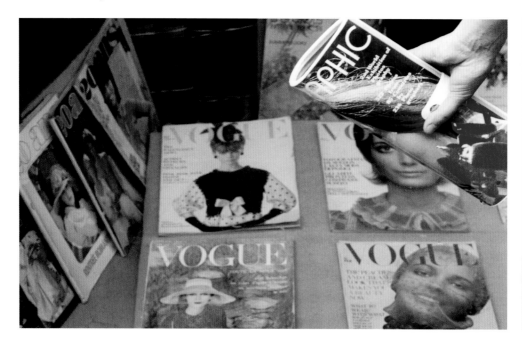

The fashion stylist works very closely with fashion magazines and photographers. A stylist is not a designer, but an interpreter of fashion, who puts together the concept of the looks for the photographs. He or she can also coordinate the fashion show looks, as well as working as a personal shopper (see Chapter 1, p. 31).

Magazines

The stylist organizes the shots for editorials. The garments are displayed, ironed and tried on the models in the studio. After discussions with the hairstylist and makeup artist, the stylist will use pins to adjust the garment on the model so that it fits perfectly. A stylist must always have his or her little box of tools so that the garments can be invisibly altered.

Celebrities

Whether it is a question of dressing a musician for a CD cover, or coordinating an actor's wardrobe for special events (festivals, award ceremonies, etc.), the stylist must find the most suitable look for that person's personality and body shape. As these people are not mannequins, it is most important not only that the garment looks its best, but also that the person feels comfortable, and not self-conscious, when wearing it.

Promotion

The stylist will also organize photographic shots for catalogs, press packs and advertising, making sure the client's brand is foremost.

There is an art in being able to adapt to the client's taste – an attribute that the stylist must possess. For catalog shoots, the stylist also arranges the settings and decor. The press pack shots, which present the entire collection to the press, are very similar to those of the catalogs.

In the case of advertising, the stylist works in the spirit of a costume designer: he or she creates the style corresponding to the staged character's identity.

Fashion show organization

Here the stylist's job is to coordinate the looks, organize the casting of the models, choose the lighting, select the music, etc., and sometimes help backstage with

the dressers, makeup and hairstylists. They can also be enlisted to send out invitations, to buy accessories, underwear and small items such as tights or inner soles, and to even manage part, or all, of the budget allocated to the models.

Consultation

Companies and designers will call on stylists for their ideas and knowledge about current fashion trends. At this point, they can inform the designer about the "best of" products that could have initially been overlooked. The price of a consultation, however, can be quite high.

Rebecca Leach, alias Molly Coddle, has worked as a stylist in Paris for seven years. Graduating from the Metropolitan University of Manchester, where she studied fashion history, she wrote a thesis on the alternative youth culture and their dress codes:

Fashion styling is a visual language, an art which helps one understand the human condition better. My sources of information stem from the internet sites of press offices, young designers and "style.com." As for buying, I choose according to my taste. I store the gathered information in a summary file on my computer, then contact the PR departments of the selected brands to see whether the clothes are available. Once the products are received, both clothes and accessories, I organise my looks.

This process of coordination does not follow any specific rules. Each fashion stylist has their own signature or trade mark – Camille Bidault-Waddington, Hector Castro (two stylists with very specific approaches), L'Wren Scott, or Carine Roitfeld, for example, all have individual and different styles.

For a fashion photo shoot, it is important to link all the elements illustrating the theme, so that the photographer has enough material to create his or her image. The cut, proportions, color and texture of the proposed garments are chosen as a consequence thereof.

The opposite is also possible – the stylist can ask the photographer to react to a theme imposed by him or her. The key to a successful shot is good solid preparation.

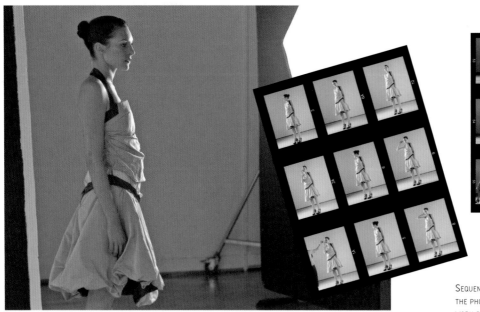

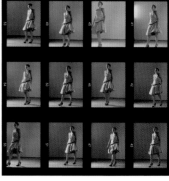

SEQUENCE OF PHOTOGRAPHS BY STEPHAN SCHOPFERER. LEFT: THE PHOTOGRAPH CHOSEN TO REPRESENT THE DRESS MELUSINE, WORN BY THE MODEL VERONICA. RIGHT: CONTACT SHEETS OF THE PHOTOGRAPHS TAKEN AT THE SHOOT.

Specialities

The fashion photographer works for fashion magazines, advertising agencies, designer campaigns, etc., and is chosen for his or her style, whether it be classic, commercial or avant-garde.

The basic journey of a photographer is in three stages: photography school; then as an assistant in a photo studio or with a photographer, where he or she applies all his or her knowledge, putting it into practice; and finally, independent practice where his or her individual style can be honed and refined.

He or she can also fill the position of artistic director, like Olivier Toscani with Benetton, who favors the concept of marketing and whose shocking images and antiracist messages are, strictly speaking, no longer fashion photographs.

A fashion photographer can specialize in a variety of fields, such as portrait, advertising, still life, art photography, etc.

Celebrity photos of Björk, Madonna or Nicole Kidman, or of sporting personalities such as David Beckham, resemble fashion shots more than they do simple portraits. However, Mario Testino is a fashion photographer who is perhaps better known for his pictures of Lady Diana Spencer than for his fashion photographs.

There is a fine line between fashion and art photography. The numerous exhibitions devoted to fashion photographers by art galleries and museums confirm this, with works by Jurgen Teller, Mario Sorrenti, and Steven Klein. However, the stolen snapshot, spontaneous and not touched up, is also in vogue.

Advertising photography stages models wearing designer labels, with the

sole purpose of promoting the products for the consumer. The desired image is that of perfection, making sure the garment is shown off to its best advantage. On the other hand, fashion photography that is inspired by still life portrays garments or products without models. This type of informative photography tends to be used for catalogs and press packs.

In addition to this, fashion photographers can produce a series of fashion compilations for magazines where the models are not staged, but going about their everyday business.

The support team

For a shoot, the photographer, stylist, model, hair and makeup stylists and photo assistant must be able to work as a team. The approach varies depending on what

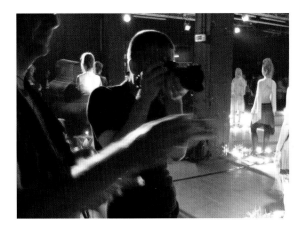

type of magazine is targeted: independent or conventional; with a fashion supplement; catalog; or press pack.

Independent magazines, such as *Techni Art*, are creative, and will allow the photography team to express themselves freely. The photographer aims to recreate an atmosphere, provoke a reaction and create an identity – in this instance, the clothes accessorize the photo. The same freedom of expression exists with certain press promotions such as those of Gucci, Yohji Yamamoto, Comme des Garçons and Dior, whose last advertising campaigns were carried out by Nick Knight. Photography must, first and foremost, inform the public about the brand. In this situation, the photographer and stylist work together to define the atmosphere and setting. The location for the shoot needs to be decided, whether it be in a studio, inside (apartment, café, hotel room, etc.) or outside (town, countryside, beach, etc.). The photographer chooses the lighting (flash, daylight, etc.) and the staging (dramatic, natural, experimental, etc.). The choice of model is very important, as it is he or she who brings the concept to life. The hair and makeup stylists' respective talents are put into practice and a brainstorming session with the whole team takes place prior to the shoot.

For large distribution fashion magazines, catalogs and press packs, where the last collection or a new season's trends are presented, the garment is central to the photo. The photographer and team work in conjunction with the client, who will have the final word concerning his or her product!

The shoot

The number of photos and days devoted to the shoot varies depending on the client's demands, the support team and the preparations required for the photograph. It can vary from two to 25 shots a day. Advertising photos, particularly beauty shots which require a lot of work with makeup, hair and lighting, take the most time. On the other hand, a series of six to 10-page fashion editorials will take one to two days. However, in the case of a special edition, or a particular magazine, the number of photos and days set aside for the shoot will vary accordingly.

For catalogs and press packs, the photographer will do 10–25 shots per day. There is less modification per shot, the studio lights are barely altered and it is rare to change venue for outside shots; hair and makeup tends to stay the same.

As with a lot of jobs today, the work of a photographer has developed with the advent of new technologies. Digital photography has introduced a new approach, with computer-enhanced images being increasingly more desired. The result is somehow not realistic, yet to our eyes it

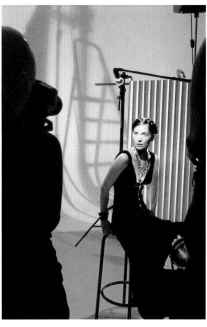

TOP: PHOTOGRAPHER JULES HERMANT TAKING A PHOTOGRAPH OF MODEL ALI MADHAVI AT A SHOOT FOR THE FOR THE LOULOU DE LA FALAISE FALL-WINTER PRESS CATALOG. ABOVE: THE MODEL IS LUCIE DE LA FALAISE. HAIR BY KATIA AND VALENTIN. MAKEUP BY TANIA GANDRE. STYLIST ELIE TOP.

has now become the norm. Skin appears softer and unwrinkled, and bodies possess a dreamlike perfection.

Photo sessions: makeup
Stéphane Marais, Beata Rosinska

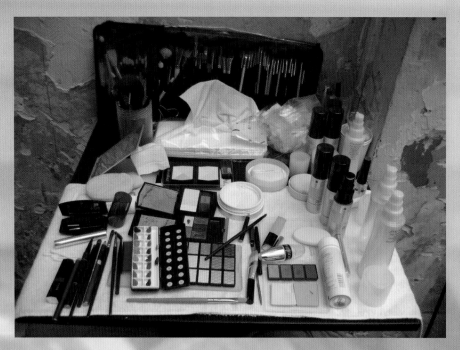

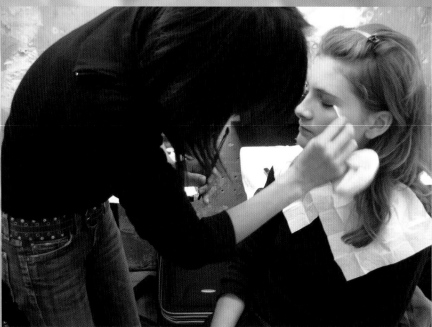

The art of makeup renders the models almost perfect for the catwalk or photo shoots. Certain makeup artists have such a distinct style that it becomes their signature. This is the case with Stéphane Marais, who has worked with numerous photographers – Peter Lindbergh, Paolo Roversi, Irving Penn, Annie Leibovitz, David Sims, Michael Thompson and Steven Klein – for international fashion magazines such as *Vogue*, *Harper's Bazaar* and *W Magazine*, and with fashion stylist Franck Benhamou for the covers of the magazine *Numero*. He has also worked with famous designers on the catwalk, including Lacroix, Gaultier, Comme des Garçons, Issey Miyake and Viktor & Rolf.

In an interview,* Stéphane Marais states that he is interested in working with all skin types – black, white and Asian. He is quoted as saying, "I am interested in ethnic groups which have long been ignored." His makeup is the result of extensive research – for example, his interest in the Nuba people of the Sudan has inspired some of his fashion show work. It is essential to have a good grasp of general culture in order to understand the stylist and reinforce the themes that are being presented.

Stéphane Marais prefers natural-looking makeup that allows the model's skin to show through. According to him, a successful makeup application is one "Which gives the illusion of being invisible, as if one has taken most of it off just after it has been applied."

He makes a Polaroid record of each of his catwalk makeup sessions, a selection of which can be found in his publication *Beauty Flash* (Edition 7L, 2001).

* France Japon Éco magazine, summer *2002*.

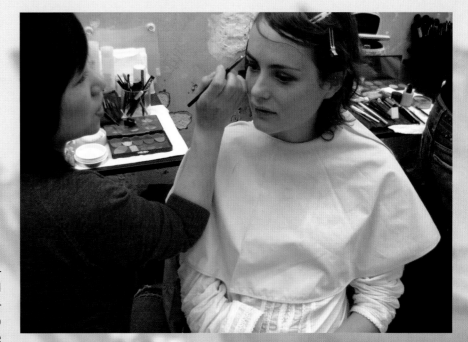

For makeup and hair stylist Beata Rosinska, ex-assistant to Nina Haverkamp (Jed Root agency) and to Ashley Ward (Watson Agency) in London, the skin is also the most important part of makeup. She chooses invisible, delicate, luminous foundations and avoids applying them around the eye area. Then she concentrates on the parts of the face that are the most inspiring: the mouth, the eyes, the cheekbones. "I prefer delicate and transparent textures that do not look overloaded."

The second stage is to correct the under-eye shadows with a cream that is fixed with a light dusting of powder. This lightens and rejuvenates the face.

Blush is the final stage, which gives structure and definition to the face, as well as correcting any blemishes and creating a radiant complexion. The most important factor is that the makeup looks harmonious.

Naturally, she changes her style to suit the different designers and clothing, without losing sight of the spirit or theme of the show. For cinema photography, the "rules" are stricter, particularly taking into account the lighting.

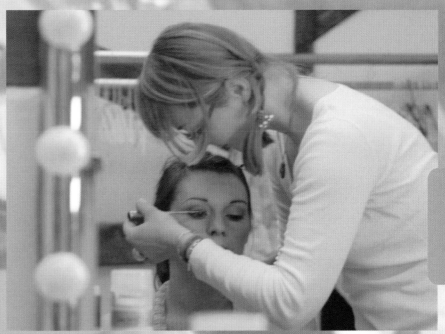

BACKSTAGE AT THE PRESENTATION OF THE SPRING-SUMMER 2007 COLLECTION BY LUTZ.
LEFT AND ABOVE: MAKEUP SESSION OF VERONICA BY BEATA ROSINSKA.

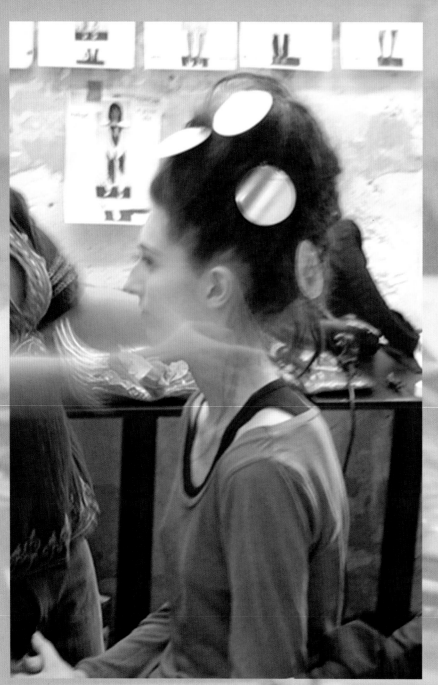

Hair styling has become a complete art for Odile Gilbert, who for more than 20 years has demonstrated her talent and skill in the world media. Supreme recognition came on the July 2, 2006, when she was made a Knight of the Arts (Chevalier dans l'ordre des Arts et des Lettres). She belongs to that generation of top models such as Naomi Campbell, Linda Evangelista and Claudia Schiffer.

Her rich experience with Chanel, Lacroix, Gaultier, Hermès, Rochas, Cèline, Bottega Veneta, etc. means that she is constantly reviewing her inventive approach to hairdressing, whether it be for a fashion show or a photo session. "Hair is alive, that is its beauty," she told us.

Odile Gilbert began her career as an assistant in 1975 in Bruno Pittini's hair salon and studio. "Hairstylists must study the techniques and chemical compositions necessary for colors and perms in a hairdressing school. Mastering the various cutting techniques, perms, straightening and hair extensions is the result of a rigorous apprenticeship and very necessary in order to adapt to the individual identity of each fashion house." This rigor has been proven by her work with houses as diverse as Chanel, Gaultier and Lacroix.

In preparation for the fashion show, the first step is to have a discussion with the stylist. This is a question of "trans-

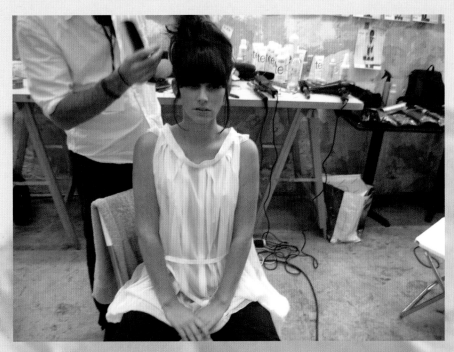

BACKSTAGE AT THE PRESENTATION OF THE SPRING/SUMMER 2007 COLLECTION BY LUTZ.

lating the theme of the collection" into the hairstyles and helping to "find a balance between the silhouette and the proportions." This analysis is critical to fashion culture, because to design a silhouette is, in fact, to create a woman. Odile describes hairstyling "as a form of architecture where one strikes a balance between the overall effect of lines, material and volume."

HAIRSTYLING FOR *VÉRONICA* BY BEATA ROSINSKA.

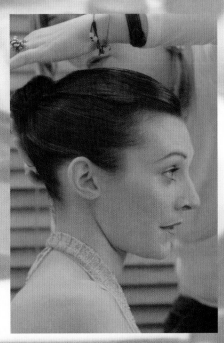

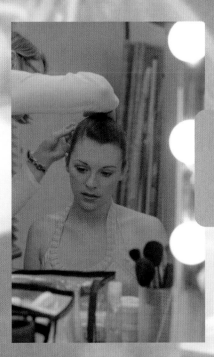

The fashion shows have allowed her to express her creativity widely. However, she is quick to note her appreciation of the collaborative aspects of her work, particulary, when working on numerous advertising campaigns (for Lagerfeld Gallery, Sonia Rykiel, Yohji Yamamoto. etc.). For her, photographs are "the result of teamwork between the stylist, makeup artist, hairstylist, photographer and model, who combine their talents with the aim of creating an image."

Odile Gilbert has published a compilation of her creations, *Her Style*, with a preface by Karl Lagerfeld (Edition 7L, 2003).

Lutz, Spring-Summer collection

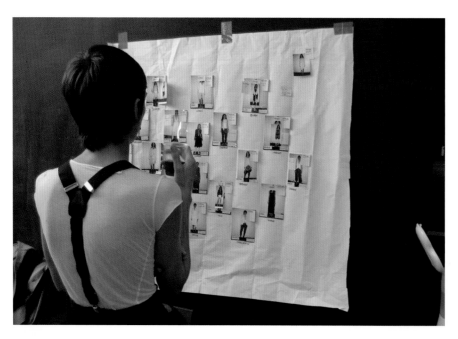

The fashion show is the event where a brand's next season's collection is presented to the industry professionals, press, photographers, buyers and VIP clients.

Large brands such as Chanel can finance large prêt-à-porter shows with up to 220 garments.

A show can range from being extremely spectacular, like those of John Galliano for Dior, to being a simple presentation. Lutz prefers short shows of 25 looks, coordinating strong pieces (that make a statement about the brand's image) with simple elements such as sweaters or accessories, chosen from some 60 items, of which 30 are woven and 30 are knitwear. He prefers not to have just "show pieces" that have been reserved exclusively for the fashion show.

Everything that Lutz presents exists in the stores. He states: "For a small business the aim is to make garments that really sell, as well as make an impression on the catwalk."

For a long time, he used modeling agencies to provide models for his fashion shows, but now he prefers to recruit amateur models who he comes across at parties or events and whose style corresponds to the collection in question.

For Lutz, the choice of makeup artist is central to the concept of his collection. "Makeup is a form of communication. It

HERE AND ON THE FOLLOWING PAGES: FINAL PREPARATIONS FOR LUTZ'S SPRING-SUMMER 2007 COLLECTION. THE MODELS' LOOKS ARE CHECKED, DECOR PUT IN PLACE AND THE SOUNDTRACK TESTED.

confirms the style of the woman chosen for the collection. It accentuates a certain model's traits or, conversely, can make the model 'disappear' in order to place more emphasis on the clothes. This is the same with hairstyling."

The choice of music is determined once the collection has been finished. It is the final touch. In Lutz's case, he chooses the music and his sound engineer, Michel Gaubert, mixes the soundtrack. He remembers having intentionally selected the entire 12-inch record of Donna Summer's "Love to Love You Baby" for one of his fashion shows. "Certain designers prefer very rhythmic music for their shows, others obscure it in their desire to surprise. However, music must not automatically respond to the public's expectations. The designer must also be able to express himself outside of the garment."

Backstage, in the wings of the fashion show, the clothes to be worn by the models on the catwalk are hung up on a rail. A sequence board displays the different turns, which are numbered and identified by snap shots.

Each model has his or her own dresser. These last finishing details are carried out among a jostling bustle of makeup artists, hairstylists, designers, models and photographers, while journalists infiltrate this mythical environment and attempt to snatch interviews and photos.

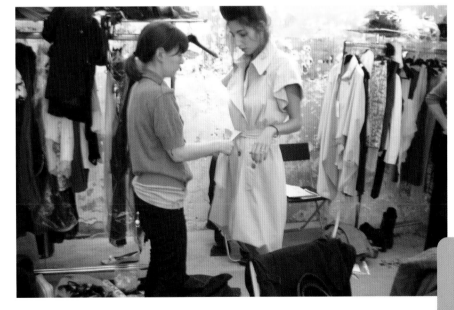

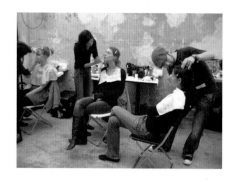
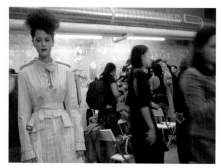

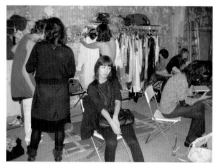
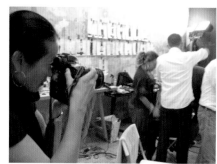
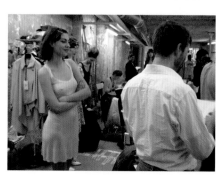
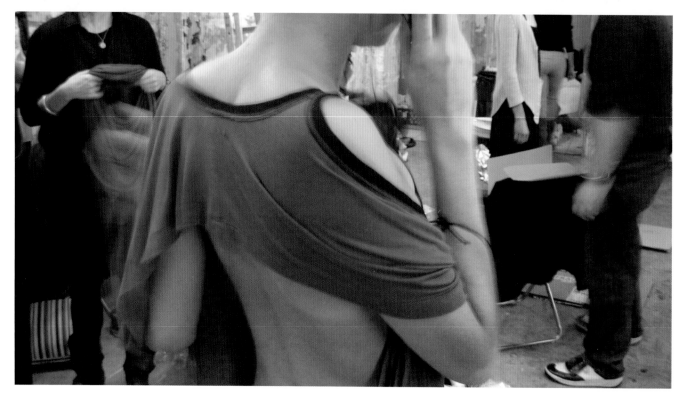

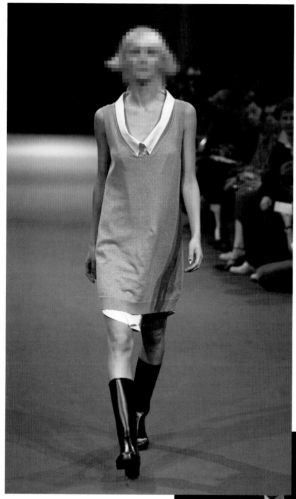

1

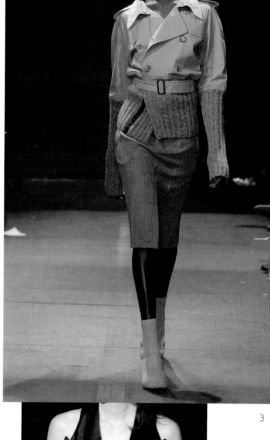

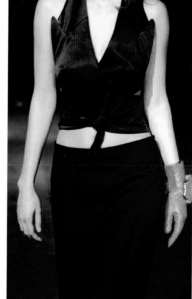

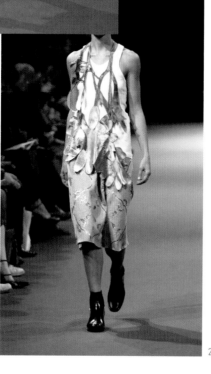

2

4

1. VERY LOW-CUT MAN'S SHIRT WITH A BUTTONED-DOWN COLLAR. LONG, WORN AS A DRESS WITH A SLEEVELESS GRAY WOOLEN TUNIC OVER THE TOP. THESE TWO PIECES ORIGINATING FROM A MAN'S WARDROBE ARE FEMINIZED BY COMPLETELY ALTERING THEIR DIMENSIONS, AND LENGTHENING. SS 2003 – PHOTO PASCAL THERME.
2. CUTOUT FLOWER IN SILK BROCADE TOP, WORN OVER A MAN'S SLEEVELESS COTTON TANK TOP AND GRAY SKIRT WITH EMBROIDERED SEQUINS. GARDENING ANKLE BOOTS IN SHINY BLACK PLASTIC. SS 2003 – PHOTO PASCAL THERME.
3. MINI TRENCH COAT WITH KNITWEAR EXTENSIONS. A "CUT AND PASTE" ITEM CREATING A SPECIFIC MIX, VERY MUCH IN THE STYLE OF LUTZ. FW 2004–2005 – PHOTO PASCAL THERME.
4. NEW LOOK SMOKING WAISTCOAT. FW 2007 – PHOTO PASCAL THERME.

DRAWING AND SEWING EQUIPMENT

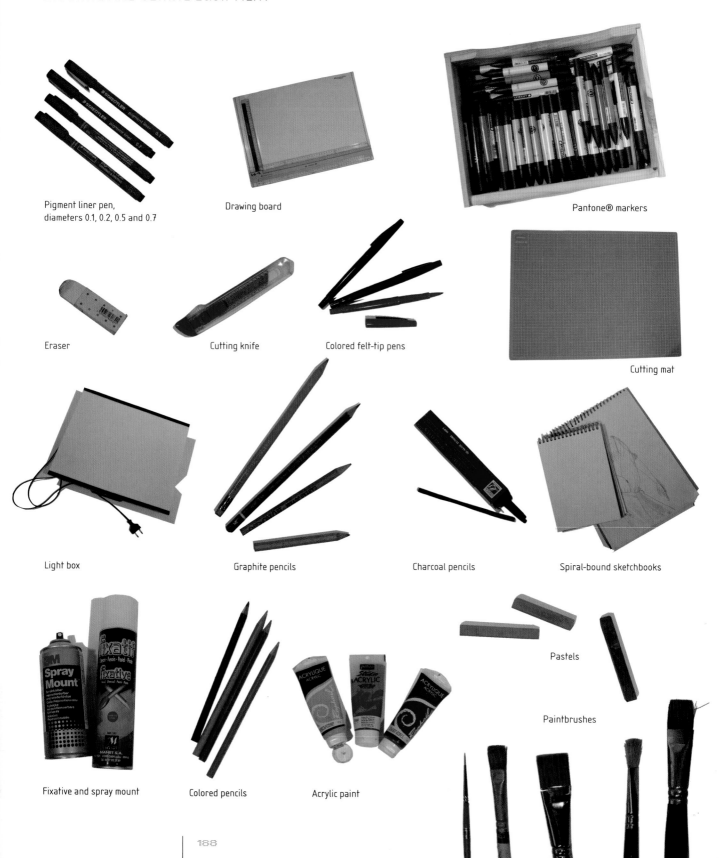

Pigment liner pen,
diameters 0.1, 0.2, 0.5 and 0.7

Drawing board

Pantone® markers

Eraser

Cutting knife

Colored felt-tip pens

Cutting mat

Light box

Graphite pencils

Charcoal pencils

Spiral-bound sketchbooks

Pastels

Paintbrushes

Fixative and spray mount

Colored pencils

Acrylic paint

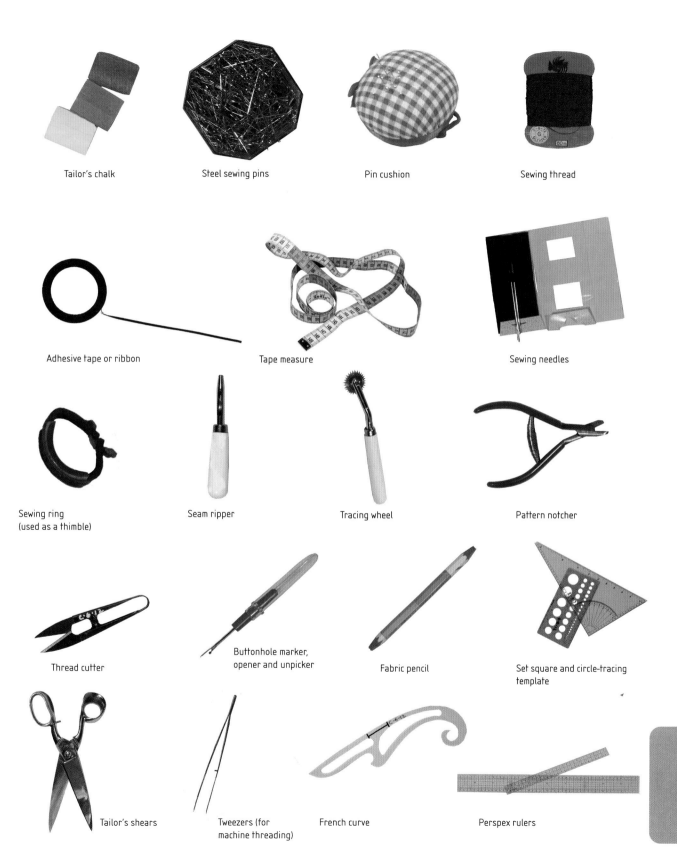

Tailor's chalk

Steel sewing pins

Pin cushion

Sewing thread

Adhesive tape or ribbon

Tape measure

Sewing needles

Sewing ring
(used as a thimble)

Seam ripper

Tracing wheel

Pattern notcher

Thread cutter

Buttonhole marker,
opener and unpicker

Fabric pencil

Set square and circle-tracing
template

Tailor's shears

Tweezers (for
machine threading)

French curve

Perspex rulers

MINI DICTIONARY OF MATERIALS AND MACHINES

MATERIALS

ACETATE
Synthetic fibers obtained from pure cellulose (cotton or wood pulp). Its name is derived from one of its components, acetic acid, and it is also known as cellulose acetate. Acetate threads can be used in viscose, cotton or silk weaves. As well as being found in delicate fabrics it is also found in denser fabrics such as taffeta, twill and satin. One of the principal qualities is its "fall," which lends it to use in net and curtain production, as well as simulating silk and linings.

ACRYLIC
Acrylic fibers are among the lightest synthetic fibers. They can be used pure or mixed with other fabrics such as cotton or wool. They allow for the manufacture of quick drying, non-creasing garments that do not require ironing: it is for these reasons that they are found in sportswear, streetwear and work clothing.

BATIK
Printed cotton fabric originating in the islands of Java and Sumatra and the East Indies, where the word *batikken* means "drawn by hand." After drawing on a fabric, wax is applied to certain areas to prevent them from being dyed, as a form of resist-dyeing. This material is characterized by bright colors and geometric patterns.

BATISTE
Originally a sheer, finely woven cloth of brushed cotton or linen. It is now the generic name for a sheer, fine, mercerized cotton used for baby clothes, blouses, dresses and lingerie.

BAZIN
Usually one-color printed cotton fabric originating in Africa (*see Wax Fabric*).

BENGALINE
Viscose material, with small ribs obtained by weaving cloth with the weft threads slightly slackened. The ribs are more pronounced than poplins and more regular than Ottoman fabrics. It is a dense and reversible material, used for furnishing fabrics and clothing (jackets, dresses and skirts).

BIRDSEYE
A worsted suiting type of fabric, featuring a small design based on a diamond with a small dot in the center of the pattern (similar to a "bird's eye"). It is achieved by a combination of weave and color. Used mainly for suits.

BROCADE
From the Italian *broccato*. Originating from luxurious silk fabrics decorated with stitched patterns using gold or silver threads, that give the impression of a raised design. It is woven and produced with a supplementary, nonstructural weft thread in addition to the standard weft threads that hold the warp together. Nowadays, these patterns are made using the jacquard method with silk and/or metallic threads. Brocade is associated with evening wear and furnishing fabrics.

CALICO
Natural plain-weave cotton cloth deriving its name from the city of Calicut in India. It is undyed and rough in texture, used for bed linen (under sheets, etc.) as well as for the toiles of garment prototypes. It is also used as the background cloth of traditionally printed fabrics of Native Americans and Indians. In this instance, calico is called Indian toile.

CASHMERE
The combings of the undercoat hair of mountain goats from Mongolia and the Himalayas. The wool is very precious and used for creating very fine, warm and luxurious fabric for coats and knitwear. It is also a fiber of Indian origin, which can be used pure or mixed to produce shawls with characteristic designs – the term cashmere can also mean a type of pattern or motif.

CELLULOSE
Cellulose is the principal constituent of every vegetable fiber and is the most widespread of all the natural organic materials. It is of capital importance for traditional as well as industrial textiles, and the fibers are found in cotton, linen, jute and hemp. After undergoing chemical treatment, cellulose produces acetate, viscose and other synthetic fibers.

CHAMBRAY (*see Pinpoint Oxford*)
A type of yarn-dyed, plain-weave cotton fabric with a colored or indigo warp and a white or beige weft: the overall effect is a denimlike effect. Its light weight makes it easy to sew and gives a more interesting fall to the fabric. Due to this, jean shirts and children's clothes are made from it.

CHENILLE
This trimming or fabric derives its name from the French word meaning caterpillar, as its soft, fuzzy-looking yarns stand out around a velvet cord. It is obtained by cutting the velvet into very thin strips. It is often used as the thread for knitted cardigans and furnishing fabrics.

CHEVIOT
Originating from the sheep on the Cheviot Hills in Scotland, this material is a type of carded wool with a rough, dense texture, traditionally used for menswear.

CHEVRON
Generic term given to fabrics that form a "V" pattern when assembled (similar to an alternate crossed twill weave). Chevron materials are normally used for coats, jackets and suits.

CHIFFON (*see Crepe*)

CHINTZ
Derived from the Hindi word *chint* meaning "printed fabric," today it refers to plain or floral printed woven cotton or viscose (or sometimes both) with a glazed or shiny side. Due to the fabric fall, it is normally used in furnishing fabrics but sometimes for summer dresses and skirts.

CLOQUE

A double fabric used in the manufacture of womenswear, with a "blistered" effect produced by the use of yarns of a different character or twist that make ridges on the inside of the material and respond in different ways to finishing treatments.

COTTON

One of the most traditional fibers, obtained by weaving the downy fiber surrounding the seeds of the cotton plant. It is the most abundant and widespread fiber in the world; it is strong, silky and easy to work and dye. Delicate and light, or heavy and dense, cotton products are used in a variety of fabrics and garments either on their own or mixed with other natural or synthetic fibers:

American Cotton: variety of ordinary cotton produced in the United States.

Egyptian Cotton: produced in Egypt, the Sudan and Mali; this cotton has a longer fiber and is of a better quality.

Cotton and Silk: (see Silk and Cotton (Silk))

Honeycomb Cotton: (see Crepe (Crepon))

Cotton Cloth: printed cotton plain-weave cloth used in the manufacture of summer clothes, aprons and furnishing fabrics.

CRASH

Plain-weave fabric originally obtained from flax. Today it is made from linen, cotton or rayon and used in the manufacture of suits.

CREPE

Originating from the Latin word *crispus* meaning "frizzy," and, subsequently, the French word *crêper* meaning to "crimp" or "frizz," this term is used to describe all fabrics that have a crinkly, crimped or grained texture. This is obtained by a particular weave effect or by using threads under strong tension. The fabric can also acquire this crimped texture after weaving, by chemical or thermal treatment.

Chiffon: very light, delicate woven fabric, mixed with silk threads and synthetic fibers, used for evening dresses, blouses and scarves.

Crepe de chine: medium-weight silk, or polyester, of which the warp is made from raw threads (beige or natural-colored originating from the silk cocoon) and the weft from crepe threads. When it is light and dense, it is called lingerie crepe; if the weft is made with thick crepe thread then it is termed Moroccan crepe.

Georgette Crepe: a sheer, lightweight plain-weave fabric with a fine crepe texture. Softer and more transparent than crepe de chine. It is composed of very tightly tensioned threads. Its lightness and delicacy make it ideal for evening dresses and camisoles.

Woolen Crepe: its woolen weft makes the fabric soft and delicate, however, it is very strong to the touch. It can be used for suits and dresses.

Satin-backed Crepe: satin-weave fabric. The right side is lustrous whereas the reverse is matte. Its lightness and fall make it ideal for dresses, blouses and lingerie.

Crepon (or Honeycomb Cotton): it can be 100% cotton or mixed with other fabrics. Its principal characteristics are its crinkled or puckered nature, with a more prominent fluted effect in the warp direction giving a tree-bark effect. Its lightness means it is used for summer dresses and camisoles.

CROCHET

Loose, open knitwear made using a small, curved knitting needle, resembling a musical crochet. Giving wool a light, characteristic quality, it can be used for summer sweaters, as well as baby clothes. This term can equally be used for clothes made from copper, steel or even wood, using this method. Crochet effects can now be made by machines.

CROSSED (or DENSE TEXTURE)

Cotton fabric and/or mixed fibers where the twill weave gives a slanted effect on the right side of the fabric, as well as on the reverse.

DAMASK

Self-colored complex-weave fabric (either satin, twill or plain weave) that owes its name to Damascus in Syria. It is generally a satin, figured pattern on a taffeta, woolen or silk background. Its main characteristic is its reversibility, so that on one side, the patterns are matte with the background being lustrous, and on the other side, the reverse. It is used in clothing, furnishing and bedcovers. In addition to this, the term "damasked" can refer to all fabrics that have reversible patterns that are alternately matte and shiny.

DENIM

Cotton fabric that owes its name to the city of Nimes in France, where it is thought to have originated. It is characterized by its twill weave with indigo warp threads and white or natural weft threads. Its flexibility and durability meant that it became the archetypal American work clothing in the 1930s, and nowadays it is synonymous with jean material the world over.

DEVORÉ

Taking its name from the French word meaning "eaten" it applies to luxury fabrics where some of the surface has been either acid-etched or burned away to create a decorative effect.

DOBBY

Fabric produced on a loom sharing the same name, i.e., a dobby attachment, with narrow strips of wood instead of jacquard cards. Dobby weaves are complex (satin, twill or plain weaves) with simple, small, repeatable allover designs, and are used for blouses and shirts.

DOUBLE FACE

This is a generic term for any reversible fabric made from different colored and contrasting warps and wefts.

DUCK CLOTH

Cotton fabric with a half-hopsack weave. Its thickness and strength means it is suitable for sportswear, work clothing and accessories (shoes, bags, etc.).

EMBROIDERY

Strands of colored silk or woolen threads sewn onto a fabric to produce a given motif. Embroidery was originally done by hand, using sewing needles, and this is still the case with haute couture items when pearls and sequins are added. For industrially produced garments, there has been significant growth in computer-assisted embroidery.

FAILLE

Coming from the Flemish word *falie*, this is a dressy, ribbed fabric with a light luster originally made in taffeta (silk) with rounded and horizontal ribs, the effect due to the alternate weft threads being of variable widths. Today, faille is normally synthetic, made from an acetate, polyester or viscose base. Its luster and delicacy means it is suitable for women's dresses, suits, etc.

FALSE FUR

Made from an acrylic base, this fabric can be knitted or woven, dyed one color or printed. Used for the manufacture of coats, linings or trimmings

FANCY YARNS

Grenadine: very fine silk thread, principally used for handmade, haute couture items. It is reputed to be the finest thread in the world.

Lamé: originally thread made from metal (gold, silver or copper). Nowadays it is made from filaments of colored polyester film.

FELT

Obtained from strands of wool or other animal hair, felt belongs to the category of nonwoven, nonspun materials. The technique of felting is still traditionally practiced by nomadic populations in the Far East. In the textile industry, felting is done mechanically using heat and humidity to produce the material.

FIGURED

This term describes the generic way every complex-weave fabric with small jacquard patterns is done. It is used for blouses and dresses.

FIL-À-FIL/YARN ON YARN

A woven fabric where a white thread is interwoven with a colored one end to end, characterized by a diagonal step pattern. This process is often used for poplin.

FLANNEL

A durable woolen (or sometimes cotton) woven fabric. There are several types (tennis flannels, partially or completely dyed.) Its strong yet soft texture lends it to skirt and trouser manufacture as well as suits, jackets, their collars and linings.

FLOCKING

Downy pattern or motif in relief, made by the "flocking" technique. This consists of laying down an adhesive onto the basic fabric and applying small textile fibers onto the sticky area. Used in the making of blouses, dresses and furnishing fabrics, and street or sportswear logos, etc.

FRENCH TERRY CLOTH

Cotton fabric made from a double warp thread: the first one is taught and the second is slack. After beating, one will become the background and the other the loop. Decorative patterns can be obtained by inserting colored threads (machinery-made jacquard) before beating the two warps.

GABARDINE

From the Spanish word *gabardina* and the old French *gavardine*, meaning coat. Durable, tightly woven cotton or wool fabric made in a twill weave with distinct diagonal ribs. Its woolen texture renders it naturally water-resistant, making it a suitable fabric for raincoats, sportswear, suits and uniforms.

GAUZE

Thin, translucent fabric with loose open weave, originally cotton, coming from the town of Gaza in Palestine. Today this material is made from wool or silk and with its light, delicate qualities is used in the production of blouses and dresses.

GINGHAM CHECK

Fresh, light plain-weave cotton fabric. Due to the way it is woven, this fabric's main characteristic is the alternating white and colored threads that give quares of varying sizes. It is used in the manufacture of children's clothes, shirts, blouses, and bed linen and furnishings.

GUIPURE

Machine-embroidered lace which is characterized by appearing to be without a background. The patterns are separated by spaces that have either been dissolved or cut out from the base material.

HORSEHAIR

Dense canvas made with a cotton warp thread and a horsehair weft thread. Used in menswear clothing.

HOUNDSTOOTH CLOTH

Twill weave with lozenge-shaped checks made by alternating the colors of the warp and weft. Available in varying sizes of check. Normally used for the manufacture of suits, coats and accessories such as bags, scarves etc.

INTEGRATED PRINTED PATTERN

Fabric on which a pattern or motif can be printed repetitively, covering the entire fabric (allover pattern), positioned just on the border (integrated printed pattern), or placed just on a specific area of the garment (placed motif).

INTERLOCK

The characteristic of this fabric is that its knit stitches interconnect with the weft, making a thicker and heavier ply. It has a more natural stretch than a jersey knit and the same appearance and feel on both sides. It is fine, easy to cut and sew. It is used for dresses, tee shirts and leggings as well as for underwear.

JACQUARD

The name comes from the inventor of this mechanical weaving method, Joseph M. Jacquard. The fabric is one-color or multi colored, presenting bands of geometric patterns that can vary infinitely. The pattern is punched into a pasteboard, each row corresponding to one row of the design, which guides the warp thread so that the weft thread will lie above or below it. Most often, a sweater with crossed, colored threads is a jacquard. Used for suits, jackets or skirts.

JERSEY

This knitwear fabric, originally made from wool, was used to make sailor's sweaters in the island of Jersey, Channel Islands. Today it is a generic term used to describe any fabric made by simple weaving, without any obvious ribs. Used for sportswear, dresses and tee shirts.

Matte Jersey: Matte and dull knit fabric made with very fine crepe yarns. Used for slinky evening wear.

Velvet Jersey: weft knit that has a velvet appearance on the right side and is flat on the reverse.

KNITTING

This generic term encompasses every fabric that is made from linked loops of yarn. It is divided into two large groups, weft knitting and warp knitting (hybrid of knitting and weaving using a band of warp threads linked together by a moving rack of needles).

2x2 Rib Knitting: ribbed weft knit, very stretchy. Used for pullovers and cardigans.

Polar or Brushed Knit: double weft knit, one color or printed, brushed on both faces with a quilted texture. Most often made from polyester, it is used for pullovers, sportswear, accessories and linings.

Single Jersey Knit: warp knit with a light lustrous texture, used for lingerie and blouses.

Double Jersey Knit: double weft knit, also known as "interlock," dense as though woven, used for dresses, suits, jackets and trousers.

Terry Toweling Knit: weft knit looped on the right side, used for baby clothes, beachwear and sportswear.

Jacquard Knit: double jersey patterned knit using as many as four colors in a row; usually programmed and controlled by computerized machinery.

Cavalry Twill or Tricotine: weft knit in twill weave, often wool, used for uniforms, coats and trousers.

LINEN

The linen fiber comes from the flax plant. Linen cloth is one of the oldest textiles in the world and has been known for centuries in Asia and Egypt, where it is considered a "noble" material. Modern techniques of treating the stalks, such as "scutching" (removing the woody portions of the stalk by crushing them between two metal rollers) and "hackling" (combing the short fibers away to leave the long, soft flax fibers), allow the fabric to range from soft and supple to stiff and rough. Used for shirts, skirts and jackets.

LINON

This fabric derives its name from linen, as it was originally woven using the flax plant fibers. Plain weave, slightly broken, this fabric is so fine it is semitransparent.

Today, it exists in cotton and ramie. It is mostly printed and used for bodices, flat collars, cuffs, summer dresses and babies' underwear.

White Linon: also called opal. This is fine, slightly transparent and very soft. It is used for blouses and nightclothes (pajamas, nightshirts, etc.).

LODEN

This is a thick, water-resistant fabric made from sheep's wool which has been boiled and carded then plain woven. It is well known in Bavaria where it is used as coat and suit material.

LUSTER

Plain-weave fabric, generally in brushed wool or mohair, which is light yet strong; used for summer suits.

LYCRA (see Spandex)

In 1959, Dupont de Nemours registered this trademark for its brand of spandex. It is a very light fabric with great elasticity used for running and sportswear.

MADRAS

This cotton weft fabric with its simple texture owes its name to the town in India from which it originates. Large squares or multicolored designs are very characteristic of this plain-weave fabric. The bright colors and lightness of this fabric lend it to traditional headdresses worn in the Antilles.

MARQUISETTE

A sheer gauze fabric that is light and transparent and made from silk, cotton or synthetic fibers. Used for lingerie and dresses and furnishing fabrics, particularly for mosquito nets, net curtains, etc.

MATELASSÉ

A double cloth with a quilted appearance commonly made with two warps and two wefts. The quilted effect can be accentuated by the use of wadding threads and the designs are formed by floating threads or small areas of waves. It is also a generic term used for the linings of coats and jackets. Matelassé can be used as stuffing, or wadding, for quilted jackets, etc.

MELTON

A thick to medium-thick tightly woven wool with a heavily brushed nap, giving the fabric a smooth finish with no warp or weft visible, similar to felt. Used in coat manufacture.

MICROFIBER

Generic term used to describe all synthetic fibers – often from a polyester base – finer than silk. Microfiber fabrics are soft, light, breathable and strong, which means they can be suitable for all sorts of garments.

MILLERAIES

Brushed woolen fabric with many fine stripes, used for suit manufacture.

MOIRÉ

This fabric originates from goat's hair. It is characterized by the wave reflections created in the manufactoring process, which involves crushing the fabric in places by passing it through pressure rollers. Generally, any fabric that has this undulating effect. It is used in the manufacture of blouses, dresses and evening wear.

MOLESKIN

A heavy quality brushed cotton used for trousers, jackets, overalls and children's clothing. By brushing the reverse side of cotton cloth, a downy and warm quality is obtained. Moleskin is sometimes used as a coating on one side of a leather garment or shoe, and so it can also refer to coated cloth.

MUSLIN

This fabric was originally made from silk (chiffon) or wool, but nowadays is made from all sorts of materials such as wool, cotton (muslin) or rayon threads. It is extremely light, soft and semitransparent. Woolen muslin is used for dresses with floral patterns, whereas silk muslin, made with tight tension threads, is used for evening dresses, lingerie and camisoles.

NAPPED

This describes fabrics that can only be cut in one direction. Particularly important for printed fabrics such as madras or those with a definite "hair" or pile, such as velvet.

NYLON

In 1935, Dupont de Nemours registered the trademark for this material and now its name, and the synthetic fiber (polyamide) from which it comes, is known throughout the world. Today, nylon can be vinyl and cotton, or rayon. Its supreme elasticity lends itself to the manufacture of tights and stockings. It is also very absorbent.

OPENWORK

Woven or knitted fabric with an open structure, having a gauze or complex weave, i.e., where the warp and weft threads are spaced out.

ORGANDY

Similar to muslin in that it is very light, delicate and transparent, yet it is stiffer. It is a plain-weave cotton that can be used for blouses, dresses, trimmings and net curtains.

ORGANZA

Plain-weave fabric resembling organdy but made from silk or synthetic threads. Its uses are similar to those above.

OTTOMAN

This Turkish fabric is made using a woolen, silk or viscose warp. It is characterized by deep transversal ribs obtained by inserting supplementary wefts. Nowadays it refers to all fabrics that display this type of ribbing, whatever their finesse and regularities (see Bengaline). It is normally used for coats and blazers.

PAGNE (see Wax Fabric)

The name given to a fabric made from vegetable fibers (raffia), which can also be made from cotton. The pattern is drawn onto the fabric and then small holes are painstakingly punched along the design lines. Hot wax then seals the image that has been dyed or painted. It is traditionally worn tied around the waist, up under the arms or tied at the nape of the neck, in places such as Africa, Asia and the Caribbean. Its lightness and bright colors, once dyed, make it suitable for the Spring-Summer collections of dresses, skirts, shirts, Bermudas and trousers.

PEAU-DE-PÊCHE

From the French term meaning "peach skin," this fabric is similar to moleskin but is lighter and softer as it is made from microfiber weaves. Its downy texture is produced by chemical treatment. It is normally used to make sweatshirts for street and sportswear.

PINSTRIPE

Very fine "pinhead" striped fabric.

PINPOINT OXFORD (see Chambray)

Lightweight, soft, cottonlike fabric with small 2x1 basket-weave repeats. The warp threads are dyed while the wefts are left white – this creates a small ribbed pattern. Oxfords can be either striped or checked. As it is very easy to sew, its texture and fall make it very suitable for shirts and children's clothing.

PIQUÉ

A knitted cotton fabric with a waffle, or diamond-shaped, pattern. Its weave is composed of two warps, one for the background, the other for the stitches. French piqué knits became an international fashion when René Lacoste, the 1920s tennis champion, designed the short-sleeved polo shirt made from 100% cotton.

Bedford Piqué: this is made with vertical ribs on the right side of the fabric. Used in children's clothing and women's outdoor wear.

PLUMETIS

This is a fabric that has patterns obtained by inserting extra warp or weft threads. It can also refer to a cloth with small relief patterns or motifs which could be embroidered, flocked or woven.

POINTELLE

Very delicate, feminine rib knit fabric made with relief eyelet patterns. Used for womenswear.

POPLIN

A durable, plain-weave fabric made originally from a mix of natural silk warps and cotton or wool wefts. Today, poplin has fine horizontal lines due to the fact that the number of warp threads is double the number of weft threads. It is similar to broadcloth but with a heavier rib and weight. Used primarily in high-quality shirt manufacture.

PRINCE OF WALES CHECK

Named for the king who popularized this material, Edward VII, when he was Prince of Wales. Very large check with a repeat of 9 inches in bold red or brown on a cream background, with a gray overcheck. Sometimes confused with Edward, the Duke of Windsor's preference for the Glen Urquhart black-and-white check.

RABANNE

Material from Madagascar made only from raffia fibers or occasionally mixed with synthetic fibers. Used in accessory manufacture such as for hats and bags, or for furnishings.

RAFFIA

This Madagascan word refers to the vegetable fiber derived from the leaves of the palm trees found in Madagascar, Africa. Being light, it is easy to weave and it is used in the manufacture of place mats, table coverings and mats as well as decorative additions, with cotton, on dresses, shirts and accessories (bags, hats, etc.).

RAYON (see artificial silk)

RIPSTOP

A fabric woven with a double thread at regular intervals so that small tears do not become larger. Very useful in the manufacture of parachutes and tents, as well as sportswear.

SATEEN

This is the reverse of satin with a smooth weft face and is normally made from cotton. Used for blouses and dresses.

SATIN

The name is derived from the Chinese town of Zaytoun. It was originally a silk cloth where the warp dominated the weft. The weft is almost completely covered, giving a smooth face free from any twill, with the main characteristic being a lustrous and glossy sheen. There are a great variety of satins: Chinese satin (shiny and smooth); Lyon satin (made in twill); Duchess satin (thick, heavy and very expensive), etc. Satins are most often made from silk, viscose or acetate and used for evening wear and costumes.

SCHIFFLI (embroidery)

This type of embroidery owes its name to the commercial embroidery machine, which uses a combination of a needle and shuttle to form a stitch. Vinelike floral patterns on sheer fabrics characterize this material. It is first embroidered by the machine, then the background material is "melted" away using a chemical treatment. It is used for emblem production, lace creation and satin fabric embroidery.

SEERSUCKER

A term originating from the USA, it is characterized by the presence of flat and puckered sections, particularly in stripes and checks. The effect is produced in various ways, either with stripes of different tensions that cause crinkling, by using yarns with different shrinkages, or by treating certain areas of the fabric, causing it to shrink.

SHANTUNG

This fabric takes its name from the province in China where it was originally made. It was hand-loomed and is thin and soft, woven with uneven yarns to produce an irregular surface. 20-century shantung is usually made of silk mixed with cotton or rayon, thus creating a heavier fabric than its original counterpart. Both fabrics are used for evening wear.

SHETLAND

Generic term referring to woolen fabrics originating from the sheep on the Shetland Islands in Scotland. These materials are often woven or knitted and used for suits and coats.

SILK

Natural fiber produced by the silkworm, a grub of the silk moth, which feeds on the mulberry tree. The worms spin cocoons exuding fine filaments that form a thread. Its production methods were kept secret for centuries. It originated in China and was bought to Europe around the 12th century along the "silk routes" by the merchant traders. It has always been considered an expensive, luxurious fabric reserved for high-quality garments. Nowadays, there are a great variety of cheaper silks, both dyed and printed, coming primarily from Japan.

Artificial or Rayon Silk: material made from viscose.

Ordinary Silk: fabric generally originating from Chinese silkworm cultivation.

Wild Silk: wild silks are more irregular than ordinary silks; they are used for dresses and blouses, as well as furnishing fabrics.

Tussah: Indian fabric obtained from wild silkworms living in tropical forests. Fiber is naturally golden as the caterpillars eat the bark from tannin-rich trees.

Dupion Silk: a lustrous silk woven from two different colored threads, that shimmers in the light. It is an irregular rough silk reeled from double cocoons or cocoons spun side by side.

Noil or Bourette: this is silk obtained from the crushed pupa left behind after making the higher-quality yarns.

Vegetable Silk: material made by weaving herbaceous plants.

Blended Silks:

Silk and Cotton: looks like silk but has the texture of cotton; used for dresses and blouses.

Silk and Wool: by adding wool this blend has all the attributes of warmth and strength yet becomes smoother and silkier due to the blending. Used for suits and jackets.

Silk and Linen: the silk softens the linen, making this fabric suitable for suits, skirts, dresses and trousers.

SPANDEX (see Lycra)

A stretchy, elastic polyurethane fabric often used for sportswear. Spandex fibers are often blended into fabrics to give stretch to close-fitting clothing such as jeans.

TAFFETA

A crisp, rustling, lustrous evening fabric often woven in plaids or with shot warp-and-weft effect. Plain silk-weave fabric that derives its name from the Persian word taftah, meaning "woven."

TARTAN

This is a generic term for any fabric that has colored warps and wefts creating a check pattern, regardless of the material. The kilts belonging to the different Scottish clans each have their own specific pattern, color or type of check. Tartans, whether they are in cotton or synthetic fibers, are used for unisex clothing, accessories and linings.

TENNIS STRIPES

Fabric with vertical stripes similar to milleraies but more spaced apart – can be woven or printed. These stripes are most commonly found in woolen flannel fabrics used in suit manufacture.

TOILE

This term has several meanings. It is one of the three basic weaves – the simplest and oldest one, made from linen, cotton or hemp threads. Its weft passes alternately under and over a warp thread which makes the right side and the reverse identical. The plain-weave fabric is generally light or of medium weight. It also refers to a light muslin used for a prototype or test garment on the dress form.

TULLE

Originating from a town in the region of Corrèze in France. Light net-type fabric produced using a specific technique and machine with a "tulle" bobbin that gives the fabric a polygonal or diagonal structure. It is normally superimposed onto another material or used on its own for blouses, dresses and tutus.

TWEED

Scottish woolen material that derives its name from the River Tweed on the border of Scotland and England. In its classic (speckled effect) or modern form (more color-weave effects and patterns), this material is ideal for the winter. It is used for suits (classic tweed) and jackets or trousers (modern tweed).

TWILL

A reversible woolen fabric with dense threads of twill weave. The relief is reminiscent of the diagonal wales on the face of gabardine, denim, tricotine (cavalry twill), etc. However, it is less pronounced. It is used for suits and jackets, or where the linings are made with viscose filaments. It is also a term to describe one of the three types of fundamental weaves, where the warp threads intersect the wefts, producing a fabric with slanting ribs that has a right side and a reverse, like denim or gabardine. Used most frequently for coats and suits.

VELVET

This word comes from the Latin villosus, which means "hairy," and describes materials made using Eastern techniques that produce the luxurious, downy texture. It is dense with a short, closely woven cut pile and is made with two warps: the first for the background, the second for the pile. It can be made in a variety of materials: silk, wool, cotton, viscose, synthetic fibers, etc.

Panne Velvet: although generally made from silk, it can be made from synthetic fibers that are woven or knitted. It has a type of finish that gives a shiny, moiré aspect to the fabric. It is light and is used for evening dresses and lingerie.

Corduroy: woven ribbed fabric, where the pile is smooth in only one direction. Supple, comfortable and durable. Used for trousers and jackets.

Cotton Velvet: velvet fabric with a regular "down" on the right side, with the pile being smooth in one direction. Used for evening dresses and furnishing fabrics.

Toweling Velvet: fabric with circular loops on one side with the reverse being smooth.

Crushed Velvet: fabric with crumpled and shimmering appearance, made from small, tendril-like threads. Normally used for dresses.

VELVET FELT
Very soft, dense, plush fabric.

VENETIAN
The woolen threads are combed to produce a luxurious, sateen, woven wool fabric used for suits and coats.

VISCOSE
This term describes a fabric, as well as a textile manufacturing process. It is a manufactured fiber made of regenerated cellulose (*see Cellulose*) that is made up in many woven or knitted forms and weights, both matte and shiny. It is soft, absorbent and drapes well, making it an ideal material for dresses and skirts.

VOILE
Plain-weave cloth made from cotton, wool or silk, originating in India. It is a lightweight, sheer fabric, colored or printed, and is often used for dresses, camisoles and furnishing fabrics such as curtains, net curtains, etc.

VYELLA
This is a registered trademark fabric of brushed wool or cotton that can be colored by weaving or printing. It is used for medium-weight winter wear and school uniforms, as well as sheets and nightclothes.

WAX FABRIC
The English imported this technique from Africa (*see Bazin*). It is used nowadays for the manufacture of the African fabrics (*see Pagne*) and the high-quality bazins which are brighter and silkier. This fabric is a printed cotton, with the color applied with a wax (inspired by batik painting). It is a light, brightly colored fabric that is used in the manufacture of summer clothing or pagnes.

WAXED
Cotton fabric that has been coated with an oil or wax to render the material waterproof. French fishermen from Brittany are famous for their yellow oilskin overalls, hats and windbreakers, as is the brand Barbour for its three-quarter length hunter's jackets. Oilskins are used for outdoor waterproof clothing, mainly jackets.

WHIPCORD
This material was originally made from wool and has an oblique ribbed texture. Nowadays, the term generally applies to all twill woven fabrics with a diagonal or relief structure. Its dense texture means it is ideal for suits and jackets.

WINCEYETTE
A brushed cotton used for pajamas and children's wear.

WOOL
Natural fiber obtained from sheep and goats (and certain rabbits in the case of angora). There are a great many varieties depending on the different breeds. The texture and weaving of the wool varies also. Generally the wool is mixed between sheep and other ovines and it is warm, absorbent and pleasant to touch. Used for coats, suits, sweaters and furnishing fabrics.

WORSTED
Durable woolen fabric, whose production revolved around the fortunes of Bradford in Yorkshire during the Industrial Revolution. It is mainly used for men's suits.

WOVEN CANVAS
Linen or starched cotton where an adhesive coating has been applied. Mainly used for men's clothing.

YARNS
There are three main types of yarns or plies for weaving and knitting:

Cabled Yarn: a yarn formed by twisting together two or more plied yarns.

Twisted Yarn: an assembly of single threads formed by inverse twisting.

Marl Thread: two different colored single strands of yarn spun together. This mottled effect is often seen in sweaters.

MACHINES

There are five categories of sewing machines.

CANON MACHINE
This resembles the tubular machine closely, however, it is perpendicular to the working bench. It has automatic systems for buttonholes and buttons, as well as being able to do straight and chain stitch.

DOUBLE-NEEDLED MACHINE (with movable arms)
This machine does not have a flatbed; instead it has a second arm that forms a U at the back of the machine just before its head. This machine facilitates the closing of tubular pieces with turned-up edges or seams, such as jeans or shirt sleeves. It can also do straight stitch and chain stitch.

FIVE-THREAD SERGER OR OVERLOCKER MACHINE
This machine has two, four or five threads for overlocking or oversewing raw edges of a garment to prevent them fraying. It is capable of great speeds, enabling stitching, overlocking and edging to be done simultaneously. It is also capable of doing chain stitch.

FLATBED MACHINE
This machine has one or two needles fitted onto an arm, of which there are three sizes depending on the size of the piece to be sewn. It is the oldest and most widespread of sewing machines. Certain flatbed machines have a double or triple feed, allowing materials such as leather or denim to be successfully worked. Straight stitch and chain stitch are able to be done with this type of machine.

TUBULAR OR CIRCULAR MACHINE
This has an arm, like the flatbed machine, but instead of a bed the material surrounds a tube. Trouser legs and sleeves are made using this type of machine. It is also capable of doing straight stitch and chain stitch.

SPECIALIST MACHINES

INVISIBLE STITCH MACHINE
This machine has a floating needle (straight with two points), making invisible or blind stitches on either side of the material.

INVISIBLE STITCHING MACHINE
Most often tubular in shape, it has a curved needle: when doing a chain stitch, the thread does not go right through the material. Instead, it goes into the center, coming out again through the top, where it entered. This machine is used for hemlines and stiffenings.

LOCKSTITCH MACHINE
This makes a chain stitch with one single thread according to normal knitting principles. It is used for making collars, sleeves and cuffs. Its lateral arm, placed under the head, allows for hook and needle movements to be printed.

GLOSSARY

ALLOVER (MOTIF)
Pattern or motif that repeats horizontally as well as vertically, i.e., spots. It is distinguished from the placed motif, which is a single motif, and the repeat pattern, which is repeated in one direction only (such as that of toile de Jouy).

ALLOWANCE
Extra fabric added to a seam line, a garment for ease of movement, or for pleats and gathers.

APPLIQUÉ
An element that is glued or sewn on, like an emblem, for example. Or, a decorative patch of fabric sewn or glued onto another.

ARTISTIC DIRECTOR or CREATIVE DIRECTOR
Person who defines the brand's image and collections. He or she decides which products will be included in the collection.

ASSEMBLE
To sew together the different pieces of a model or item. Or in lace making, the assembling together of the different pattern elements, such as flowers, leaves, etc., to make a flower.

AWL
Sharp pointed tool for making holes in patterns and leather.

BASTING
Temporary stitching, also called tacking, used to hold fabrics together for fittings and before machining.

BIAS
The diagonal line at 45 degrees to the straight and crosswise grain of the fabric. Bias binding is a tape cut "on the bias." It has pressed, folded edges and has more give than flat woven tape. Ideal for hemming and seaming.

BONING
Originally made from whale bones, they were used for reinforcing clothes such as corsets, tutus and shirt-collar corners. Nowadays, plastic or metal stiffeners are used.

BOOKING
When preparing for a fashion show or photo shoot, a model, photographer, makeup artist and hairstylist are signed up to create the team for the presentation.

BOUTIQUE
A shop and its shop window promote the brand's image, and/or the designers and artistic directors, who have often styled the interior decor themselves.

BRAINSTORMING
Meeting of colleagues during which different ideas and concepts are exchanged and discussed.

BRANDING
Consumers' desire to buy internationally recognized brand products or ethos.

BREAK LINE
Fold line of a collar lapel, or an ironed fold of a trouser leg or pleat.

BUTTON STAND
Piece of supplementary fabric added to a garment where a fastener or button is to be added, i.e., at the base of a collar.

BUYER
Person responsible for buying, and planning orders, in the buying office of a shop or department store.

BUYING OFFICE (*see Buyer*)
The department responsible within a store, or an independent body that arranges to buy for chains and boutiques, especially from overseas suppliers.

CAD/CAM
Computer-aided design/computer-aided manufacturing.

CASTING
Choice of models for a fashion show or a photo shoot.

CLASSIC OR STAPLE GARMENT
Wardrobe item that is easy to wear or for everyday use.

COLLAR STAND
The under-collar, before the "fall" or fold-back of a collar, often reinforced and buttoned on a shirt.

COLLECTION COORDINATOR
Person in the design studio responsible for the development and organization of a collection.

COLLECTION PLAN
Plan itemizing the number of fabrics and items necessary for the different products: coats, jackets, skirts, trousers, dresses, tops, etc. It defines the structure of a collection and can be presented either as a written document, or as presentation boards with sketches detailing the fabrics, organized by product type.

COLOR CHART
Collection of several referenced colors facilitating choice. Pantone® is the registered trademark company.

COLOR HARMONIES
Classification of the color tones used in a colorway, or the balance of the chosen colors in the given proportions of a collection.

COLOR PALETTE
Presentation of a large number of colors from which a selection will be made to narrow down the finished color range for the collection.

COLORWAY
The name given to a limited range of colors chosen for a style or collection. It is also used for the choice of colors available for a fabric (knitwear, print, jacquard, etc.).

CONVERTER

A manufacturer who treats raw fibers, making them into a fabric, or converts greige goods (pronounced gray) into fabrics. Different processes are used for different raw products to improve their quality: wool is felted; fabric is mercerized to give it a shiny appearance, or is waterproofed, etc.

CONTOUR MASTER

Curved ruler used by pattern makers.

COUTURIER

This was a French term used in the 1960s and 1970s to describe the fashion designer of a brand in reference to the haute couture sector. Nowadays the term "artistic director" is used

CREATOR

Term used in the 1980s to describe a designer.

CROQUIS

A line drawing or sketch made by the designer to illustrate a garment, or a painted-out design for a printed fabric. It shows the lines of the style, garment look or pattern.

CUT AND SEWN

Term used to describe products that are made from industrially knitted materials (jerseys) made on a roll or cylinder.

CROTCH OR CRUTCH

Seam between the legs of a pair of trousers, shorts, Bermudas or culottes.

CUSTOM TAILORED/BESPOKE

Individual made-to-measure tailoring for suits.

CUT

Assembly lines of a garment, as with the princess lines in a dress, and straps in the case of a top.

CUTTING

Production stage where the different pieces of the garment are cut from the fabric.

CUTTING PLAN or LAY PLAN

Plan for the pattern pieces to be cut according to the width and type of material.

DART

A stitched-down fold, tapering at one or both ends, to allow the fabric to follow the shape of the body.

DÉCOLLETÉ

Low neckline, without a collar (boat, V-neck, etc.).

DECONSTRUCTION

A style of designing originating with Belgian designers where the garments were left rough or unfinished, or revealing construction details.

DESIGN CONSULTANTS OR STYLE AGENCY

Outside agency that proposes advice on trends, design and product research to its clients (brands, industry, distributors or fashion show organizers).

DESIGNER

General term used to describe a fashion designer, as well as anyone working in the design field.

DETAILS

Pieces or finishes of a garment, such as pockets, etc.

DIFFUSION LINE

A secondary, usually lower-priced garment line that allows consumers on a budget, to buy the designer "look" and for the manufacturer to maximize sales.

DRAPING

In the fashion world this refers to the fitting of a fabric onto a dress form to make the toile or sample garment. The term "draped" refers to giving volume to a fabric.

DRESS FORM OR STAND

Toiliste or pattern cutter's work tool, which is the body form of a torso of average size, i.e., size 10/38, usually on a stand that rotates to help the pattern cutter make the toile and work on the garment.

EASE

Similar to allowance, i.e., extra fabric to allow for loose fit and comfort.

EDGE TO EDGE

Two pieces of a garment that join without crossing, such as a zipper fastening.

EMPIRE LINE

Dress with a short bodice, usually with a seam or drawstring under the bust.

FACING

Interior of a garment made in the same fabric as the garment itself. It is attached to the lining, if there is one, finishing off the piece properly.

FALL OF A GARMENT

The look of a garment, which is determined by the cut and by mastering volume. There are certain rules that need to be adhered to if a garment is to have a good fall.

FASHION

Term used to describe the influence of one season, although a trend or fashion can last a decade.

FASHION CULTURE

Collection of signs, codes, language, images and references that define the world of fashion.

FASHION CYCLE

The time necessary to develop a collection, including planning, designing, making and marketing, in relation to a determined market. The cycle will vary according to the market.

FASHION ILLUSTRATION OR PLATE
Stylized design of the silhouette volume used to express the idea of a garment.

FASHION STYLIST
Person responsible for creating the "look" for a shoot, by coordinating the fabrics and accessories.

FEELER or SWATCH
A sample of fabric offered by salespeople to help the designer choose materials or colorways.

FIT MODEL
A live model who is used as the company's standard sizing sample for the fittings.

FITTING
Work session where the modeler and the designer work together to confirm the fit and details of a garment. This fitting is carried out using half the toile or the entire one, on the dress form or on a "fit model." Normally it requires three fittings to arrive at a successful conclusion.

FLARED
To cut a garment on the bias to obtain a trapeze or flared effect such as pagoda sleeves, bell-bottomed trousers, A-line skirts, skirts with godet insets, flapper dresses or a redingote jacket.

FLAT COLOR
Application of a color in such a way that the surface is painted smooth and uniformly, where no paintbrush or felt-tip pen mark is visible.

FLAT PATTERN DRAFTING (see lay plan)
Precision drawing that requires accurate measurements and use of proportions to make a lay plan.

FOUR-COLOR PRINTING
The three primary colors (magenta, cyan and yellow), then the black.

FRENCH CURVE
Pattern-cutting tool with a "golden mean" to aid in the drafting of tight and open curves.

FROG FASTENINGS
Trimming loops or straps used as garment fastenings.

GATHERS
Fabric that is drawn up for ease or fullness on a double line of stitches. Used to give volume to the head of a sleeve, skirt on a dress, or to drape a jersey material.

GODET
A triangular piece of fabric inserted into the bias or hem of a skirt to give it flare and movement.

GRADING
Operation that consists of sizing a pattern up or down from the standard measurement fitting.

GROSGRAIN
A broad, stiff ribbon with striped relief used for waistbands and hat trimmings.

GUSSET
Triangular or lozenge-shaped piece of material inset into another piece of fabric for ease of movement or comfort. It can be added to sleeves, in the case of a kimono or underarm, or into the crotch of a pair of trousers.

HABERDASHERY
General term for garment trimmings including needles, threads, ribbons, buttons, fasteners, etc.

HAUTE COUTURE
French term used for the highest quality of bespoke dressmaking. Designers will use specific accessory specialists such as feather makers, jewelers, embroiderers, furriers, etc. to embellish their designs. Designers cannot call themselves *haute couture* unless they have been passed by the Chambre syndicale de la Fédération française de la couture.

HEAT-FUSIBLE
With the aid of a press, the glue that is present on a cloth such as an interfacing is melted. This gives a type of reinforcement to the material in areas such as collars, cuffs and facings.

INSET
A piece of fabric or trimming used decoratively in a seam.

LACING
Two edges with eyelets and ties, or laces that can be adjusted to vary fits. Used for fastening garments or for decorative details.

LAIZE
Direction of the width of a fabric.

LAMINATE
To coat, glue or heat-bond two fabrics together.

LAPEL SEAM
Interior seam of a suit-jacket collar, at the point where the collar and the lapel meet.

LICENSE
Contract giving authorization to use a brand, logo, type of product or a concept by a third party in exchange for royalty payments.

LINE
Schematic shape of a garment, or a range of products developed around the same theme.

LUREX
Metallic thread used either pure, or mixed, of colored metal — gold, silver, platinum, copper, etc., but can also be red, blue, green, etc.

LUXURY PRÊT-À-PORTER
Term used to describe the top end of prêt-à-porter goods in general.

MAQUETTE

Mock-up made to illustrate a project, either on the flat or by volume: can be a drawing for a textile print, a model for some jewelry, or the heel of a shoe. The term maquette is also used for the visual identity of a catalog or magazine; it includes the page layout, choice of typeface and visuals.

MARKET

Group of people established according to geographical criteria, consisting of different types of consumers having specific commercial constraints.

MARKETING DEPARTMENT

Department or office dealing with a company's promotion and coordination thereof.

MERCHANDISING

Term used to denote all aspects of optimizing commercial results.

MIX AND MATCH

Term used to describe garments that are mixed, an assortment of, organized and coordinated.

MODELING

Term used in the fashion world to denote the method of construction of the garment: it consists of working from a flat drawing in the first instance, to give a garment volume according to the different methods of construction, i.e., flat pattern drafting or draping.

MOOD BOARD

A presentation board that gives the overall concept and direction of the design collection, including photos, fabric swatches, colors and sketches.

MUSIC PRODUCER or SOUND ENGINEER

Person responsible for the music research and soundtracks used in a fashion show, publicity film or educational video.

NOTCH

Marks cut into the seam allowances of patterns or fabrics, to indicate sewing positions and match balance points made by a tool called a pattern notcher. They can also be used around necklines and armholes to make the curves more rounded and supple.

PASSEMENTERIES

Finishing details created using thread used to embellish a garment (shoulder pads, emblems, braids, etc.).

PATTERN DRAFTING, CUTTING AND MAKING

The drawing out of a flat pattern, made from card or paper, using measurements or through the use of block templates, comprising all the pieces necessary for a garment.

PATTERN HOOK

Commercial patterns are usually stored by hanging onto a metal hook, rather than folding.

PEPLUM

Bottom part of a jacket that descends from the waist to hip level.

PERSONAL SHOPPER

Person responsible for selecting products for a particular client who does not have the time to do the research themselves.

PINBOARD

Board covered with fine pins on which smooth or ribbed velvet is placed so that the pile is not squashed.

PINKING SHEARS

Serrated shears used to cut fabric or seam allowances to prevent fraying.

PIPING

Strip of fabric added to the slit of a pocket or buttonhole, or run into a seam to bind or decorate the edge.

PLEATS

Pleats can be made by regular manipulation of a fabric into a yoke or waistband, or by an industrial steaming process. There are many different types, e.g., box, flat, kick, inverted, knife, etc. There are some fabrics that are made up of a series of pleated fabrics, such as Fortuny's and Issey Miyake's pleated fabrics.

PUBLIC RELATIONS and EVENTS ORGANIZER

Office or department that is responsible for the planning of the fashion shows, product launches, boutique openings, etc.

PRESS OFFICER

Person responsible for the public relations of a brand or company.

PRINCESS LINE

A slim dress or bodice shape, using only vertical seam lines starting at the armhole.

RAGLAN SLEEVE

Sleeve made in two pieces with a seam line running down the top of the sleeve from the neckline to the bottom. Gives the shoulder a more or less rounded effect.

RESEARCH DEPARTMENT

Where the prototypes are developed and technical services are offered, such as regulating and grading the patterns, as well as launching the collection.

RETRO PLANNING

Planning a work schedule working backward, i.e., from the date of the presentation, to the finished product, to the date of the fashion show, etc.

ROUGHS

Quick first-stage drawings or sketches, usually made in pencil and without extraneous detail, which illustrate the idea.

RUCHED

Slightly puckered folds of ruched material are almost a cross between a fold and a dart.

SAMPLE

First model of a garment, made in the definitive fabric or one as close as possible, which tests whether the garment will be kept in the collection or not. It is rare that the first prototype is able to be shown to sales or marketing teams — normally several prototypes are made.

SAMPLE LENGTH

Small amount of fabric from which the prototype is cut.

SATURATED (COLOR)

Color that has been pushed to its maximum intensity.

SCENE COSTUME

Garment created for a piece of theater, ballet, concert or opera.

SELVAGE

The finished, lengthwise woven edge that binds the width of a fabric, preventing fraying.

SHIRT SLEEVE

Sleeve with buttoned cuff.

SHOOT

Photo session.

SHOULDER PAD

Piece of padding or foam added to a shoulder to support the hang of a jacket or coat. There are several different types: tailored shoulder pad, raglan, half-raglan, etc.

SHOULDER ROLL

A preformed piece of either foam or material, shaped and placed in a garment to reinforce and form the shoulder shape.

SHOWROOM

Space where the collections are presented to the press and buyers.

SILHOUETTE

General look of a person. In the fashion world, it is also the collection of elements that make up an outfit, reduced to basic geometric description, e.g., boxy, A-line, figure-8, etc., and the name given to a fashion show appearance, i.e., silhouette No.1, No. 2, etc.

SMOCKING

Areas of ornamental stitching on a garment that gather up the cloth tightly to form a relief.

SOURCING

Research of ideas, suppliers, markets and other useful elements necessary to make a product.

SPECIFICATION SHEET

A design drawing with measurements, manufacturing details such as trimmings and stitching, and front and back views of the garment, that is attached to the fashion illustration. It also serves as a gauge for pricing the garment.

STIFFENING

Cloth added to the inside of a suit jacket to reinforce the structure.

STORYBOARD

Also known as a theme board; a presentation of the concept for a collection with the breakdown of styles and coordinates.

STRAIGHT GRAIN

Line running parallel to the warp thread of a fabric that gives the garment its balance. It is the direction of the weave of a fabric.

STRIP

Width of fabric between the two selvage edges.

STUDIO

Work space where the collections are conceived and designed. For photography, it is the space where atmospheres are created with lighting and decor.

STUDIO DIRECTOR

Person responsible for the design studio. He or she coordinates the workload of each of the designers in relation to the artistic director's instructions.

STYLE DEVELOPMENTS

This involves research from a given idea for different models, volumes, shapes and products.

TAILORED SLEEVE

Sleeve that has a top and an underneath part so that the elbow can be worked. The top of the sleeve is made so that it has a rounded volume, giving a particular tailored line to the jacket or coat.

TAILOR'S CHALK

Waxy chalk that is puffed or drawn onto the fabric to mark the positions and guides for the machinists. The chalk is easily removed with steam.

TEMPLATE

Piece of card that guides the machinist when making pockets or collars. It is a pattern piece without the seams.

TEXTURE

A material's structure and consistency.

TICKING

Cotton twill-weave fabric characterized by its dense and strong qualities, used mainly for work clothing and furnishings, notably mattress coverings.

TOILE

Mock-up or draft of a garment, made in a fabric similar to natural-colored muslin and worked on a dress form.

TONES

All the intermediary colors obtained from a single one.

TREND

A trend may last a decade, but in the fashion world, it lasts just a season. This is a well-used term in the fashion industry when announcing themes and future season ideas.

TREND BOOK AND FORECASTING

Forecasting book that presents all the season's trends concerning color, fabrics, looks, beauty products and style. Prospective studies are done by a group of people who come together twice a year to summarize and define the broad industry trends for a given market.

TRIMMINGS

A term used for the decorative details on a garment, such as fur on a collar or cuffs on a coat, and for the process of finishing or cutting loose threads.

TURN-UP

The underside of a collar when turned up, or an added cuff at the trouser hem.

VINTAGE

Old garment, representative of an era, conserved in its original state.

WARP and WEFT

Term used by professionals to refer to the direction of the weave. The warp threads of a woven fabric are those which make up the lengthwise grain. The weft threads are placed in by a shuttle, at 90 degrees to the warp, and run from selvage to selvage giving the fabric its width.

WEAVE

Method of organization of a fabric's warp and weft threads. There are three principal arrangements – plain, twill or satin weaves – from which innumerable combinations are derived.

WHIPPING or OVERSEWING

Finishing stitch on a garment that stops any fraying of the fabric after it is cut. It is commonly used for knitwear and jersey.

WORKROOM or ATELIER

Place where the samples and prototypes are developed and where technicians such as toilistes or pattern cutters, machinists and cutters work.

Flou, or Dressmaking, Workroom: place where dresses, blouses and unstructured items are developed.

Suit Tailoring Workroom: place where fitted sleeves are made that require a specific skill, as seen in suits, costumes and coats, etc.

These are the two types of workshops most commonly encountered in the world of haute couture.

Assembly Workroom: this where batch production items are made up.

Cutting Workroom: place where the above are cut.

YOKE

A piece of material used to support a fuller or gathered length, e.g., across the shoulders of a shirt or from the hip line.

ZIG ZAG

Stitch used to bind or finish edges decoratively or where the seam must be allowed to stretch safely, e.g., with knitwear and lingerie.

FASHION DIRECTORY

SHOPS AND SUPPLIERS

FABRICS
USA

B&J Fabrics
525 7th Avenue
New York, NY, 10018
212-354-8150
www.bandjfabrics.com

Leather Impact
256 West 38th Street
New York, NY, 10018
212-302-2332
leatherimpact.com

Mood Designer Fabrics
225 West 37th Street, 3rd floor
New York, NY, 10018
212-730-5003
www.moodfabrics.com

Mood Designer Fabrics
6151 West Pico Boulevard
Los Angeles, CA, 90035
323-653-6663
www.moodfabrics.com

Paron Fabrics
206 West 40th Street
New York, NY, 10018
212-768-3266
www.paronfabrics.com

CANADA

Darrell Thomas Textiles
153 Preston Street
Ottawa, ON, K1R 7P6
613-239-3854
www.darrellthomas.com

Designer Fabrics
1360 Queen Street West
Toronto, ON, M6K 1L7
416-531-2810
secure.designerfabrics.ca/shop/scripts

Dragonfly Fabrics
2679 Alta Vista Drive
Ottawa, ON, K1V 7T5
613-521-9839
www.dragonflyfabrics.ca

Leo's Textiles
400 Queen Street West
Toronto, ON, M5V 2A9
416-504-6060
www.leostextiles.com

DRAWING SUPPLIERS

New York Central Art Supply
62 3rd Avenue
New York, NY, 10003
USA
212-473-7705
www.nycentralart.com

Blue Rooster
1718 North Vermont Avenue
Los Angeles, CA, 90027
USA
323-661-9471
www.blueroosterartsupplies.com

Curry's
90 Yonge Street
Toronto, ON, M4Y 1X5
Canada
416-967-6666
www.currys.com

Wallack's
603 Bank Street
Ottawa, ON, K1S 3T4
Canada
613-238-8871

STUDIO AND BOUTIQUE EQUIPMENT

Roxy Display
18 Kennedy Boulevard
East Brunswick, NJ, 08816
USA
732-246-7058
www.roxydisplayinc.com

PGM-Pro Inc.
5041-5047 Heintz Street
Baldwin Park, CA, 91706
USA
626-338-1990
www.pgmdressform.com

SUNDRIES

Button World
389 5th Avenue
New York, NY, 10016-3354
USA
212-768-4771

Beadworks
619 East Passyunk Avenue
Philadelphia, PA, 19147
USA
215-413-2323
www.beadworksphiladelphia.com

The Bead Factory
810 South Maple Avenue
Los Angeles, CA, 90014
USA
213-624-2121
www.beadsfactory.com

Bead Junction
389 Roncesvalles Avenue
Toronto, ON, M6R 2N1
Canada
416-533-8555
www.bead-junction.com

Rainbow Minerals
2255 Gladwin Crescent
Ottawa, ON, K1B 4K9
Canada
613-733-8440
www.rainbowminerals.com

USEFUL ADDRESSES

Council of Fashion Designers of America
1412 Broadway, Suite 2006
New York, NY, 10018
USA
www.cfda.com

FASHION SCHOOLS

France

Atelier Chardon Savard
BTS Stylisme de mode
15, rue Gambey
75011 Paris

Chambre syndicale de la couture parisienne
Formations aux métiers artistiques
45, rue Saint-Roch
75001 Paris

École C-Six-Douze
École supérieure privée art et design
44 bis, rue Lucien-Sampaix
75010 Paris

École Duperré
BTS Mode-Textile DMA Arts textiles (DSAA Mode et Environnement)
11, rue Dupetit-Thouars
75003 Paris

ENSAAMA Olivier de Serres
BTS Art textile et Impression
63-65, rue Olivier-de-Serres
75015 Paris

ESMOD
École supérieure privée de création de mode
12, rue La Rochefoucauld
75009 Paris

LISAA
13, rue Vaucquelin
75005 Paris

Lycée Auguste Renoir
Arts appliqués (spécialisation industrie de l'habillement, prépa BT)
24, rue Ganneron
75018 Paris

Lycée Choiseul
BTS Arts appliqués stylisme de mode
78, rue des Douets
39095 Tours

Lycée de la mode
BTS Stylisme de mode
20, rue du Carteron
49321 Cholet

Lycée Elisa Lemonnier
20, avenue Armand-Rousseau
75012 Paris

Studio Berçot
29, rue des Petites-Écuries
75010 Paris

Belgium

Académie royale des Beaux-Arts d'Anvers
Blindestraat 9
BE-2000 Anvers

Flanders Fashion Institute
Mode Natie
Nationale Straat
Drukkerijstraat
Anvers

La Cambre
École supérieure d'Arts visuels
21, abbaye de la Cambre
1000 Bruxelles

UK

Central Saint Martin's College of Art and Design
School of Fashion and Textiles
107-109 Charing Cross Road
London WC2H 0DU

Edinburgh College of Art
Lauriston Place
Edinburgh EH3 9DF

Kingston University
School of Fashion
Knights Park
Kingston upon Thames
Surrey KT1 2 QJ

London College of Fashion
20 John Princes Street
London W1M 0BJ

Manchester Metropolitan University
Faculty of Art & Design
Ormond Building
Ormond Street
Manchester M15 6BH

Middlesex University
School of Fashion and Textiles
Cat Hill
Barnet
Hertfordshire EN4 8HT

Royal College of Art
(MA course only)
School of Fashion and Textiles
Kensington Gore
London SW7 2EU

University of Brighton
School of Design – Fashion Textiles
Grand Parade, Brighton
East Sussex BN2 2U

University of Newcastle upon Tyne
Department of Fine Art
5 Kensington Terrace
Newcastle upon Tyne NE4 7SA

USA

Academy of Art University
79 New Montgomery Street, 4th Floor
San Francisco, CA, 94105-3410
800-544-2787
www.academyart.edu

California College of the Arts
1111 Eighth Street
San Francisco, CA, 94107-2247
415-703-9500
www.cca.edu

Columbus College of Art and Design
60 Cleveland Avenue
Columbus, OH, 43215
614-224-9101
www.ccad.edu

Drexel University
3141 Chestnut Street
Philadelphia, PA, 19104
215-895-2000
www.drexel.edu

Fashion Institute of Technology
227 West 27th Street
New York, NY, 10001-5992
212-217-7999
www.fitnyc.edu

Massachusetts College of Art and Design
621 Huntington Avenue
Boston, MA, 0211
617-879-7000
www.massart.edu

Otis College of Art and Design
9045 Lincoln Boulevard
Los Angeles, CA, 90045
800-527-6847
www.otis.edu

Parsons The New School For Design
66 Fifth Avenue
New York, NY, 1001
212-229-8900
www.newschool.edu

Pratt Institute
200 Willoughby Avenue
Brooklyn, NY, 11205
718-636-3600

Rhode Island School of Design
2 College Street
Providence, RI, 02903
401-454-6100
www.risd.edu

Savannah College of Art and Design
42 Bull Street
Savannah, GA, 31402
912-525-5100
www.scad.edu

University of Cincinnati
2600 Clifton Avenue
Cincinnati, OH, 45221
513-556-1100
www.uc.edu

Canada

Alberta College of Art and Design
1407-14 Avenue Noth West
Calgary, AB, T2N 4R3
403-284-7600
acad.ab.ca

Emily Carr University of Art and Design
1399 Johnston Street
Granville Island Vancouver, BC, V6H 3R9
604-844-3800
www.ecuad.ca

Nova Scotia College of Art and Design
5163 Duke Street
Halifax, NS, B3J 3J6
902-444 9600
nscad.ca

Ontario College of Art and Design
100 McCaul Street
Toronto, ON, M5T 1W1
416-977-6000
www.ocad.ca

Sheridan Institute of Technology and
Advanced Learning
PO Box 2500, Stn Main
Oakville, ON, L6L 7T7
www.sheridaninstitute.ca

University of Guelph
50 Stone Road East
Guelph, ON, N1G 2W1
519-824-4120
www.uoguelph.ca

RECRUITMENT SITES FOR FASHION PROFESSIONALS

www.abc-luxe.com

www.fashionjob.fr

www.ks-interim.com

www.modefashion.com

www.modemonline.com

www.profilmode.com

24 Seven Inc.
120 Wooster Street
New York, NY, 10013
USA
212-966-4426
www.24seveninc.com

Floriane de St-Pierre
134, rue du Faubourg-Saint-Honoré
75008 Paris

Interim Nation
75, boulevard de Picpus
75012 Paris
www.interim-nation.fr
Tel: 01 43 45 50 00

Janou Parker
4, rue du Faubourg-Saint-Honoré
75008 Paris
Tel: 01 45 23 18 54

Manpower Couture
42, rue Washington
75008 Paris
Tel: 01 56 59 32 70

Modelor
18-20, rue Daunou
75002 Paris
www.modelor.fr

Proforce Personnel
300 Saint Sacrement, suite 208
Montreal, QC, H2Y 1X4
Canada
514-905-0606
www.proforce.ca

Kate Sasson conseil
21, rue Cambon
75001 Paris
www.katesasson.com

Rag Trade Jobs
88-90 Foveaux Street, Level 3, Fortune House
Surry Hills, NSW 2010
Global
Tel: 02 9211 8212
www.ragtradejobs.com

LIBRARIES

Les Arts décoratifs
63, rue Monceau
75008 Paris
Tel: 01 53 89 06 40

Bibliothèque des Arts décoratifs
107, rue de Rivoli
75001 Paris
Tel : 01 44 55 57 50

Bibliothèque nationale de France
Bibliothèque François-Mitterrand
11, quai François-Mauriac
75013 Paris

Bibliothèque Publique d'Information
- Centre Georges-Pompidou
19, rue Beaubourg
75004 Paris
Tel: 01 44 78 12 33

Musée Galliera - musée de la Mode de la Ville
de Paris
Centre de documentation - bibliothèque
10, avenue Pierre-Ier-de-Serbie
75115 Paris
Tel: 01 56 52 86 00

National Gallery of Canada
380 Sussex Drive
Ottawa, ON, K1N 9N4
Canada
613-990-1985
www.beaux-arts.ca

New York Public Library
Fifth Avenue at 42nd Street
New York, NY, 10018-2788
USA
917-275-6975
www.nypl.org

MUSEUMS

USA

Cooper-Hewitt, National Design Museum
2 East 91st Street
New York, NY, 10128
212-849-8400
cooperhewitt.org

The Getty
1200 Getty Center Drive
Los Angeles, CA, 90049–1679
310-440-7300
www.getty.edu

Kent State University Museum
P.O. Box 5190, Rockwell Hall
Kent, Ohio, 44242-0001
330-672-3450
dept.kent.edu/museum/general/general.html

The Metropolitan Museum of Art
1000 Fifth Avenue
New York, NY, 10028-0198
212-535-7710
www.metmuseum.org

Mint Museum of Art
2730 Randolph Road
Charlotte, NC, 28207
704-337-2000
www.mintmuseum.org

The Museum of Modern Art
11 West 53 Street
New York, NY, 10019-5497
212-708-9400
www.moma.org

The Textile Museum
2320 S Street NW
Washington, DC, 20008-4088
202-667-0441
www.textilemuseum.org

Canada

The Bata Shoe Museum
327 Bloor Street West
Toronto, ON, M5S 1W7
416-979-7799
www.batashoemuseum.ca

Royal Ontario Museum
100 Queen's Park
Toronto, ON, M5S 2C6
416-586-8000
www.rom.on.ca

PRINCIPAL TRADE SHOWS

Accessories
Modamont (Paris)
Première classe

Leather
Anteprima (Milan)
Le cuir à Paris
Linea Pelle (accessoires and prêt-à-porter)
Salon du cuir

Yarn
Expofil (Paris): September and March
Indigo

Knitwear
Expofil (Paris)
Moda In (Milan)
Pitti Filatil (Florence)

Prêt-à-porter
Atmosphère (Hotel St James)
Tranoï
Who's next

Finished products
Intersélection

Fabrics
Moda In (Milan)
Première Vision (Paris): September and March
Texworld (Paris)
Tissu Premier (Lille): January

BIBLIOGRAPHY

Books

Big Active, *Head, Heart and Hips: The Seductive World of Big Active*, Berlin, Die Gelstalten Verlag Edition, 2004.

Susanna Anna, Eva Gronback, Miriam Matsuszkiewicz, *The Fashion Generation*, New York, Hatje Cantz Publishers, 2006.

Maggy Baum, Chantal Boyeldieu, *Dictionnaire des textiles*, Paris, Editions de l'industrie textile, 2003.

George Beylerian, Andrew Dent, *Material Connexion: The Global Resource of New and Innovative Materials for Architects, Artists and Designers*, New York, John Wiley & Sons, 2005.

François Boucher, *Histoire du costume en Occident de l'Antiquité à nos jours*, Paris, Flammarion, 1983.

David Bowie, Karl Lagerfeld, Mario Testino, *Dreaming in Print: A Decade of Visionnaire*, New York, Edition 7L (Steidl), 2002.

Collectif, *Beyond Desire*, New York, Ludion, 2005.

Collectif, *Embroidery*, New York, Damiani, 2006.

Collectif, *Fabrica 10: From Chaos to Order and Back*, Milan, Electa, 2004.

Collectif, *Technologie du vêtement*, Québec, Guérin, 1999.

Collectif, *Total Living*, New York, Charta, 2002.

Collectif, *Uniform: Order and Disorder*, New York, Charta, 2001.

Collectif, *Modemuseum/The Fashion Museum*, New York, Ludion, 2003 .

Collectif, *Shopping*, New York, Hatje Cantz Publishers, 2003.

Luc Dericke, Sandra Van De Veire, *Belgian Fashion Design*, New York, Ludion, 1999.

Dictionnaire international de la mode, Paris, Editions du Regard, 1994–2004.

Maria Luisa Frisa, Stefano Tonchi, *Excess: Fashion and the Underground in the '80s*, New York, Charta/Fondazione Pitti Immagine Discovery, 2004.

Christine Garaud, Bernadette Sautreuil, *Technologie des tissus*, Paris, André Casteilla, 1984.

Antoine Kruk, *Shibuya Soul*, Paris, Archimbaud, 2006.

Pierre Hirsch, *Textile Glossary, English–French*, Metz, Librairie de l'industrie textile, 1994.

Sue Jenkyn Jones, *Le stylisme, guide des métiers*, Paris, Pyramid, 2005.

Dorling Kindersley, *Le grand livre de la couture*, Paris, Hachette, 1997.

Didier Ludot, *La petite robe noire*, Paris, Assouline, 2001.

Stéphane Marais, *Beauty Flash*, Paris, Edition 7L (Steidl), 2001.

Isaac Mizrahi, *The Adventures of Sandee the Supermodel*, New York, S&S Editions Comic Book Series, 1997.

Ludovico Pratesi, Vichy Hassan, Gianluca Lo Vetro, *Artenergie*, New York, Charta, 1998.

András Szunyoghy et György Fehér, *Anatomie humaine à l'usage des artistes*, Cologne, Köneman, 2000.

Françoise Tellier-Loumagne, *Mailles, les mouvements du fil*, Genève, Minerva, 2003.

Heidemaria Tengler-Stadelmaier, *La couture pratique*, Hoenheim, V. A. Burda, 2002.

Walter Van Beirendonck, *Mode 2001: Landed-Geland Part I*, New York, Merz, 2002.

Walter Van Beirendonck, *Mode 2001: Landed-Geland Part II*, New York, Merz, 2002.

Nadine Vasseur, *Les Plis*, Paris, Le Seuil, 2002.

Veerle Windels, *Young Belgian Fashion Design*, New York, Ludion, 2001.

Fashion trade publications

Bloom
California Apparel News
Daily News Record (DNR)
Fashion Daily News
Fashion Reporter
Journal du textile
Selvedge
Tank
Texnews (www.texnews.fr)
Textile View
Tobe Report
View textile
Women's Wear Daily (WWD)

Fashion magazines

Another magazine (British)
Another man (men's – British)
Arena homme + (men's – British)
Biba (French)
Citizen K (French)
Collezioni (Italian)
Crash (French)
Deutsch (German)
Doingbird (Australian)
Elle (international)
Figaro Madame (French)
Glamour (international)
GQ (men's – international)
Harper's Bazaar (international)
ID (British)
Jalouse (French)
Marie Claire (international)
Milk (children's – French)
Muteen (French)
Neo2 (Spanish)
Numéro (French)
Nylon (American)
L'Officiel (French)
Oyster (Australian)
Pop (British)
Purple (French)
Quest (German)
Self-Service (French)
Sleek (German)
Stilleto (French)
Tank (British)
Ten (British)
Ten men (men's – British)
L'Uomo Vogue (men's – Italian)
V (American)
V men (men's – American)
20 ans (French)
Visionaire (American)
Vogue (international)
W (American)
Wad (French)
Zoo (German)

FILMOGRAPHY

Amadeus
Milos Foreman, 1984
Inspirational film for 18th century costumes.

American Gigolo
Paul Schrader, 1980
With Richard Gere playing the role of a high-class gigolo dressed in Armani.

Le Bal
Ettore Scola, 1983
Evolution of fashion from the 1920s to 1950s portrayed in a ballroom setting.

Barbarella
Roger Vadim, 1967
Futuristic film starring Jane Fonda, with costumes by Paco Rabanne.

Barry Lyndon
Stanley Kubrick, 1975
Inspirational film for 18th-century costumes.

Belle de Jour
Luis Bunuel, 1967
Starring Catherine Deneuve, dressed by Yves Saint Laurent.

Bilitis
David Hamilton, 1977
Soft eroticism and romance fashions.

Blade Runner
Ridley Scott, 1982
Science-fiction film, with costumes from the 1940s and a touch of futurism.

Blowup
Michelangelo Antonioni, 1966
Swinging London in the 1960s with the Mary Quant style; the world of a fashion photographer with Veruschka and Jane Birkin.

The Blue Angel
Josef von Sternberg, 1930
Germany in the 1920s, with Marlene Dietrich in her famous theater costume.

Bonnie and Clyde
Arthur Penn, 1967
American fashion of the 1930s with Faye Dunaway and Warren Beatty.

Bram Stoker's Dracula
Francis Ford Coppola, 1992
Fashionable look at the end of the 19th century.

Breakfast at Tiffany's
Blake Edwards, 1961
The elegance and style of Audrey Hepburn.

Breathless
Jean-Luc Goddard, 1960
Jean Seberg: her style, hair and tomboy look.

Ciao! Manhattan
John Palmer and David Weisman, 1972
Starring Edie Sedgwick, one of Andy Warhol's muses and an icon of 1970 New York.

A Clockwork Orange
Stanley Kubrick, 1971
1960s style and the influence of the "boy" look on men's fashion up to today.

The Cook the Thief His Wife & Her Lover
Peter Greenaway, 1989
Highly stylized film with costumes by Jean Paul Gaultier.

Desperately Seeking Susan
Susan Seidelman, 1985
The Madonna look of the 1980s.

The Devil Wears Prada
David Frankel, 2006
Film about the life of a fashion editor in New York.

La Dolce Vita
Federico Fellini, 1960
Cult film with Anita Ekberg about Italian society in the 1950s and 1960s.

Donkey Skin
Jacques Demy, 1970
Princess dresses worn by Catherine Deneuve.

Dune
David Lynch, 1984
Science-fiction film, futuristic look and original costumes by Bob Ringwood.

Easy Rider
Dennis Hopper, 1969
Hippie and biker looks in the 1960s and 1970s with Dennis Hopper, Jack Nicholson and Peter Fonda.

The Eyes of Laura Mars
Irvin Kershner, 1978
Suspense film about a fashion photographer played by Faye Dunaway, with original photos by Helmut Newton.

Fahrenheit 451
François Truffaut, 1966
An imagined futuristic film made in and strongly redolent of the 1960s.

The Fifth Element
Luc Besson, 1997
Science-fiction film with Mila Jovovich in Jean Paul Gaultier's costumes.

Flash Dance
Adrian Lyne, 1983
Explosion of Lycra body stockings and dance wear.

Funny Face
Stanley Donen, 1957
Audrey Hepburn dressed by Hubert de Givenchy.

Gilda
Charles Vidor, 1946
With Rita Hayworth; Hollywood glamor style in the 1940s.

Girl with a Pearl Earring
Peter Webber, 2003
Historical film inspired by a Vermeer painting.

Grease
Randal Kleiser, 1978
Schoolgirl Olivia Newton-John transforms herself into a femme fatale at the end of the 1950s.

The Great Gatsby
Jack Clayton, 1974
Life in the 1930s in America's high-class society.

The Great Rock 'n' Roll Swindle
Julien Temple, 1980
Punk film.

Hair
Milos Forman, 1979
Film about the hippie movement.

In the Mood for Love
Wong Kar-Wai, 2000
Hong Kong in the 1950s – highly stylized.

Jules et Jim
François Truffaut, 1962
Jeanne Moreau in the role of a free-spirited woman in 1910.

Kids
Larry Clark, 1995
Film about youth culture in New York in the 1990s.

Kika
Pedro Almodóvar, 1993
Costumes by Jean Paul Gaultier.

Last Year at Marienbad
Alain Resnais, 1961
This film presents the sumptuous years of the 1950s with Delphine Seyrig wearing a Chanel dress.

Liquid Sky
Slava Tsukerman, 1982
Underground cult film of the New Wave era.

Lolita
Stanley Kubrick, 1962
Lolita fashion – fashion subculture in Japan, primarily influenced by Victorian children's clothes as well as costumes from the Rococo period.

Lucifer Rising, Invocation of My Demon Brother, Scorpio Rising, Inauguration of the Pleasure Dome, etc.
Kenneth Anger, 1972, 1969, 1964, 1954, etc.
Sources of multiple inspiration, particularly to do with the underground world.

Mad Max I, II and III
George Miller, 1979, 1981, 1985
Science-fiction films with futuristic warriors.

Marie Antoinette
Sofia Coppola, 2006
Sumptuous staging of a historical film.

Matrix, Matrix Reloaded, Matrix Revolutions
Andy and Larry Wachowski, 1999, 2003, 2003
Futuristic black films featuring somewhere between gothic and dandy costumes.

Metropolis
Fritz Lang, 1925
Cult science-fiction film set in the 1920s.

Model
Frederick Wiseman, 1980
Modeling agency in New York in the 1970s.

Morocco
Josef von Sternberg, 1930
Marlene Dietrich in a smoking jacket.

Notebook on Cities and Clothes
Wim Wenders, 1989
Film about the designer Yohji Yamamoto.

Pandora's Box
Georg Wilhelm Pabst, 1929
Louise Brooks and her famous "bob" cut and style.

Performance
Donald Cammell and Nicolas Roeg, 1970
Swinging London with Mick Jagger and Anita Pallenberg dressed by Ossie Clark.

Prét-à-Porter
Robert Altman, 1994
Film presenting the world of the Parisian fashion scene with fashion shows by Christian Lacroix and Jean Paul Gaultier.

Quadrophenia
Franc Roddam, 1979
Film about the mods and rockers in the 1960s, featuring Sting.

Reservoir Dogs
Quentin Tarantino, 1992
Black suits, white shirts and thin black ties.

Rize
David LaChapelle, 2005
Film documentary on the hip-hop dance scene in the U.S., by a fashion photographer.

The Rocky Horror Picture Show
Jim Sharman, 1975
Cult film with outrageous costumes.

Saturday Night Fever
John Badham, 1977
The disco movement explodes.

Seven Year Itch
Billy Wilder, 1955
With Marilyn Monroe and the famous scene where her dress blows up over a New York subway grate.

Shadows
John Cassavetes, 1959
New York jazz musicians in the 1950s and 1960s.

Shaft
Gordon Parks, 1971
Cult film about blaxploitation (exploitation of black people).

Shampoo
Hal Ashby, 1975
The American jet set of the 1970s, with Warren Beatty.

A Streetcar Named Desire
Elia Kazan, 1951
Cult film starring Marlon Brando in his sleeveless tee shirt.

Suzhou he
Lou Ye, 2000
Shanghai in the year 2000.

Taxi Driver
Martin Scorsese, 1976
Cult film with Robert de Niro playing a New York taxi driver and Jodie Foster playing a young prostitute.

The Thomas Crown Affair
Norman Jewison, 1968
Cult film about an art robbery, with Faye Dunaway.

Traffic
Jacques Tati, 1971
Modernism as seen by Jacques Tati.

Unzipped
Douglas Keeve, 1995
Documentary on Isaac Mizrahi.

The Virgin Suicides
Sofia Coppola, 1999
1970s teenage fashion in the U.S.

Who Are You Polly Magoo?
William Klein, 1966
Fashion parody with a fashion show by Paco Rabanne.

The Wild One
Laslo Benedek, 1953
Cult film with Marlon Brando in motorcycle gear.

Wild Style
Charlie Ahearn, 1983
Cult film about the beginnings of hip-hop.

The Women
George Cukor, 1939
Film about Hollywood women including a 10-minute fashion parade.

The Young Girls of Rochefort
Jacques Demy and Agnès Vanda, 1967
Catherine Deneuve and Françoise Dorléac, with original costumes by Jacqueline Moreau.

ACKNOWLEDGMENTS

I would like to thank:

The team at school c-6-12:
Steve Régis, assistant editor, for his research and collaboration on the organization of the texts, Benoît Bonté for his advice on visuals, Victoria Cahouet for coordinating the visuals, Tomoe Kamiya for the fabric boards and advice on garment techniques, Martine Adrien and Jean-Philippe Bouyer for their re-reading and professional information, and Masaya Ito for his active contribution.

The students for their contribution:
Angouma Poulcherie, Miwa Nakata, Ninjin Puntsag, Morgan Cahouet, Sono Fukunishi, Toshihiko Yoshino, Lei Matsuno, Li Ge, Li Chen, Jun Zhan, Juan He, Nadia Kahil, Hanako Chiba, Rumi Kikuchi, Steven Hamon, Shuntao Chen.

External contributors:
Lucie Laroche and Shunsuke Nakamura for their advice on the graphics, Antoine Kruk for his general contribution, Stephan Schopferer for his photo documentaries and general contribution to the book, Beata for her makeup, David Courtin for the image editing, Rebecca Monsarrat, Michelle...., Danaé Monseigny, Frédéric....

Fashion Professionals:
Didier Ludot for his support, preface and contribution to the vintage clothing and "little black dress" texts.
Odile Gilbert for her interview.
Stéphane Marais for his interview.
Rebecca Leach for her information on fashion photography.
Lutz Huelle for opening the doors of his studio to us and giving us an insight into his working methods.
David Ballu, financial director of the brand Lutz, for his information on how to organize a fashion company.
Le Bon Marché and Promostyl for the loan of materials.
Loulou de la Falaise.

And, in particular, Anne Le Bras, for the interest she has shown in my work, for her collaboration, advice and availability throughout this project, and also for this book, which she instigated.

CREDITS

Illustrations

pp. 16, 17, 18 (left): Miwa Nakata and p.18 (right): Kana Matsunami

p. 19: Morgan Cahout

p. 20 (left): Antoine Kruk and pp. 20 and 21 (center): Miwa Nakata

p. 30: Antoine Kruk

p. 31: Victoria Cahouet

pp. 32, 33, 34, 35: Morgan and Victoria Cahouet

pp. 36, 37: Li GE

pp. 38-53: Tomoe Kamiya and Benoit Bonte with:

Toshihiko Yoshino, Le Ge, Lei Chen, Juan He and David Courtin.

p. 40 (left), 41 (left and bottom right)

p. 42 (left), 46, (left), 47 (right) 49 (right)

p. 50 (left): Jun Zhan (illustrations)

pp. 56, 57, 58, 59: Lutz (notebooks)

p. 63: Antoine Kruk

p. 65: Rei Matsuno

pp. 67-73: Antoine Kruk

p. 74, 75 (right): Sono Fukunishi (textile design)

p.75 (left): Antoine Kruk (illustration)

p. 77: Rei Matsuno

p. 78 Jun Zhan (illustration) and Rei Matsuno (flower illustration)

pp. 90, 91: Li Zhen

pp. 96-99, 101, 104, 106, 108, 109-11: Jun Zhan

pp. 118, 119: Promostyl (trend book)

pp. 120, 121, 122, 123: Hanako Chiba

p. 125: Ninjin Puntsag

p. 126: Takashi Nakao

p. 127: Rumi Kikuchi (tee-shirt portfolio)

p. 130: Aki Shinada (portfolio)

p. 131: Takashi Nakao (portfolio)

p. 132 (portfolios): Takashi Nakao (top) and Hanako Chiba (bottom)

p. 133 (portfolios): Takashi Nakao (top) and Rumi Kikuchi (bottom)

p. 134: Nadia Kahil (portfolio)

p. 135: Takashi Nakao (portfolio)

pp. 136, 137: Tomoe Kamiya (drawings, board)

p. 142 (left): Lutz (research sketchbook)

p. 176: Antoine Kruk (left and center) and Benoit Bonte (right)

p. 177: Antoine Kruk

Photos

Cover : Stephan Schopferer

pp. 22, 23, 24, 25, 26, 27: Stephan Schopferer

pp. 28, 29: Stephan Schopferer (model: Victoria C, dresses by Lutz)

pp. 62, 64, 79: Shun Tao Chen (flower)

pp. 140, 141, 142 (right), 143, 144, 145, 147: Steven Schopferer

p. 150: Ninjin Punstag

pp. 156-64: Stephan Schopferer

pp. 174, 175: Olivier Gerval

pp. 178-80: Stephan Schopferer

p. 181: Olivier Gerval (top) and Jules Hermant (bottom)

p. 182: David Ballu

p. 183: Olivier Gerval (top) and Stephan Schopferer (bottom)

p. 184: Olivier Gerval

p. 185: Olivier Gerval (top) and Stephan Schopferer (bottom)

p. 186: Olivier Gerval

p. 187: Olivier Gerval (top and center) and David Ballu (bottom)

p. 188: Olivier Gerval

p. 189: Pascal Therme

Fabrics

p. 67 (skirt):	Teseo s.r.l. (T)
	Hellenic Fabrics/s.a. (H)
	Teseo s.r.l. (T)
p. 68 (dress):	Komatsu Seiren (K)
	Teseo s.r.l. (T)
p. 69 (trousers):	OBO (C) (Chugai Kunishima Corporation)
	Hellenic Fabrics/s.a. (H)
	Komatsu Seiren (K)
p. 70 (jacket):	Nikke (N)
	Daiwabo Co. Ltd. (D)
p. 71 (coat):	Leathertex (L)
	OBO (C) (Chugai Kunishima Corporation)
	Daiwabo Co. Ltd. (D)
p. 72 (tee shirt):	Nikke (N)
	Girl's (A)
p. 73 (shirt):	Komatsu Seiren (K)
	Teseo s.r.l. (T)
	OBO (C) (Chugai Kunishima Corporation)
p. 76 (color variations):	Teseo s.r.l. (T)